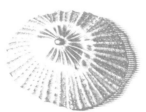
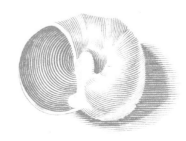
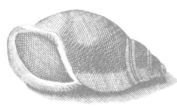

Martin Lister

AND HIS

Remarkable Daughters

Martin Lister

AND HIS
Remarkable Daughters

THE ART OF SCIENCE IN THE SEVENTEENTH CENTURY

ANNA MARIE ROOS

Bodleian Library
UNIVERSITY OF OXFORD

THE
ROYAL
SOCIETY

This publication has been generously
supported by The Royal Society

First published in 2019 by the Bodleian Library
Broad Street, Oxford OX1 3BG
www.bodleianshop.co.uk

ISBN 978 1 85124 489 8

Cover design by Dot Little at the Bodleian Library
Designed and typeset in 11 on 14 Janson by illuminati, Grosmont
Printed and bound in Great Britain by TJ International Ltd, Padstow, Cornwall,
on 80gsm Munken Premium Cream FSC paper

British Library Catalogue in Publishing Data
A CIP record of this publication is available from the British Library

Contents

Acknowledgements

A number of colleagues, friends and institutions helped make this project possible.

This book had its inception in the Cultures of Knowledge Project in the Faculty of History at Oxford. I had the distinct pleasure of working at Oxford with Philip Beeley, James Brown, Sue Burgess, Pietro Corsi, David Cram, Peter Harrison, Kateřina Horníčková, Howard Hotson, Neil Jeffries, Rhodri Lewis, Noel Malcolm, Kim McLean-Fiander, Richard Ovenden, Leigh Penman, Michael Popham, William Poole, Richard Sharpe and Kelsey Jackson Williams. Miranda Lewis in particular deserves a big hug for encouraging me to pursue this project.

I am also fortunate to have lovely colleagues at the University of Lincoln and am most grateful for their patience and kindness.

The assistance of the University of Oxford has also been essential. The bulk of the Lister family papers are in the Bodleian Library, and librarians in Special Collections have acceded with consummate professionalism to my numerous requests to examine materials. Clive Hurst, Alexandra Franklin, Colin Harris and Bruce Barker-Benfield indicated the provenance of several manuscripts. Richard Ovenden was super with assisting me in finding appropriate images. Samuel Fanous, Dot Little, Janet Phillips and Leanda Shrimpton at Bodleian Library Publishing made the publication process a pleasure.

The Royal Society was extraordinarily supportive of this book, giving me a History of Science grant to assist with its completion. My special thanks to Keith Moore, the Royal Society Librarian, for being his splendid

self and for making me laugh when I took myself too seriously. Rupert Baker has also been very kind.

Other colleagues and friends who provided encouragement through this process include Jim Bennett, Tim Birkhead, Jane Brocket, Helen and Bill Bynum, Jeff Carr, Pratik Chakrabarti, Isabelle Charmantier, Belinda Clark, Julie Davies, James Delbourgo, Sven Dupré, Florike Egmond, Patricia Fara, Mordechai Feingold, Robert Fox, Alex Franklin, Uta Frith, Sallyanne Gilchrist, Rainer Godel, Anne Goldgar, Anita Guerrini, Jo Hedesan, Felicity Henderson, Michael Hunter, Rob Iliffe, Charlie Jarvis, Mike Jewess, Dorothy Johnston, Erik Jorink, Marika Keblusek, Sachiko Kusukawa, Vera Keller, Elaine Leong, Karin Leonhard, Dmitri Levitin, Arthur MacGregor, Scott Mandelbrote, Gideon Manning, Brian Ogilvie, Nancy Patrick, Margaret Pelling, Richard Serjeantson, Sally Sheard, Anna Simmons, Sally Shuttleworth, Charlotte Sleigh, Lisa Smith, Paul Smith, Anke Timmermann, Benjamin Wardhaugh, Kathie Way, Charles Webster, Simon Werrett, Cathy Wilson, Marianne Wilson, Jeremy Woodley and Beth Yale.

Andrew, Ruth and Joseph Bramley, June Benton, Lori Rausch, Sally Sheard, Neil Storch, Connie Jacoby and Mari Trine have been loyal and true friends. During the course of finishing this book, Lisa Jardine, whom I admire beyond price, passed away. I continue to miss her and be inspired by her generous spirit.

My husband Ian Benton continues to stand by my side throughout, a calm and steady presence to help me weather scholarly angst, writer's block, computer woes, illness and, worst of all, running out of coffee. Thank you, you stubborn Lincolnshire man.

To Ian, again.

To K: *βιβλιόφιλος*

To Lisa Jardine,
ad perpetuam memoriam

Art is the provocation for talking about enigma and the search for sense in human life. One can do that by telling a story or writing about a fresco by Giotto or studying how a snail climbs up a wall.

John Peter Berger

I sent a Box of Books as a present to the Musæum … if I could gett better, I would: but the warr hinders all correspondence so I desire they will accept of what I have.

Oglbies Atlas 6 volumes
The Three French accounts of Learning & books. viz
Bibliotheque Universelle
Nouvelle des Lettres
Histoire des ouvrages de Scavans
a Booke of drawings pasted of my childes…

Martin Lister to Edward Lhwyd, 18 October 1693

AN ACCOUNT

OF

PARIS,

AT THE

CLOSE OF THE SEVENTEENTH CENTURY:

RELATING TO THE

BUILDINGS OF THAT CITY, ITS LIBRARIES, GARDENS,
NATURAL AND ARTIFICIAL CURIOSITIES, THE
MANNERS AND CUSTOMS OF THE PEOPLE,
THEIR ARTS, MANUFACTURES, &c.

BY MARTIN LISTER, M. D.

NOW REVISED,

WITH COPIOUS BIOGRAPHICAL, HISTORICAL, AND
LITERARY ILLUSTRATIONS AND ANECDOTES,

AND

A SKETCH OF THE LIFE OF THE AUTHOR,

BY GEORGE HENNING, M. D.

Obscurata diu populo bonus eruet, atque
Proferet in lucem speciosa vocabula rerum,
Quæ priscis memorata Catonibus atque Cethegis,
Nunc situs informis premit et deserta vetustas,
Luxuriantia compescet: nimis aspera sano
Levabit cultu, virtute carentia tollet.
Hor. L. 2. Ep. 2. v. 115.

SHAFTESBURY :
PRINTED AND PUBLISHED BY J. RUTTER;
ALSO PUBLISHED IN LONDON
BY LONGMAN AND CO, PATERNOSTER-ROW; YOUNG AND CO.
TAVISTOCK STREET, AND UNDERWOOD, FLEET STREET.

fig. 1 Frontispiece to Martin Lister's *A Journey to Paris*, reprinted in 1823 by George Henning. Lister's travel account had in total ten editions.

Introduction

O N 17 JULY 1681 the English naturalist and physician Martin Lister (1639–1712) wrote to his wife Hannah en route from York to France. The good doctor suffered from severe and chronic asthma throughout his life, and he took 'the waters' on the Continent periodically to convalesce and rest away from a busy medical practice and growing family responsibilities. Lister was also a fervent Francophile, having studied medicine in Montpellier in the 1660s, and he would go on to write a bestselling travel guide to Paris telling his readers which curiosities to see, which wine to drink, and making perceptive comments about the differences between French habits and those of the English. The work was so popular that it was reprinted for the next three centuries in English and French for a cross-cultural audience (*fig.* 1).

Lister left his wife at home to care for their 'sweet Babes', urging her in his absence: 'prithee again be merry, and make much of thy self and barnes [children].' He explained to Hannah that he left 'to gain my health and ease my spirits, over tired with my calling and thoughts'. Hannah, left at home with the children, was apparently not so sanguine. Lister

fig. 2 Portrait of Martin Lister. Sketch by the author after Charles Jervas.

I

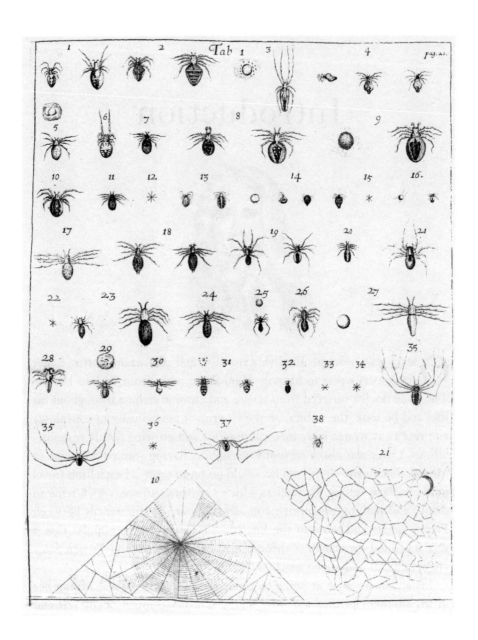

fig. 3 Illustrations of spiders in Lister's *Historiæ Animalium* or *History of Animals* (London: John Martyn, 1678). This was an illustration to the very first catalogue of English spiders.

2

continued, 'my deare I admire you can be soe hard harted as not given me a line all this time, this is my fourth Letter. And the second weeke of my journey only.' He promised his wife that he would come home by August, but pleaded 'doe not let a week or soe break any squares with thee and me', and he promised to bring some presents from France.[1]

At least Lister could console himself that he was in good company in his travels. In his party were his favourite sister Jane Allington, as well as Rosamund Kirke, the wife of Thomas Kirke, a Leeds antiquary, topographer and fellow of the Royal Society. Lister's travelling companions also included Francis Place, printmaker, topographical draftsman and potter. Thomas Kirke and Place were members of the York Virtuosi, an informal group of like-minded natural philosophers (in our terms scientists), antiquarians, artists, inventors and literary figures that met periodically in the Mickelgate house of glass painter Henry Gyles, near Lister's own residence. Gyles was famous for his paintings in the college chapels of Oxford and Cambridge, and he did one of the first drawings of Stonehenge.

During these meetings Lister demonstrated a number of scientific experiments, eventually becoming known as the first 'spider man'. He was the first scientific arachnologist, a pioneer in describing species of British spiders, classifying them by the types of web that they spun. Using an early microscope and a hand lens, Lister burned off the hairs from the heads of his spider specimens so he could more easily count their eyes, and discovered that two-eyed spiders never make silk and that some smaller spiders shoot webs into the air to balloon, or fly, hundreds of miles to hunt for prey (*fig.* 3).

For his work, Lister, like Kirke, was appointed a fellow of the Royal Society, ultimately contributing over sixty papers and writing fourteen books on topics including early archaeology, Roman cookery, the formation of fossils and, not surprisingly, the chemistry of spa waters. He was vice president of the Royal Society from 1683 to 1687, often chairing meetings when the president, Samuel Pepys, was called away on business. During his term of office, Lister sponsored the eminent botanist John Ray's books on insects and birds, helping to identify species, and was on the committee to see *De Historia Piscium* (*The History of Fishes*, 1686) by Francis Willughby and Ray through the press (*fig.* 4). A lavish folio, this work was one of the first scientific studies of ichthyology. Lister supervised

the completion of the illustrations by a team of artists and copperplate engravers. Its costs nearly bankrupted the Royal Society, so much so that the Society could barely afford to publish the following year Sir Isaac Newton's *Principia Mathematica* containing the three laws of motion and of universal gravitation. Though we tend to remember the physical scientists of the early Royal Society, such as Newton and Robert Boyle, natural history in the seventeenth century was clearly considered at the centre of scientific knowledge and was prioritized. Lister also sponsored the research into fossils of Edward Lhwyd (1660–1709); designed the cabinets for the mineral collection at the Royal Society Museum, known as the Repository; advised Astronomer Royal John Flamsteed (1646–1719) on the engravings for his star catalogue; and proposed a new method of barometric observation that involved the creation of the first histogram. Later he moved to London, became a royal physician for Queen Anne, and enjoyed a glittering London career, living a stone's throw from Westminster Abbey with another fashionable residence in Epsom.

All this was in the future, as we return to Lister's letter to Hannah, which also had a set of instructions. He wrote:

> I did send home a Box of Colours in oil for Susan and Nancy to paint with. As for the pencills sent with them, and the colours in shells, which are for Limning, I would have thee Lock them carefully up, till I return, for they know nott yet the use of them.

'Susan and Nancy' were his oldest daughters Susanna and Anna, who were 11 and 9 years old at the time. The term 'limning' has its source in the word 'illumination', or the medieval technique of painting on parchment. In the sixteenth century the miniaturist Nicholas Hilliard's *A Treatise on the Art of Limning* explained his manner of working. Portraits or figures were painted in watercolour, made by mixing finely ground pigments and gum arabic to the proper consistency. Rather than the watercolour being applied in translucent washes, limners produced more opaque images, building highlights and deep shadows by stippling and cross-hatching. Typical pigments included vermilion, ultramarine, indigo, white lead,

fig. 4 Frontispiece to Francis Willughby and John Ray, *De Historia Piscium Libri Quatuor* (Oxford: Sheldonian Theatre, 1686).

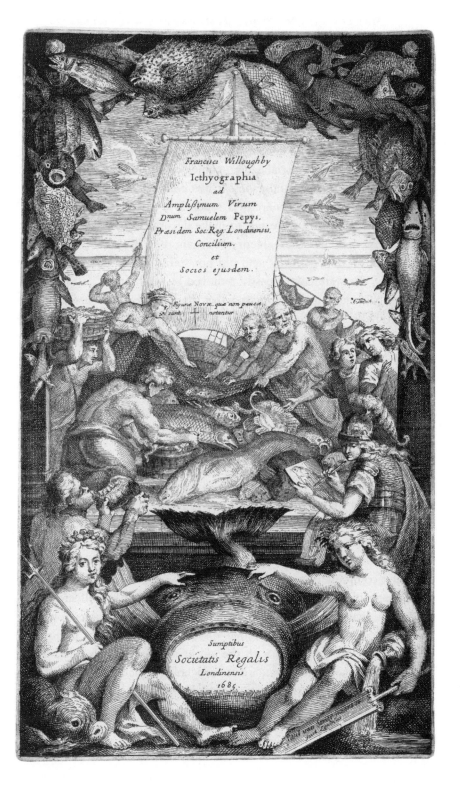

Francisci Willoughby
Icthyographia
ad
Amplißimum Virum
Dnum Samuelem Pepys,
Præsidem Soc: Reg: Londinensis,
Concilium,
et
Socios ejusdem.

Figuræ Novæ, quæ non paucæ sunt, † notantur

Sumptibus
Societatis Regalis
Londinensis
1685

ceruse, black made out of deer horn, and ochres from naturally occurring coloured earths. The limner's surface was usually vellum, a very thin calfskin parchment, or rag paper; for miniature portraits the vellum was applied to a playing card with flour paste. The painting was laid in with 'pencills', which were small sable or squirrel-hair brushes mounted in quills. In the seventeenth century, limning was used mainly for painting heraldic shields, maps, aerial views, copies of old-master paintings, and miniature portraits and landscapes. It was considered a suitable pastime for young ladies, being generally a sedentary, clean and quiet pursuit, which employed costly materials to make decorative works.[2] In his book *The Gentleman's Exercise* (1612), Henry Peacham remarked that limning 'was not as smelly as oil painting' and did not stain the silk clothes worn by the gentry, the watercolour easily removed by washing.[3]

Lister also mentioned in his letter that the colours he sent his daughters came 'in shells'; this refers to the practice of keeping watercolours of paste consistency in mussel shells. Edward Norgate in his treatise on limning entitled *Miniatura* (1627–8) advised taking as much pigment 'as will lie in a muscle [mussel] shell (which of all others are fittest for limning, or otherwise those of Mother Pearle) and with a little gum water temper it with your finger till it come to a fitting consistency or stiffnes'.[4] (Too much gum arabic meant the paint would peel; too little gum and the paint would become powdery.)

But the presence of shells had a double significance. For Lister was not just a 'spider man', but a mollusc man as well, and within a few years he was relying on his adolescent daughters to illustrate his scientific works. As the first scientific conchologist, he entrusted Susanna and Anna with illustrating his landmark *Historiæ Sive Synopsis Methodica Conchyliorum* (*History of Molluscs*), assembled between 1685 and 1692 (2nd edition 1692–97). This first comprehensive study of conchology (*see plate* 1) consists of over 1,000 copperplates portraying shells and molluscs that he collected from around the world, as well as an appendix of molluscan dissections and comparative anatomy. The detailed dissections of molluscs performed by Lister and his daughters with the aid of microscopes also meant the *Historiæ* established a new standard for conchology, such that the work was in constant use by natural historians and taxonomists of the seventeenth, eighteenth and nineteenth centuries.[5]

Sir Hans Sloane, whose collections formed part of the British Museum, lent Lister specimens from his travels in Jamaica.[6] In 1674 Thomas Townes, 'a learned and ingenious Physician' working on a sugar plantation, wrote to Lister: 'I goe shortly to the Barbados, where of I can serve your curiosity in inquiring after anything that is rare ... you may command me.'[7] Townes subsequently sent parcels of snail shells, jimson weed seeds and a gannet bird or booby (we do not know whether stuffed or live).[8] Lhwyd, the keeper of the Ashmolean Museum, reported: 'I have sent by John Bartlet of the White Swan at Holbourn bridge a small strawberry basket, with a parcel of your curious wrong turned snails of the woods: which now and then I call *Heterostophes sylvaticus aculeatus*.[9] The snails were kept alive by being buried in wet moss. John Ray, considered the father of English botany, and his colleague Samuel Dale, an Essex physician, also compared conchological notes with Lister, commenting upon gastropod morphology, shell pattern and habitat, and sending him species for identification.[10] The over 1,000 pieces of Lister's correspondence left to us show he was part of a global Republic of Letters of specialists who exchanged ideas and specimens.[11] The Republic was considered a form of imaginary space where thinkers could freely exchange their thoughts through correspondence.

It was not only a challenge to collect the molluscs for the *Historiæ*, but a considerable effort to engrave images of their shells onto copperplates. In the early modern era, scientific illustration was a novel genre with few artists able to combine in one image the necessary attention to empirical detail, accurate perspective views of the object, and a scientist's aesthetic judgement.[12] The illustrator, by reductionist objectification, needed to focus the viewer's attention on the essentials of the specimen without losing its context, scale or dimensions. Difficulties in producing illustrations were compounded by the fact that engravings were expensive to produce, requiring their own rolling press, which was a costly piece of heavy machinery. Often authors had to coordinate efforts between the printing house that owned the hand press for setting the text and another printer who owned the rolling press. The result was then collated for binding, often performed by a third entity, which could lead to mistakes, frustration and expensive delays.

Even getting the text printed for such books was a difficult task. Natural history publications often required specialized fonts, knowledge of Latin

and sensitivity to the proper placement of figures, and many printers simply were not capable. Printing houses were often reluctant to publish books of natural philosophy because their detailed images were expensive to produce, and their markets small.[13] Accurate representations of natural philosophy were thus not something that could be taken for granted.[14] There were some copperplate illustrations of instruments, such as air pumps and microscopes in works of Restoration science by authorities such as Robert Hooke and Robert Boyle, which went beyond abstract representation. Their realism and cast shadows were appropriate to the minute literary detail describing their use in experiments.[15] But these tend to be exceptions, particularly when we consider the Royal Society, as there are few illustrations of the Society in action, its Repository collections or its instruments in use.[16]

The task of illustrating his book was one that Lister accomplished in a novel manner. He turned to a literal 'in-house' press, teaching his two teenage daughters, Susanna and Anna, how to limn, and likely how to etch and engrave. Lister later claimed the engravings for the *Historiæ* 'could not have been performed by an Person else for less than 2000*l*. Sterling [£2,000]; of which Sum yet a great share it stood me in, out of my Private Purse'.[17] The press, likely in Lister's residence, or nearby, turned out images on the same thin and watermarked paper that Lister used for his correspondence, allowing for the creation of his masterpiece.[18] By the time they were adolescents, Susanna and Anna Lister's names appeared on the title page of the *Historiæ*. In 1712 Lister bequeathed the copperplates to the University of Oxford. In the mid-eighteenth century, William Huddesford (1732–1772), keeper of the Ashmolean Museum, used the copperplates to create another edition of the *Historiæ Conchyliorum*, but after that nothing was seen of them in the published literature.[19] Until now.

When researching Lister, I had assumed that the plates were lost or simply not catalogued. After all, the Royal Society had its copperplates for the early editions of *Philosophical Transactions* melted down for the war effort in World War I. Lister's donation of specimens of natural history to the Ashmolean Museum had also disappeared with the vagaries of time, removed from the collection in 1796 by the keeper William Sheffield (keeper 1772–95).[20] At the time I rediscovered the plates, the Lister copperplate shelfmark in the Bodleian Library was not also part of the general

catalogue, as the plates were objects, and not books or manuscripts. (This has since been rectified.)

In September 2010, a conversation with Jeremy Woodley, a coral reef biologist and Lister descendant, revealed that he had seen the plates in some 'tea chests' at Oxford several decades ago.[21] Lee Peachey at the University of Pennsylvania subsequently was in email contact, and Clive Hurst from the Bodleian Library later confirmed that the plates still existed.[22] In 2012 I curated an exhibition featuring them. Not only that, but several of the original shell specimens that Lister's daughters illustrated are extant in the Natural History Museum in London, and the sketchbooks of the Lister sisters are also in the Bodleian Library. This study of the historical context of these materials in this book elucidates not only the bibliographic history of the *Historiæ*, but the nature of early scientific illustrations, the first museums and natural history collections. Examination of these materials reveals Lister's extensive use of his pan-European patronage network of artists and collectors to gather mollusc specimens and illustrations of shells, including artworks by Rembrandt and Wenceslaus Hollar. These sources also suggest the possibility that Lister's adolescent daughters were the first female scientific illustrators to use a microscope in their work.

I first concentrated my efforts on studying Martin Lister himself, creating an academic monograph, *Web of Nature* (Brill, 2011), of nearly 500 pages. A significantly shortened version of this biography appears in Chapter 1, and it informed some of the scientific context of this book. Readers who wish to know more about Lister's medical practice, his role in the Royal Society, his discoveries of natural history, and even his cookbook are referred there.

This work, however, is for the general reader and is dedicated to a more detailed analysis of the works of his daughters Susanna and Anna Lister, or the Lister sisters. We will see that their remarkable father nurtured his daughters as artists and scientists in their own right, but their artistry is the star of the show. The sketches, paintings and engravings of the Lister sisters are witnesses to the important and often hidden role of family connections, artisanal work, aesthetic practice and empirical perception in the transformation of a field specimen into an object of scientific inquiry in the early modern era.

Sir Martin Lister Knight 1626.
Engraved from a scarce print in the Collection
of Sir William Musgrave Bar.t

Published as the Act directs Nov 11 1794, by W. Richardson Castle Street, Leicester Square.

ONE

Martin Lister:
a scientist by nature

M ARTIN LISTER was the fourth child of Sir Martin Lister and Susanna née Temple, born in Radclive, Buckinghamshire, a 'small, but neat and cleanly' village perched on a cliff of reddish soil that overlooks the River Ouse (Radclive is a derivation of the Anglo Saxon for 'red cliff'.) His parents were each in their second marriages. They had Martin and four of his siblings baptised at the small church of St John the Evangelist. Martin was christened on 11 April 1639 in the font that still remains on its square plinth. He was born in Radclive Manor itself, a stately brick house that belonged to New College, Oxford, within view of the church (*fig.* 6). The manor, built in 1620, still stands, featuring a uniquely splendid period oak staircase with an intricate openwork balustrade. One can easily imagine Susanna walking her tightly swaddled infant up and down these stairs in a more stately and careful manner to comfort him when he cried. From the house she could see green fields and a winding river with willows beside it, their grey-green leaves quivering and their branches dipping to the banks.

Susanna's aunt and uncle, Thomas and Susan Denton, were subleasing the manor at the time, so it was an appropriate place for her to have her 'lying-in' or recovery period of up to a month. During this time, Susanna was in an almost exclusively female world among sisters, aunts and mothers who provided experience, advice and small comforts to assist her in her many pregnancies. She would have received congratulatory visits

fig. 5 Sir Martin Lister, Knight. Print dated 1626.

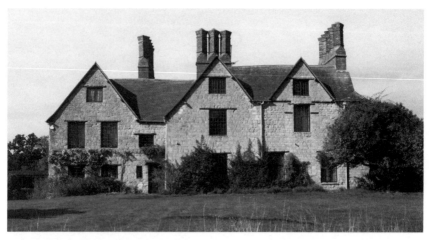

fig. 6 Radclive Manor, Buckinghamshire.

and perhaps a women-only party to celebrate the birth with delicacies and wine.[1] Susanna then attended a service of thanksgiving at St John the Evangelist to celebrate the birth, a Protestant version of the Catholic ritual of churching. In this way the community of Radclive recognized Susanna's status as a mother.

BIRTH OF A NATURALIST

Little is known about the upbringing of Martin Lister. His eldest sibling Richard inherited the family estates in Buckinghamshire and Lincolnshire, so Martin received an education to ready him for a profession as a doctor, clergyman or lawyer. Susanna probably introduced Martin to the rudiments of reading and was responsible for his basic moral and religious education through the Psalms and the testament. Her letters indicate a good reading proficiency and irregular phonetic spelling, typical of court ladies of the period. Susanna and her son had an affectionate relationship throughout their lives, she sending him gossip about the family and food packages when he went to university, including 'a goose pye with a duck in the belly of it'.[2]

As a young lady, Susanna had been a maid of honour for Queen Anne of Denmark in James I's reign, and was considered one of the most distinguished beauties of her time. Several of her portraits are still extant,

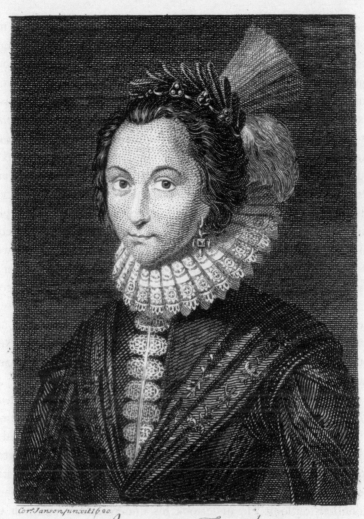

Cor.ᵗ Janson pinxit 1620.

Susanna Temple

The only Daughter of Sir Alexander Temple, Knight.

Lady Thornhurst, Lady Lister.

Published as the Act directs, July 1795 by W. Richardson, Castle Street, Leicester Square.

fig. 7 Engraving of Susanna Temple Lister, 1620.

the earliest a charming image by painter Cornelius Johnson, the first native British artist to sign his paintings regularly. Johnson had done numerous portraits of members of Susanna's family, the Temples, including one of her father, Sir Alexander Temple, which survives in various versions.[3] His portrait of Susanna, done when she was 20 years old, was one of his first works (*see plate* 4). The artist enjoyed portraying his sitters using *trompe l'œil* to demonstrate his virtuosity with the brush, and so Susanna is set within an opening painted to resemble a stone niche. His art was well suited to the intimacy of the bust-length portrait in which, with an air of detachment, he captured the reticence of the minor aristocracy and English landed gentry.[4] Like most of his works, Susanna's head was placed low in the frame, and Johnson meticulously and precisely handled her green silk brocade sash and delicate and high lace ruff, symbols of wealth and social rank.[5] Susanna also had an ostrich feather fascinator in her hair, and her earrings sported martlets, heraldic birds from the Temple coat of arms. Her lovely youthful energy that nearly bursts out of the confines of the portrait made it a popular image, and Robert White reproduced her visage as an engraving for public consumption. Collectors like the famous diarist Samuel Pepys, who had an eye for court beauties, had her engraved portrait (*fig.* 7) in his collection.[6]

It is likely that Martin's father met Susanna through his great-uncle Matthew Lister, who served as physician to the wife of King James I, Queen Anne of Denmark. The antiquarian Anthony Wood stated that Matthew Lister supervised Martin's education closely; he certainly had the means to provide him with such private instruction. Matthew was a man of the world, and undoubtedly gave his great-nephew a cosmopolitan outlook. He undertook his undergraduate study at Oriel College, Oxford, but rejected Oxford for his medical training in favour of Basle University, which taught the new and still controversial 'chemical medicine' of Paracelsus. Matthew was elected a fellow of the College of Physicians in 1607 along with William Harvey, and served as a censor, or examiner, of new candidates.[7] A portrait of Sir Matthew by Paul van Somer, one of the leading painters of the royal court (*fig.* 8), shows a dashing figure wearing a fashionably slashed and buttoned waistcoat with a rich cloak, his neat pointed collar visually echoed by a closely trimmed Van Dyck beard.[8]

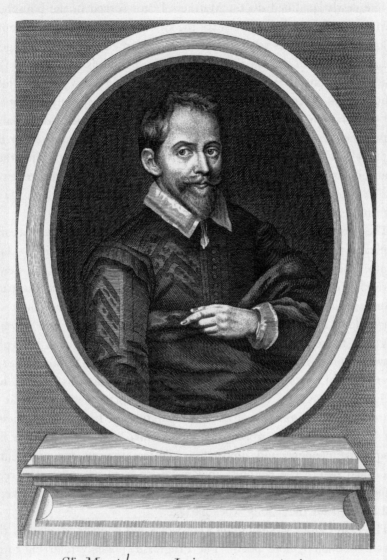

S.ʳ *Mathew Lister* Knight,
and
D.ʳ *of Phisic* . 1646.

fig. 8 Engraving of Matthew Lister, 1646.

The newly qualified doctor Matthew Lister served in the household of Mary Sidney Herbert (1561–1621), the Countess of Pembroke. Recently widowed, the countess was attracted to the 'learned and handsome gentleman' ten years her junior, with whom she flirted as well as having a business relationship. Matthew assisted in managing Mary's estates. John Aubrey, in his collection of short biographies *Brief Lives*, speculated that she had secretly married the doctor.[9] Gossip about the couple also appeared in the State Papers, where the countess was 'said to be married to Dr. Lister, who was with her at the Spa'.[10] Anthony Wood sniggered that their arrangement was to 'her best advantage', noting the good doctor received £120–£140 per year upon Mary Herbert's death in 1621, his being 'well worn in her service'.[11]

Their relationship, though intimate, was fraught, as the countess became suspicious that Matthew Lister was having an affair with her niece, Mary Wroth. The dark-eyed and dark-haired Wroth was 19, nubile and newly married. Though Mary Herbert's accusation was untrue and born out of sheer jealousy, there was a persistent air of intrigue in the countess's household at Penshurst. Wroth was a playwright; her work *Love's Victorie* refigured the countess's romance with Matthew Lister as a love plot between her characters Simeana (the countess) and Lissius (Lister).[12] Simeana and Lissius are deeply enamoured, but Lissius wins Simeana too easily for the goddess Venus to be satisfied. Wroth's playful analysis of desire features the mischievous Venus separating the lovers with rumours that Lissius is secretly wooing another woman.[13] The play, which has masque-like elements and, unusually, eight female parts, was apparently performed before the countess in Penshurst's gardens under the trees, Cupid declaring: 'Freinds shall mistrust theyr freinds, lovers mistake, / And all shall for theyr folly woes partake.'[14]

The Lister affair was common knowledge and publicly libelled by the literati. The anonymous poem 'The Progresse', possibly referring to an actual royal progress by the Stuart court, crudely sneered:[15]

You ar well met good Doctor Lister
Often y have given a great Lady a glister[16]
Your Pipe was good, shee could not refuse
But all thinges ar the worse for use

Despite the prurient gossip, Lister and the countess shared significant intellectual interests in the 'new science', with a particular penchant for plant distillations and the new chemical medicine. Although some of Matthew Lister's prescriptions were traditional folk remedies – for example, advocating a plaster of egg and honey for a woman's sore breast – several featured such ingredients as mercury to treat syphilis and diluted oil of vitriol (sulphuric acid), used as a panacea. Matthew Lister left numerous pages of these sorts of medicament in code to Mary Herbert, perhaps in tribute to 'Her Honour's genius', which 'lay as much towards chemistry as poetry'.[17]

The Countess of Pembroke was a patron of many natural philosophers and 'chymists', including Adrian Gilbert, the half-brother of the royal physician William Gilbert, who wrote the first comprehensive reviews of the property of magnetism, making a clear distinction between magnetism and the 'amber effect', or static electricity.[18] She gave an 'honourable yearly Pension' to Thomas Moffet, one of the first entomologists, famous for the surname that became associated with the arachnophobe Miss Muffet.[19] Less successfully, the countess was also a supporter of 'one Boston, a good Chymist … who did undoe himselfe by studying the Philosophers-stone'.[20]

Sir Matthew's colleague and fellow court physician Theodore Turquet de Mayerne (1573–1654/5), who also was a 'chymical physician', left manuscripts containing a number of Lister's prescriptions.[21] Mayerne, in turn, had his portrait done by Cornelius Johnson, the artist who painted Susanna Lister's portrait, and consulted the artist on handling orpiment (a poisonous yellow pigment).[22] Influenced by his great-uncle, who guided his education, Martin Lister would also complete his medical studies abroad and become an excellent 'chymist' in his own right, using some of his great-uncle's medicaments in his own prescriptions and studies of pigments that his daughters would use in their works of scientific illustration.

Matthew Lister lived in Covent Garden, having bought a substantial property in 1625 on a twenty-one year lease from the Duke of Bedford. His illustrious neighbours included the Tradescants (father and son), who served as the royal gardeners and owned 'The Ark', the first museum in England, and Mayerne.[23] Matthew Lister and Mayerne were not only neighbours and colleagues, but also friends, jointly proposing to the Crown the formation of an English board of health in 1631 in order to limit plague mortality.[24] The board was to issue all decrees and statutes

necessary for public health and safety, appoint officers of health, establish pest houses and a treasury, and punish offenders.[25] Though the initiative was acclaimed, it ultimately became caught in monarchical bureaucracy and came to naught, only to resurface later in the eighteenth century.

Despite this professional setback, Matthew's medical expertise was highly valued by the royal family, and Charles I knighted him on 11 October 1636.[26] Sir Matthew went on to prove his loyalty to the Stuarts during the height of the English Civil War, delivering Queen Henrietta Maria's baby in the most trying of circumstances. In 1644 the heavily pregnant queen had travelled to France to raise money to support her husband's war effort. Unsuccessful in her efforts, she returned to England via Yorkshire to rejoin her husband in Oxford, but the fighting proved too dangerous for her to make the journey. Marooned in the temporary haven of Exeter, she was pregnant, past due, and worried if she would survive childbirth. Charles sent a panicky letter from Oxford to Matthew Lister and Mayerne: 'pour L'Amour de moy alle trover ma Femme. C.R.' ('for the love of me, go find my wife').[27] Though Matthew Lister was nearly 80 and Mayerne obese, gouty and not a good traveller, the two doctors took the queen's coach and covered the 170 miles from London in a week.[28] After the physicians arrived, Henrietta Maria apparently told the two elderly physicians that she thought she was being driven insane, whereupon Mayerne replied, 'Madame, you already are.'[29] The physicians' skill and professional demeanour, however, had a happy result – her last child Henrietta was delivered safely, and she escaped back to France where she settled in Paris with the support of the French government. Sadly, however, she would never see her husband Charles again. Matthew Lister's loyalty to the royal family would later serve his great nephew Martin, the father of the Lister sisters, very well when he himself was training as a physician who would ultimately serve the Stuart Queen Anne.

THE CULTIVATION OF A NATURALIST

In fact Matthew Lister overall was an excellent mentor to his great-nephew. After two or three years of reading and penmanship practice under Sir Matthew's supervision to learn to 'lean softly upon his pen', Martin Lister went to the grammar school at Melton Mowbray, Leicestershire. Here he had the great good luck to have Henry Stokes as his schoolmaster. Stokes

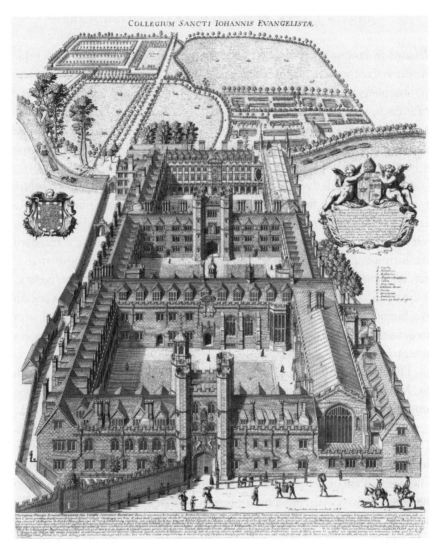

fig. 9 Seventeenth-century view of St John's College, Cambridge, by David Loggan.

had been master at Grantham School in Lincolnshire, where he had taught Isaac Newton; it was Stokes's intervention with Newton's mother which ensured the young genius went to Cambridge rather than being confined to managing Woolsthorpe, the family's Lincolnshire farm.

In addition to the disciplining of the mind that learning Latin at grammar school entailed, it is evident that Martin Lister learned his

lessons in languages thoroughly, for the Latin style in his later scientific works is exceptional, and when appropriate he makes reference to ancient philosophers in the original Greek. He may have attained a basic command of French, which would serve him well. Lister would later translate French scientific works; get his medical training in Montpellier, where he gained an appreciation of the author Scarron and of French burlesque; and write a bestselling memoir of his travels to Paris in 1698.

Stokes also added some practical arithmetic to the Melton curriculum for his prospective farmers and landowners. His lessons comprised to a large degree measurements of shapes and areas, featuring algorithms for surveying, and calculating acres (though the acre did not have a standard measurement from county to county). Stokes also offered more than a farmer would need, instructing his charges how to inscribe polygons in a circle to compute the length of each side, as the Greek mathematician Archimedes did to understand infinitesimals and to estimate pi.[30] Lister benefited enormously from Stokes's instruction, his teacher honing his scientific prowess.

The Melton Mowbray grammar school had a special relationship with St John's College, Cambridge, its students traditionally admitted for undergraduate studies, and Martin Lister was no exception (*fig. 9*). He was admitted as a pensioner to the University in 1655, and his tutor was Henry Paman (baptised 1623, d.1695), the Linacre professor of 'physick' or medicine. Again, Lister was extremely fortunate in his choice of college and tutor. Paman was an exceptional physician in possession of a large personal library, evincing a multiplicity of interests. Along with the latest volumes on anatomy and physiology, Paman collected cartographic works, numismatic guides, volumes written by antiquaries, and other works of polite literature such as the letters of Jean-Louis Guez de Balzac.

St John's College was the most loyal to Charles I in Cambridge during the English Civil War. In 1645, under the aegis of Lord Manchester, the major-general of the Eastern Association of the Parliamentary Army, the University of Cambridge saw the ejection of a large number of fellows thought to be of the religiously or politically incorrect persuasion.[31] Many students subsequently abandoned a career in the Church or in government, pursuing scientific studies and medicine, called 'physic', instead. In 1657, physician and natural philosopher Walter Charleton wrote, 'Our late Wars

and Schism, having almost wholly discouraged men from the study of Theology; and brought the Civil Law into contempt: the major part of young Scholars in our Universities addict themselves to Physic.'[32]

So Martin pursued physic due to natural inclination, but also out of expedience and personal preservation. He had the right royalist connections through his great-uncle Matthew to be given a fellowship in physic by 'his Majesties' Command' at St John's on 31 August 1660 due to his 'learning, civill behavior, and abilities'. Other candidates who had been ejected by Parliament in 1644–45 and 1650–51 were waiting to be restored to their fellowships, but Lister's appointment was made immediately 'to the first voyd place'.[33]

When he was at university Martin wrote several letters to his family, the correspondence displaying his intelligence and liveliness. His friend Thomas Briggs, the junior bursar of St John's, noted that Martin had 'very many good wishers and ffriends in College', and was often sent tokens of their esteem.[34] Lister's college room-mate Robert Grove, who would later become Bishop of Chichester, was a close companion, penning humorous Latin poetry, which he shared with Lister. Grove later published a more serious effort extolling the achievements of William Harvey, who discovered the circulation of the blood. Grove described Harvey's groundbreaking vivisections in heroic hexameter verse (the reader will be spared his efforts).[35] Susanna Lister sent a number of more prosaic gifts from Burwell to St John's, including 'the best venison we can get you', though she was not optimistic about their prospects.[36] She described their keeper at Burwell as weak and lazy, complaining 'we haue had non[e] killed sence before michallmas' though there 'has been many days spent in the persute' of deer. Although her husband was in rude good health, as he had a 'new companion Captain goodhand' from the neighbouring estate as a 'Jockie [jockey] to ride his horses', Susanna was a valetudinarian, only stirring from her 'chambar' occasionally to go to the 'parlar'.[37] She also fussed over her son's health; he was having trouble with asthma and had hurt his arm, and her letters of motherly concern, with their erratic spelling, were frequent.

Susanna also mentioned in her correspondence that her 'daughter Hamlleton' delivered a boy, but it was 'dead she cam 9 weeks before her time'.[38] 'Daughter Hamlleton' was Frances Jennings [Jenyns] (1649–1731),

Susanna's granddaughter by her first marriage. Frances was the older sister of Sarah Jennings (1660–1744), the future Sarah Churchill, Duchess of Marlborough, who would write letters to Martin Lister throughout her extraordinary life. On 30 May 1667 Martin received his first letter from the 7-year-old Sarah, accompanied by a small and heartfelt gift, a ruby-coloured wax seal affixed to several blue silks (*see plate 5*). The 'bond seal' with its silks still survives in her correspondence. It was described by her mother as a token from 'litell Sarey', which served as a widow's mite until she herself was able to pay her respects more substantially.[39] Sarah was already being taught the power of patronage and gifts; when an adult she would give her uncle her support for his candidature to be royal physician to Queen Anne. Sarah would later write to Lister's younger sister Jane that she had the

satisfaction of seeing my uncle Lister at London, which I was very well pleased with, for I think hee is very agreeable company and a very ingenious man, and I think its a misfortune to have lived so long & had soe little acquaintance with soe near a relation as hee is to me, but I am sure it was not my fault, & I will convince of that truth, by watching for ... all opertunitys of doing him all the service that can ever bee in my power.[40]

Lister's family apparently missed his presence deeply when he was at Cambridge. His little sister Jane was especially keen to hear from her older brother, who she plainly hero-worshipped. Jane wrote:

Deare Brother, – If loue to any parson in the world would aford matter enoufe, to fill a letter, it ware imposable for me to want when I wright to you if I had not so dull a fance [fancy] I would not for a world have you the least doubtfull of the real pation I haue for you but if I do neglect wrighting to you, imagine tis to fetch you over to Chide me, which insteed of spouyling our merth would hughly highten it, and make us much more hapy then we are espetially she who is your reall affectionat sister and saruant [servant] we want no books yet. [P]ray you present our sarvices to my Hant [Aunt] ... and my Cosen.[41]

Lister's pursuit of a medical career necessitated a long period of study in what his mother termed his 'old cloisters'. The University Statutes required a student of 'physic' to take an arts degree before beginning medical studies. Oxford and Cambridge made compulsory nearly fourteen

years of study from matriculation, consisting of seven in the arts course and seven in medicine.[42] It was thus cheaper and more efficient to travel to Europe, where medical training and the degree could be obtained more quickly, usually with a comparable or even superior medical faculty.[43] Medical education at Oxford and Cambridge, despite advances by Thomas Sydenham (who did the first studies in epidemiology), William Harvey and Thomas Willis (who did pioneering work on the cranial nerves), also remained resolutely conservative, concentrating upon the dictates of Hippocrates and Galen.[44] From 1632 to 1688, only 136 of the 255 fellows and candidates of the College, or a little more than half, received their MD from Oxford (58) or Cambridge (78).[45]

FRENCH CONNECTION

Those candidates who chose to do their degrees abroad benefited from more limited residency requirements. At some universities, such as Leiden, one could in effect buy a medical degree; in 1633 the physician Thomas Browne received his MD after a month's residency.[46] Martin Lister studied abroad but for a more extended period, leaving in 1663 to travel and to obtain a medical education in southern France. His decision to take a *peregrinatio medica* was part of a time-honoured tradition in the early modern era. Medicine was a subject where international study and travel were considered most valuable, as medical students brought back new theories, *materia medica* and sometimes surgical techniques to their homeland. In the 1670s the Danish physician Thomas Bartholin remembered his own grand medical tour, remarking: 'Today there are many travellers; indeed, it seems as if the whole of Europe is on the move.'[47] Lister decided to continue his studies in Montpellier, though he never formally received his degree at the University there.

Lister's experiences in Montpellier were crucial to many aspects of his professional development. He travelled to Montpellier during the most convenient years for most gentlemen to travel abroad, between leaving university and settling down to married life. He was going on his *peregrinatio medica* not only to earn professional credentials, but also to attain accomplishments becoming of a gentleman of quality, a cosmopolitanism to add polish to his English education. Sir Thomas Browne wrote to his son in 1661, advising him to lose his *pudor rusticus* (rustic bashfulness)

23

abroad by practising a 'handsome guard and Civil boldness which he that learneth not in France travaileth in vain'.[48]

In the early sixteenth century, Montpellier attracted large numbers of students from abroad, foreigners comprising 37 per cent of the student population.[49] It was a particularly popular choice for English medical students, not only affording the chance to learn the French language and *politesse*, but also possessing a fine university and renowned academies for foreign students in a beautiful setting with over 300 days of sunshine a year. The reputation of Montpellier's medical school was due especially to its emphasis on practical botany and its Jardin des Plantes, based in its design upon the Orto Botanico in Padua. The Jardin was donated to the University by Henry IV in 1593 and was first directed by Pierre Richer de Belleval, the chair holder in anatomy and botany from 1593 to 1632; Belleval dedicated portions of the garden to mountain plants from arid Languedoc. The oldest in France, the Jardin served as a model for the design of all subsequent French botanical gardens, including the one in Paris created forty years later. The renowned botanist Pierre Magnol (1638–1715), who had received his MD shortly before Lister's arrival, reorganized and enlarged the garden, separating it into plants' known eighteen medical and 'therapeutic duties'.[50] Honoured by Linnaeus with the genus name 'magnolia' for ornamental flowering trees, Magnol first published the concept of plant families as we know them, based upon plant morphology.[51] His *Botanicum Monspeliense Sive Plantarum* (1676) describes over 1,300 species that he gathered from the area around Montpellier and was one of the most important local floras. Magnol and other medical professors were eager to demonstrate to their students examples of the medicinal herbs, or simples, used in medicines, a form of knowledge that physicians previously had learned on their own.[52]

Although student numbers declined severely during the Wars of Religion, the Wars and their outcome ironically were the making of the town and the medical school (*fig.* 10). Montpellier was a Huguenot stronghold, with a faculty under the patronage of King Henri IV and his Huguenot coterie at court; during the monarch's rise there were chairs created at Montpellier devoted to anatomy, botany, surgery and pharmacy. These positions were in addition to the four Regent professorships dating from the late fifteenth century.[53] The four Regius Professors, and the year-long

fig. 10 Montpellier Medical School.

course, were by the seventeenth century considered to be the best for preliminary medical studies.[54] When the professors paraded once a year in their scarlet satin robes and ermine hoods, it was a matter of splendid ceremony and civic pride.[55]

After the city capitulated to a royalist army in 1622, the religious violence that occurred between 1560 and 1622 did not generally reoccur; the Crown and the Catholic Church made significant efforts to ensure the loyalty of the population, building a citadel garrisoned by royal troops. A series of reforming bishops instituted a programme of conversions, inviting reformist regular orders to establish houses in the city, and by 1656 the Capuchins, Dominicans, Carmelites, Jesuits and Fathers of the Mission were established in Montpellier. A Protestant community remained in the city, but its power was severely diminished by 1650.[56]

It was an even grimmer picture for foreign Protestants like Lister, who studied in Montpellier after 1650:

Seventeenth-century English gentlemen, attracted to Montpellier by its reputation, may have been surprised to find how few and how peripheral Protestant scholars were in the university, and how uncertain was the security enjoyed by Huguenots under the increasingly fragile Edict of Nantes. As foreigners and Protestants, they were barred from formal matriculation in the University of Medicine and were therefore forbidden to attend its lectures or disputations. The only exceptions were the occasional official anatomy, more a public spectacle than a serious investigation, and the demonstrations of the official herbarist in the botanical garden, which non-members of the university could also watch at a distance.[57]

As a foreigner and a Protestant, Lister could not formally enrol, but he did belong to an academy in association with other foreign students, and could observe what was taking place in studies in medicine and natural philosophy at the University.

During Lister's three years in France, he kept a detailed journal in an almanac (*see plate 6*), published as *Every Man's Companion: Or, An Useful Pocket-Book*,[58] which is a wonderful snapshot of the intellectual development of a significant seventeenth-century physician, providing a vivid account of early modern medical education, and a detailed representation of the grand tour of a gentleman. His pocketbook advertised that it had 'table-book leaves' whose erasable surface was made from a mixture of gesso and glue, allowing one to write on it with soft metal, graphite or ink. Graphite pencils would still have been relatively new in the seventeenth century and another form of erasable writing. The earliest example of an erasable table book dates from Antwerp in 1527; they were mass-produced in London by the end of the sixteenth century. Table books even featured in Shakespeare. Hamlet when having seen his father's ghost: "'Remember thee? / Yea, from the Table of my Memory, / Ile wipe away all triuiall fond Records....' Hamlet imagines his memory as an erasable table-book that can be wiped clean', a Lockean *tabula rasa*.[59] For Martin Lister, the pocketbook served a quite different purpose, as a memoir of his experiences, a list of the books that he read – his 'Lectiones Achevées' – whilst in Montpellier, and as a small commonplace book recording details of botany, zoology, and the descriptions of crafts and techniques to, as he noted, put 'Nature to various uses'. Due to the vast and varied nature of particular studies that characterized the realm of physic and natural history, lost notes meant lost observations.[60]

Lister's observations thus not only filled this and his later notebooks, but would pervade his later medical records as well. A further seven printed almanacs survive in the Bodleian Library which were used as his medical casebooks when he was established as a physician in the 1680s. His notes include not only patient records, but tests for magnetism, pigments and 'the way of painting in fresco', lead and copper ore refining, and detailed botanical descriptions of lilacs, attesting that natural history was never far from the mind of this physician. Although he did not know it at the time of his voyage to Montpellier, 'physic' and natural history would compete for attention throughout his life, his education and development as a virtuoso encouraging him to see the world from a multiplicity of perspectives. Lister's expertise in natural history was reflective of its 'becoming the foundation for a great deal of contemporary science, including medicine'.[61]

ALL AT SEA

Lister left his Manor House in Burwell, Lincolnshire, on 11 August 1663 for his journey to Montpellier. He recorded in his notebook that he sailed from Yarmouth on the brig *Matthew* bound for Bordeaux, conscientiously reading the *History of the French Academy*, as well as perusing the entertaining and timelessly bawdy *Satyricon* of Gaius Petronius Arbiter (*c.* AD 27–66) to pass the time.[62] Narrated by Encolpius, whose name roughly translates as 'crotch', the work abounds with endless feasts, contemporary Roman slang and tasteless ostentation. It was an entertaining work that would appeal to a young man to stave off boredom during travel. Indeed, when Lister donated over 1,200 books to the Bodleian Library, over the course of his lifetime, he made sure to include a copy of this work in the collection.[63]

Lister reached London on 20 August and then sailed for Rye, reaching the port in six days. The ship was driven back from its channel crossing by storms three days later, and he was stuck in Weymouth for three weeks, making observations of Chesil Beach. In his notes, Lister correctly observes that the pebbles were graduated in size according to location, the flint and chert pebbles ranging from fist-sized near Portland Beach to pea-sized at Bridport.[64] Thousands of years of storms sifted the pebbles by size; local fishermen and smugglers who landed at night were said to be able to ascertain their location by the grade of shingle.[65] Despite the shore's inherent scientific interest, one can imagine Martin's impatience

to get to France while watching the high crashing waves grinding the rocks in an unsettled sea.

Finally, on 5 and then 8 September, the ship attempted to leave Weymouth, but was turned back due to the weather; 'with great hazard of our lives', Lister changed plans and boarded the frigate *Dove* for St Malo on the 19th. Again the ship was driven back for three weeks by storms and moored in Guernsey; a seasick Lister did not reach France until 16 October. Lister recorded that the captain of the ship, Mr Bat, told the first friend he met with that he had a grand affair with a *femme sans langue* – his ship or his silent *Dove*. Bat conquered his woman and the seas in the end.[66]

After taking a journey by land through the flat terrain of the Vendée from Rennes to Nantes, Lister arrived in Bordeaux, where he stayed for three months recuperating from his travels. He refers to himself as possessing a 'very crazy body', having problems with asthma throughout most of his life. The attacks apparently had worsened when he was at St John's College. In a draft letter with many crossings out, insertions and blotches, he wrote from Bordeaux to an unknown recipient, most likely his tutor Henry Paman:

> Most reverend Sir – If I acquit my self very late of my duty, it is my ill happ and not my fault: my great indisposition of body I contracted at the College was no small trouble and hindrance to me in my pretended Voyage; and now I can say that I have set up my self in this City where I purpose to rest my selfe a while, so here the first moment I found my selfe in a tolerable condition to pay my respects and honour I bear you.[67]

He then remarks, 'If I had my health as other men theirs, I should be undoubtedly as happy as they and instead of being a Stranger to my Religion and Country', and laments that he could not assist when 'you officiate at the Altar', begging the recipient to 'remember me there in your Prayers'.[68] Conduct manuals and travel essays commonly advised that the best way for a young Protestant to avoid the 'snares of popery' was to have a thorough foundation in the Protestant faith, and Lister was clearly in need of some extra spiritual succour.[69] It is obvious he was not only ill, but also homesick and afraid. Lister probably did not have very much to worry about. He recorded when he arrived in Montpellier that when he admitted he was Protestant, he was told 'il y a des honetes gens de toutes Rel. et des toutes

nations' (there are honest people from all religions and from all nations).[70] Students were often protected from religious disputes as long as they did not make a show of their own religious observance. Felix Platter, a sixteenth-century student in Montpellier, noted that Protestant students learned to cook eggs secretly in paper held over the fire, as Catholics in Montpellier would not allow pans or pots to be used during Lent.[71]

Lister's curiosity eventually won out over his self-pity and fears for his soul. As he was in Bordeaux, he made notes on the terroir and its effect on wine production, detailing the site-specific qualities of the best vineyards. Wine would always be an interest in his life. In his voyage to France in 1698, when he was an old man, he extensively and perceptively discussed the delights of oenology.[72] Even as a young student, he had realized that a slight difference in the amount of sunshine or soil minerals made a large difference to the grapes' sugar production and the wine's quality. Lister wrote in his notebook:

> The wines which they call at Bordeaux vin de graves is that which groweth in pebly ground and it is there observed that the earth which is fullest of small white pebbles, produceth the best wines. The ground on this side the river is very low and affordeth much better wines than the other, which is mountanous. The wines on the other side if they be of redde plantes are observed of a darke colour.[73]

He was attentive in his observations, as the best left-bank wines usually feature Cabernet Sauvignon from gravelly terroirs, and wines of the right bank tend to favour Merlot (or occasionally Cabernet Franc), and here limestone and clay (and sand) are more prominent.[74]

Leaving Bordeaux on 6 January 1663/4, Lister made for Montpellier on a direct and efficient route that followed the River Garonne and then the old Roman road *Via Aquitania*, no doubt making up for lost time.[75] He made stops with little comment at Cadillac, St-Hilaire-de-Lusignan, Finhan, Toulouse, Villefranche-de-Lauragais, Carcassone, Narbonne and Pézenas, reaching his destination on 16 January.[76]

MEDICAL STUDY IN MONTPELLIER: THE OLD AND THE NEW

Where did Lister stay when he was in Montpellier? His choice of lodging was influenced by the fact that the city was also known for the diverse

arrangements established in the town for clinical, pharmacological and anatomical instruction. When he visited Montpellier in the 1660s, the eminent botanist John Ray (1627–1705) was amazed at the 'number of Apothecaries in this little City ... there being 130 shops, and yet all find something to do'.[77] Many apothecaries offered private lessons to those studying medicine at the University. Indeed, Lister's letters reveal that, like many early modern students of 'physic', he roomed with an apothecary, Jean Fargeon, so he could receive tuition about the names of *materia medica* and the preparations of particular drugs.[78]

Fargeon was not only a chemist, but also a perfumer of royal privilege, or *apothicaire Iuré et parfumeur ordinaire de S.A.R. Mademoiselle d'Orléans*. The Fargeons' shop was in central Montpellier, on the Grand Rue (now the Grand Rue Jean Moulin), across from the Traverse des Grenadiers. The shop was called Le Vase d'Or, The Golden Vase, situated in the western quarter of the town, where tradesmen congregated. By 1668 Fargeon had brought formulations of a large variety of products to perfection, classing them as either 'compositions for health' or 'perfumes for embellishment'.[79] Like many perfumers, his shop sold a range of small objects such as toothpicks and powder puffs, delicacies like dried fruit, as well as snuff boxes and tobacco pouches, displayed alongside baskets of scented gloves, and of course perfumes.[80] As Fargeon's catalogue demonstrates, he was engaged in producing not only herbal medicaments, but also more exotic concoctions, including theriac, a compound containing viper powder, thought to be a universal antidote to poison (*fig.* 11), as well as kermes tablets, a preparation from scale insects thought to cure heart palpitations.[81] By lodging at the Vase d'Or, Lister could thus see the plant *in vivo* in the garden, and *in vitro* in the apothecary's shop of Monsieur Fargeon. This hands-on approach was typical of part of a long tradition of purely practical medicine that did not emphasize to such a degree the abstract principles of Aristotelian logic behind medical precepts.[82]

In between concocting medicines, Lister also sent his younger sister Jane some French perfume from the shop, which she thought was most 'rarely good, ... confident the parfum that Madam de Bourdet sent Balzac ware not so good'; the writer Balzac said of the perfumes he was sent, 'I speak not of the delicacy of your perfumes, in which you laid me to sleep all night; to the end, that sending up sweet vapors into my brain, I

Tinea Bartholo.in li.de proprie.rerũ tinea ẽ ue stimento rũ ỹmis dicta, eo ǫ teneat: et eo ulcǫ uestibus insidat q̃ corroda, & ex ue stium corruptione gignitur,qñ scilicet ue stis aliquādiu in aere grosso cōprimit, nec uentu psunditur et in puro aere libere nul latenus explicat: insensibiliter aũt pāni su perficiā cōsumit:& cũ sit sensibile animal infra panni substantiam se occultat,ǫ uix unǫ uideri oculis se permittit.

OPERATIONES.

1 Amara & odorifera tineę fugiũt ad ue stes respersa,talibus de facili non accedũt.
2 Et ideo folia lauri,cedri & cipressi ethu iusmodi imposita in cistis, uel uestes ibi repositas,& libros corrumpi à tineis non permittunt. Constan.Est quædam sca
3 bies capitis, quæ propter suam tenacitatē et adhęrētiam tinea est dicta.De qua que re insra ĩ tabula de infirmitatibus quomo do sit curanda.

CAPVT. 146.

Tyr⁹. Ex li bro de na turis rer. Tyrus est serpēs in partibus Hiericho circa soli tudines Iordanis, infestus auibus et animali bus maxi me ouis auium quæ cum ipsis auibus co medit.Huius carnes cōfectæ cum quibus dam admixtis,omne toxicum uenenum expellunt: ǫ confectionem tyriacam di cunt.Ferunt autem nōnulli hunc ante pas sionem Christi nullum habuisse remediũ maxĩmeǫ fuisse hominibus infestum.Ipa uero die passionis unum ex eis infestissi mum circa partes Hierusalem casu fuisse comprehensum,& Christi latus fuisse cru ce suspensum,atǫ ex illo die totum illud serpentis genus accepisse uirtutēm cōtra omne uenenum. Actor.Tyrus idem es se fertur,quod uipera .Nam & autores in medicina loquentes de carne serpentina uel tyriaca conficienda raro uel nunǫ de tyro sub hoc nomine saciunt mentionem, sed de uipera.A tyro uero denominatiōe dicitur tyriaca.

OPERATIONES.

1 Auicenna in can.5.Tyriaca affarath id est à morte liberans sublimior est medici narum compositarum:propter multitudi nem sui iuuamenti: proprieǫ in uenenis, quæ sunt ex puncturis ul morsibus,ut ser pentium,& scorpionis,& canis rabiosi.
2 Ex lib.de natu.rerum.Tyriaca cum ex tyri carnibus admixtis quibusdam sit con fecta omĩe aliud uenenũ extinguit,sed cō tra uenenum ipsius tyri nihil prodest.

CAPVT. 147.

Tigris Isid. Tigris uocata ē ppter uo lucrem fu gā:sic ẽ nominãt Persī & Indi sagit tam. Est bestia ua rijs distin cta macu lis uirtu te & uelocitate mirabilis :ex cuius nomĩe Tigris fluuius appellatur, eo ǫ rapidissi mus sit omnium fluuiorum.

h 3

fig. 11 Caput 146 shows a man making theriac from snakes. *Hortus sanitatis* (Strasburg: Mathiam Apiarium, 1536), fol. 39r.

might have in my imagination, none but pleasing visions.'[83] One wonders if Fargeon made the fragrance for Lister to send to his sister, or gave the task to his young lodger.[84]

Besides making medicines, what did Lister study when he was in Montpellier? In addition to the traditional medical texts by Hippocrates and Galen, and Dioscorides' *De Re Medica*, students at Montpellier were exposed to the new theories of chemical medicine and Cartesian philosophy. Month by month in the back pages of his pocketbook, Martin listed the texts he had read or consulted in his studies, a mixture of established and more innovative works.[85]

To learn the pharmacopeia, Lister perused *Histoire des drogues espiceries* (1602) by Garcia de Orta and Nicolás Monardes, one of the best compilations on Eastern spices and drugs. Garcia de Orta (1501/2–68) was a physician with the Portuguese navy in Goa, having first written *Colóquios dos simples e drogas he cousas medicinais da India* (Conversations on the simples, drugs and medicinal substances of India, 1563). The work was translated and spread across Europe; it was the earliest analysis of Indian medicine by a European. Monardes (1493–1588), on the other hand, was a physician and native of Seville, and he never left Spain. However, Seville had a trade monopoly with the Americas, and he could thus become familiar with their medical simples. The Spanish Crown created institutions, such as the Council of the Indies and the *Casa de la Contratación*, to facilitate the distribution of new knowledge from their colonies in Central and South America. Spanish physicians working in the New World not only verified claims from antiquity in Pliny and Dioscorides about the medical efficacy of plants, but also provided detailed descriptions of the new plants they encountered to determine if they could treat disease. *Cinchona*, known as quinine, was among their discoveries, found in the tropical Andes forests of western South America.

Lister read these works in addition to Johann Schröder's standard *Pharmacopoeia Medico-Chymica* (1644), one of the most widely used seventeenth-century handbooks of remedies.[86] Schröder (1600–1664) was a German physician who served as a surgeon to the Swedish army and as the town physician of Frankfurt. Book IV of his work contains an extensive *Phytologia*, an index of plants and their uses, which may have been of interest to Lister in his own botanical expeditions with John Ray, who,

as we will see below, had a great influence on Lister's medical education in Montpellier. Ray's biographer Charles Raven has noted that John Ray was heavily indebted to Schröder for his medical notes on plants in his own botanical *Cambridge Catalogue*, the first English scientific botanical published.[87] Along with the more innovative 'chymical' medicines, such as mercury to treat syphilis (which does kill the spirochete causing the infection), Schröder's work also contains instructions to make cures we could consider magical, such as the famous weapon salve – a salve believed to cure a wound by its application to the weapon that made the wound.

Lister was in the midst of this intellectual transition between traditional and non-Galenic medicine, learning the ancient principles of humoral medicine, sympathy and antipathy, as well as reading revolutionary works in physiology and philosophy. On his reading list was Descartes's treatises on light and his work on physics, *Le monde* (The World). Lister also annotated books about natural history, such as *Osservazioni intorno alle vipere* (Observations concerning vipers, 1664) by Francesco Redi, which in a virtuosic display of scientific observation identified the location of the viper's poison and explained its toxic effect. Also on Lister's reading list was Malpighi's *De pulmonibus observationes anatomicæ* (Observations on the anatomy of the lungs, 1661). In this groundbreaking work, Malpighi began viewing lungs using the microscope, finding they were composed of alveoli surrounded by a capillary network. In the process he discovered the long-sought-after connection between the arteries and the veins, furthering the work of William Harvey on blood circulation. Lister noted Thomas Willis's book on fevers, which contained brilliant observations on the types of fever, accurately describing fevers associated with malaria, and camp fever. Willis thought the fermentation of blood was the essence of fever, which was a model similar to classical models of putrefaction to explain fevers. Willis, however, put a mechanical gloss on his model, using chemistry to explain illness.[88]

To complement Willis's chemical theories, Lister also read works by Nicaise Lefebvre, fellow of the Royal Society since 1663 and chemist and apothecary at the court of Charles II. Lister recalled reading the first issues of the *Journal de Scavans*, which had recently commenced publication in 1665.[89] Along with the *Philosophical Transactions of the Royal Society*, they were the first scientific journals in the world.

Finally, to round off his education as a gentleman, Lister read litera-
ture – the authors and poets of classical Rome as well as contemporary
French letters and histories.[90] Lister was concerned with polishing his
spoken French and his knowledge of belles-lettres. In contemporary
letters, we see R. Bary's *La Rhétorique française* (1653), which lists all
the appropriate grammar and figures of speech permissible in polite
conversation. Vernacular rhetorics appeared in Western Europe in the
sixteenth century, becoming common by the seventeenth. In the second
half of the seventeenth century, French writers recast rhetoric in a form
to serve contemporary needs applicable to their own language, Bary's
work being a major example.[91]

Lister also noted the *Lettres* and *Entretiens* of his favourite (or at least
most mentioned) author Jean-Louis Guez de Balzac (1597–1654), a French
author and member of the Académie française, who published correspond-
ence that introduced new stylistic qualities of precision and clarity to
French prose. Balzac's works were full of subversive observations on the
public reputations of a variety of public figures and also featured witty
conversations that Balzac had with a variety of literary colleagues. For
example, Balzac wrote of the constant spitting of the French poet François
de Malherbe (1555–1628) that he had never known 'd'homme plus humide,
ny de poète plus sec' (of a man more wet, nor of a poet more dry). Lister
donated later editions of several of these works to the Bodleian Library,
some of which feature his own marginal notes.

To put his polite reading into practice, Lister recorded in his pocketbook
that he went to the residence of Sir Thomas Crew to discuss ornithology
and literature in an informal salon. Crew enjoyed meeting with the young
man regularly, and 'amongst other discourse' entertained him 'upon the
loves of Henry the Great of France'.[92] For Lister's part, he was quite taken
with King Henry's correspondence to his many mistresses, writing 'I like
the passage in another letter when his Mistresse Marquisse de Verneuil
would be peevish and out of humour with him. Madame Gabrielle's letter
to the King pleaseth me especially', as did some of the more salacious
French plays with their 'good relish of witty things'.[93] In his memoirs he
copied out several passages from the letters and plays, noting their prose
style and elegance, and perhaps, as young men do, dreamed of having a
bit of romance himself. Four years after he returned from France, Lister

confessed in a letter to John Ray, 'in the days of my Vanitie ... I chose rather to court Ladies than Nature'.[94]

However, while he was certainly courting women, and reading the French burlesque poet and satirist Paul Scarron (1610–1660), Lister also courted Nature, evincing great interest in natural philosophy. Lister encountered at Montpellier a variety of doctors and natural philosophers who would shape his future research interests. In December 1665 he met the Danish physician Niels Steensen, known as Steno (1638–1686).[95] Steno would later write the *Prodromus* (1668), which was a bold assertion of the organic origin of fossils and how they came to be enclosed in layers of rock. He described a process in which juices seeped through cracks in the earth that were caused by the movement of geological strata. These juices dissolved mineral salts, penetrating the interstices of animal shells, eventually replacing the shells with a stony substance. Lister would incorporate Steno's findings in his own works on fossilized molluscs, which his daughters would later draw and engrave.

Steno was also an anatomist already known for his discovery of the duct of the parotid salivary gland (Steno's duct). When in Montpellier, Steno and Lister performed a dissection of an ox head in the study of Robert Bruce, First Earl of Ailesbury and Second Earl of Elgin. Ailesbury evinced interest in natural philosophy throughout his life and was made a member of the Royal Society in 1685. Lister secured the introduction to the earl due to his family connection to Sir Matthew Lister; in a manuscript entitled 'Adversaria',[96] Lister wrote: 'I made my reverence to my Lord of Alsbury, who was infinitely civil to me upon my Unkle Sr. Matth. Listers memory.' Lister would assist Steno in four dissections in the Earl of Ailesbury's study; he praised Steno's technique, which was 'neat and clever', and stated: 'I observed in him (very much) of the Galant and honest Man as the french say, as well as of the schollar.'[97] Here Lister was writing of the French ideal of the *honnête homme*, an 'honest man' or a gentleman who was moral with the qualities of 'civil boldness'. Lister was especially fascinated by Steno's dissections of the lacteals in the intestines of a dog, and his experiments with the passage of blood and chyle through the digestive system; in the 1680s Lister would repeat these experiments, collaborating with William Musgrave, the secretary of the Royal Society.[98]

JOHN RAY AS MENTOR

During his studies in Montpellier, Lister also had the good fortune to collaborate with the eminent naturalist and botanist John Ray, as well as Ray's former student Francis Willughby (1635–1672) of Trinity College, Cambridge, who was on his own grand tour. Ray and Willughby's fieldwork on the Continent would result in the first scientific work of ornithology organizing species according to physical and type characteristics – *Ornithologiæ Libri Tres* (1676).[99] Willughby also compiled a *Book of Games*, an encyclopaedia of leisured pursuits, including 'Tick', a game of tag involving touching, or 'tag', and running.[100] More seriously, Ray's classification of plants in his *Methodus Plantarum Nova* (1682) into monocotyledons and dicotyledons was a crucial step towards modern taxonomy; the cotyledon becomes the embryonic first leaves of a seedling and its characteristics largely determine the physical appearance of the mature plant (*fig.* 12).

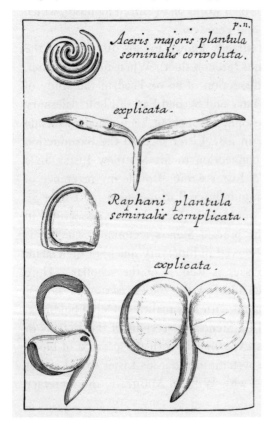

fig. 12 Images of cotyledons. John Ray, *Methodus Plantarum Nova* (London: Henry Faithorne and John Kersey, 1682), facing p. 11.

Although Lister and Ray were at Cambridge at the same time, Ray being a fellow and tutor in Greek, Mathematics and Humanities at Trinity College 1649–62, there is no known written evidence that they met before Lister was in France. (St John's College and Trinity College are neighbours, so it is not outside the realm of possibility they were acquainted previously.) Ray previously had taken three different journeys throughout the greater part of Great Britain, to botanize, two of them accompanied by Willughby, and in 1660 Ray published the result of their research in his *Catalogue of English Plants*.[101] In December 1665 Lister recorded an encounter with Ray, who informed him that on his botanical expeditions he had not found any plant in France that he could not find in England. In fact, Ray claimed that 'he knew not scarce any one plant which he could call properly English'. Lister also indicated that Ray was 'pretty well satisfied concerning the Plants of Europe and that he beleeved he had seen the greatest share of them growing in their natural soiles' and places of origin.[102]

Lister subsequently did a natural-history tour in Languedoc and Rousillon with Ray, riding to Frontignan, outside of Montpellier. Here they dined and enjoyed the muscat wine of the region, tasting of liquid raisin, and then proceeded to ride 'along the beach between the estang and the sea to a cape ... where rare plants grow'.[103] Ray botanized and identified *Frutex terribilis*, or white turbith, a plant which grows in several areas of France, particularly Provence and Languedoc, as well as navelwort.

These idyllic journeys of wine sampling and plant simpling came to a sudden end. On 1 February 1666 King Louis XIV ordered all Englishmen to leave France within three months in preparation for the War of Devolution, a dispute between France and Spain over the ownership of the Spanish Netherlands. Lister's studies at Montpellier were peremptorily ended. Joined by companions Francis Jessop; physician Henry Sampson; Peter Vivian, a fellow at Trinity College, Cambridge; and Sir Thomas Crew, he left for Lyon. Lister later met there Ray, 'Dr Moulins' (the Scotsman James Milne from Aberdeen) and Sir Phillip Skippon (the son of the Cromwellian major general and former pupil of Ray's at Cambridge) before they all proceeded to Paris on horseback.[104]

After they arrived in Paris on 16 March, they met Dionys Joncquet, who had written a magisterial catalogue of the 4,000 plants grown in the Jardin Royal des Plantes Médicinales. Founded in 1626 for Louis XIII as a

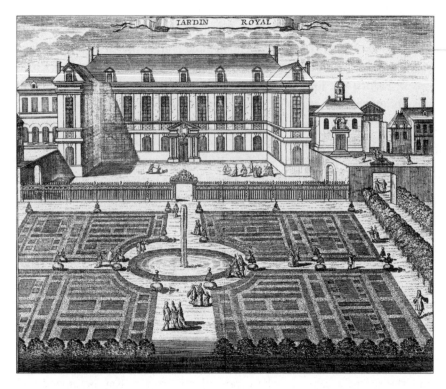

fig. 13 Jardin Royal des Plantes, Paris, by Gérard Jean-Baptiste Scotin (1671–1716).

garden primarily dedicated to medicinal plants, the Jardin featured courses on botany, zoology and dendrology for aspiring natural philosophers and physicians.[105] Like its sister garden at Montpellier, it was considered mandatory to visit for any botanical explorer, serving as part of a network of early museum collections or curiosity cabinets for interested virtuosi (*fig.* 13). As mentioned, Lister would visit Paris again when he was older, and write a renowned guidebook to natural-history collections there – as he put it, 'to satisfie my own Curiosity and to delight my self with the Memory of what I had seen'.[106]

On April Fool's Day in 1666, their botanical tourism at an end, Ray along with a 'Mr Howlet and Dr Ward' left their lodging to travel out of Paris in a *chasse-marée*, or 'fish-cart', for Calais. While the other members of the party continued to Calais in the fish-cart, Lister and Skippon,

'not liking that way of travelling', stayed behind sightseeing for a week. They eventually left Paris not in a fish-cart, but in a more comfortable and less aromatic 'coach waggon' along with a Genevan refugee and a young Swedish soldier who 'had stolen away a wench'. Although three Frenchmen went in hot pursuit of their wagon, the Swede 'outvapour'd them, and turn'd them down stairs ... hectoring them all the way at the inn-gate' where they stayed en route. Skippon related, 'When he came to London, I met with this Swede, and ask'd him in Italian where was his Bella Donna, he replied he had dismissed her and said ... I have got a handsomer.'[107]

Before he left France, Lister still had one last task, and like the Swede it had to do with a relationship he had with a woman. When he was in Lyon, Lister corresponded with an unknown mademoiselle, writing in (relatively elegant) French:

> Mademoiselle, I did not know how to leave France without saying farewell to you once again... I have you so much in my heart and your courtesies will be forever in my memory in whatever country I dwell. I may be returning home, but I will eagerly await news of you there. Cursed war! How you give me pain as I tear myself from my delights. This is for you and for everything beautiful in Montpellier... Pray do me the honour of your remembrance from time to time. I will see if there are means by which you may have my letters.[108]

It was a secret romance, as in the postscript Lister indicated: 'pay my compliments to Mesdemoiselles Pougit, mother and daughter... I forbid you to do as much towards my mistress, she whom you know.' Whether he sent the letter or if she ever replied we cannot determine, but he kept the draft in his personal papers until his death.

RETURN FROM MONTPELLIER

Upon his return to Cambridge, Lister recorded his travel expenses in his pocketbook. He noted that the relatively staggering sum of £136 was 'expended upon the roade' for his three-year journey, an amount that was many times the annual income of an academic in this period.[109] He was still awaiting some bills of exchange, an early modern manner of obtaining credit while travelling. Though he recorded that he received his stipend from his Cambridge fellowship when he was away, it is clear

some of this small fortune came from his family upon his reaching the age of majority.[110]

During this time, he also accomplished his first systematic observations of the behaviour of arachnids and molluscs, and developed his own views on controversial topics such as the spontaneous generation of insects. These endeavours were accompanied by an extraordinarily productive exchange of letters with his mentor John Ray that continued regularly for ten years. In these letters between Lister and Ray we see the discussions that resulted in Lister's first publications in the *Philosophical Transactions*, and the beginning of his interest in molluscs, which in turn would so shape the life of his daughters Susanna and Anna. The two virtuosi also exchanged views about Lister's literature reviews of the nascent field of entomology, Ray strongly encouraging Lister's efforts. Ray commented, 'I found a letter from you, the reading whereof gave me no small content, it containing expressions so significant and full of heat and πάθος [*pathos*, or passion], as certainly nothing but sincere love [of the field] could dictate.'[111]

The first of the letters from Ray to Lister, dated 9 June 1666, has been lost, surviving only in an abstracted form, describing plant species that Ray had encountered in Calais during one of his excursions with Willughby.[112] Shortly afterwards, on 18 June 1666, Ray paid Lister a visit in Cambridge. Together with the apothecary and naturalist Peter Dent (1628/9–1689), who had previously contributed to Ray's *Cambridge Catalogue of Plants*, they went on a botanical 'simpling' expedition. The journey lasted from June to September 1666, began at Histon and Taversham in Cambridgeshire, proceeded to the Gog Magog Hills, and continued to Lincolnshire, including a visit to Burwell.

They travelled to Lincolnshire not only to collect specimens, but to escape the plague that was still ravaging Cambridge. Lister's university friend Thomas Briggs reassured him that 'all your relations as I understand are well in country', noting the colleges 'are all shutt up the infection being somewhat in Towne though very little (praised bee God)'.[113] Indeed, the Plague Bills of Mortality from 2 July 1665 to August 1666 did indicate that 'all the Colledges (God be praised) are and have continued without any Infection of the Plague', though a thousand in the town would die of the Black Death by January 1667.[114] This was the same outbreak of disease keeping the young Sir Isaac Newton from Cambridge on his Lincolnshire

farm in Woolsthorpe. In that remote hamlet, Newton sat under his famous apple tree and transformed physics, invented calculus and discovered the spectrum of visible light using a prism bought at Sturbridge Fair. One speculates whether Lister and Newton knew of the other's presence in the county.

Lister's field notes on the flora and fauna that they encountered still survive; he makes numerous comparisons between his English samples, using Ray's *Catalogue of Plants* as a guide, and the flora he encountered in Montpellier. Some of the plants which Lister recorded in Burwell Wood still exist there, including lady's mantle (*Alchemilla vulgaris*) as well as hawkweed (*Hieracium perpropinquum*), which Lister accurately recorded as having a 'small round hard and stiff stalk, some two foot high. Sett with very brawd leafes something long and sharp pointed, in order one after another at a distance the leaves and stalk are somewhat ruffe [rough] and hairy.'[115]

After their tour, Ray spent the summer of 1667 'between Essex and Sussex visiting friends', and reading 'over such books as Natural Philosophy as came out since my being abroad'. These included Robert Hooke's *Micrographia*, tracts by the famous chemist Robert Boyle, Thomas Sydenham's work on fevers, and a perusal of Athanasius Kircher's *Mundus Subterraneus* (1664–5), his treatise on geo-cosmology. In between reading, Ray was cataloguing the collections of 'plants, fishes, foules [fowls], stones, and other rarities' he made with Willughby, and remarked to Lister: 'I could wish you would take a little pains this summer about grasses, so we might compare notes, for I would fain clear and compleat their History.'[116]

Lister was interested not only in grasses at that point, but in observing insects and spiders around his parents' home at Burwell and at Cambridge. This is not as abrupt a change of focus as one might think, as all branches of natural history were interconnected in the early modern period; it encompassed investigation of all *res naturæ* – the things of nature.[117] Lister himself remarked: 'we must note, how necessary it is, in order to the compleating of Natural History, that our naturalist should be well skilled in plants.'[118] Zoology, botany, entomology and ornithology were considered parts of natural history, but so were cosmology, geography, chorography and meteorology. Early modern physicians such as Lister were often also prominent natural historians, arguing natural history was the best way of

knowing.[119] As Lister wrote in his notebook, 'I must yet for my owne part affirm that I am much beholden to the studdie [study] of Insects for the disciplining my thoughts, and making of them readier in observing, if you will ... usefull and necessarie things in Phisic.'[120] From September 1666 to February 1668/9, Lister was at Cambridge and dedicated himself not only to medical studies, but also to the investigation of minerals, plants, insects, molluscs, spiders, birds and fish.

In addition to his making extensive observations of the natural world, Lister's closing remarks in his letter to Ray of 25 March 1668 also reveal that the two naturalists were concerned about the problem of spontaneous generation, or the generation of life from inanimate matter. Usually the term refers to the creation of insects or worms from animal or plant tissue, such as maggots that seemed to be spontaneously generated from rotting meat (in reality, blowflies laid eggs in the meat, their young hatching out). Lister wrote: 'I myself remember to have formerly elicited your judgment about [Athanasius] Kircher. In the tract, the *Mundus Subterraneus*, among other things, he discourses about the spontaneous generation of insects; which I vehemently doubt occurs.'[121]

At this point, Ray was even less sure than Lister about spontaneous generation. He wrote, replying to Lister, 'I have no judgment about Kircher; I am unable to determine truly if insects spontaneously generate.'[122] Kircher describes his theories of spontaneous generation in the last book of the *Mundus*, which centres on his concept of *semina*, a 'seed' which contains a plastic force that gives each living thing its form, figure and colour. There are two types of seed, one forming minerals and other inanimate bodies, and one forming plants, insects and animals.[123] Kircher asserts that the universal spermatic force in living creatures is individualized in living beings as a particular seed, and diffused throughout their bodies. If this seed drops from the body of an animal when it dies, thus losing its original power and nature, it becomes a separated seed. Kircher argues that insects can spontaneously generate from unheated 'separated seeds' in putrefied matter from a dead body of a plant, insect or animal, but as they have less latent heat they will be more degenerate in form.[124]

Kircher's premisses, and indeed the whole concept of spontaneous generation, were the source of much debate in the early Royal Society, one of the world's first scientific organizations. The Royal Society had its very

first meeting on 28 November 1660 following a lecture at Gresham College by architect and virtuoso Christopher Wren. The Society subsequently received a charter from King Charles II, who hoped that the new natural philosophy would lead to discoveries of the secrets of nature and resulting profits for the nation. Although the organization became known as 'The Royal Society of London for Improving Natural Knowledge', in reality its members were largely interested gentlemen who enjoyed entertaining experiments curated by the Society secretary Robert Hooke. As Thomas Birch's detailed *History of the Royal Society* (largely a publication of Society minutes) shows us, monstrous calves, kittens with two heads, strange bodily stones, shining phosophorus, magnets and static electricity were all subject to wide-ranging discussion. The nature of matter and whether it had inherently vital principles or was subject to motion imparted by the deity was also a grave topic of concern. It impacted the fossil debate: did nature shape stones spontaneously that only resembled living creatures, or were fossils remnants of extinction, which in itself was a heterodox concept? Materialists such as Thomas Hobbes, who believed matter was self-moving, were opposed by other natural philosophers such as Robert Boyle who feared the new science would be associated with atheism.

For these reasons it is not surprising that the idea of spontaneous generation of life from dead matter was a topic of discussion in the correspondence between Ray, a Royal Society fellow, and Lister. In May 1661 a Royal Society committee, which met at Robert Boyle's lodgings, was formed to 'erect a library' and to examine the generation of insects; members included John Wilkins, Seth Ward, Christopher Merrett, Henry Oldenburg and John Evelyn, among others. In 1663, Royal Society members were testing the Duke of Orleans's claim that he had produced animals by the putrefaction of vegetables, and Mr Evelyn 'was put in mind of the experiment committed to him of closing up blood and pieces of flesh, to see whether it would produce any insects'.[125] Cheese and sack were tested to see if they could produce maggots, and from 1665 to 1668 Robert Boyle created a 'catalogue of experiments relating to spontaneous generation to be made two ways 1. in glasses hermetically sealed, having the ordinary air in them: 2. in glasses first exhausted, and then sealed up'.[126] In this manner, Boyle 'sought to test the hypothesis that the capacities of seminal principles of animals might be activated without the presence

of air'.[127] In doing so, Boyle indirectly foreshadowed the experiments of Francesco Redi, published in his *Esperienze Intorno alla Generazione degli Insetti* (Florence, 1668).

Lister had read Redi's work in Montpellier. In it, Redi directly criticized Kircher's belief in spontaneous generation, so perhaps Lister was convinced by some of his arguments. As we will see, Lister's thinking about spontaneous generation also made him ponder whether fossils could be spontaneously generated from stones or minerals, their shapes sports of nature rather than remains of living creatures.

In Lister's first paper for *Philosophical Transactions of the Royal Society*, submitted by Ray on his behalf, he made his first published comments arguing against spontaneous generation[128] (*fig.* 14). The paper opens with his observations on snails, reproduction and the phenomenon of sinistral shells of snails that are 'left-handed' or coiled in a counter-clockwise direction. Just as the majority of humans are right-handed, most snail species have shells that turn from left to right, but the species he examined were a rare exception. Sinistral snails in right-handed species can also be rare genetic mutations, their survival in the wild compromised as their genital openings are on the wrong side, making it difficult though not impossible to mate; their rarity has led to their moniker 'snail kings', and they are much in demand by collectors.[129]

Early naturalists often failed to notice the chirality of the shells. As engravings were inverted left-to-right when printed, unless one engraved them the wrong way around, all samples would come out as mirror images. Shells were thus often printed backwards in engravings or arranged symmetrically purely to make engaging designs. Symmetry (*see plate* 7) was one of the most important design principles that was widely employed in literature about the philosophical basis of the fine arts, usually in Palladian or Vitruvian architecture.[130] Even when chirality was noted, it was for the wrong reasons. Ray remarked to Lister that there was a nonsensical though 'steadfast belief among scholars that all snails to the north of the equator twist from left to right (observing the movement of the sun of course)'.[131]

Lister's paper was the first to discount such theories and to notice the significance of shell chirality, as he had been observing snails for a number of years. In the paper, Lister noted that the sinistral specimens were small, so fragile that he could not send Ray samples, and duskish in

Hewing of all forts of plain pelmell *per* 1000 —— 1 —— 6.

Pinning *per* 1000 8d : Pins *p* 1000. 8d —— 1 —— 4.

Three bufhels (*Winchefter* meafure) of good Lime will take 6. bufhels of frefh water fand, and ferves to lay on one Poole of work ; though much lefs may ferve the turn,

300 of lathes to every Poole of work.

1000 of Lath nailes to every 300 ot Lathes.

An able workman may $\left\{\begin{array}{l}\text{lath 1.poole of work}\\ \text{lay on 2000 or more of flate}\\ \text{hew 1500 plaine}\\ \text{pin 4000}\end{array}\right\}$ by the day.

Chequer-work confifts in Angles, Circles and femi-circles &c. which requires no common skill, and time in hewing and laying.

It is worthy obfervation, that if a fide-wall happen to take wett by the beating of the weather, or the like, when nothing elfe will cure it, our kerfeing with Slate (which is much ufed in the curious fronts of houfes, efpecially in Townes) will quickly remedy it.

Some Obſervations

Concerning the odd Turn *of ſome* Shell-ſnailes, *and the* darting of Spiders, *made by an Ingenious Cantabrigian and by way of Letter communicated to Mr. I.* Wray, *who tranſmitted them to the Publiſher for the R. S.*

Sir, I Can deny you nothing, and you may doe what you pleafe with the Notes I fend you. You would know of me (you fay) what I have obferved concerning the *Odd Turn* of fome *Shell-ſnailes* with us in England, and the *Darting of Spiders*.

I will tell you then of the *firſt*, that I have found two forts of them, eafily to be diftinguifht one from the other, and from all befides, becaufe the *Turn* of the wreaths is from the right hand to the left, contrary to what may be feen in common Snailes. They are very fmall, and might therefore well efcape thus long the more Curious Natura'ifts ; neither of them much exceeding, at leff in thicknefs, a large Oat-corne.

B bbbb 2 The

fig. 14 Frontispiece of Martin Lister's first published paper in *Philosophical Transactions*, 1669. He submitted it anonymously through John Ray to gauge the reaction of his audience.

colour; he wrote, 'the opening of the shell is pretty round, the second turn or wreath is very large for the proportion, and the rest of the wreaths, about the number of six, are still lessen'd to a point.'[132] It is likely Lister was observing the most easily obtained sinistral land snails in the UK, the *Clausiliidæ* (the 'door snails').[133] These are very small turret-like snails that can be found at the base of trees in damp deciduous woodland. The British species tend to be brownish in colour and rarely grow to more than 20 mm in length; they have a little shell door that they can shut behind them as they withdraw from the outside world (*see plate* 8). As we will see, Lister's observation of the handedness of the shells made by these tiny creatures would prove to be crucial to the success of his later books, and to his instruction of his daughters in scientific illustration.

In publishing his paper in *Philosophical Transactions*, Lister also established a long and voluminous correspondence with the Royal Society's secretary, Henry Oldenburg (1619–1677), including sending him a box of insects and sinistral snails; Oldenburg remarked that the 'viviparous fly was found altogether shaken into small pieces, whilst the litel [little] curious snails were all very safe and entire'.[134] Oldenburg patiently encouraged the work of remote provincials like Lister, and he was noteworthy in his efforts to introduce the values and mores of London and the Royal Society to isolated medical men, clergy and gentlemen.[135] Oldenburg prompted Lister to contribute his work in natural history to *Philosophical Transactions*. Ultimately Lister would publish over sixty papers in the journal as well as several books under the Royal Society's imprimatur, and in the 1680s would serve as the Society's vice president. Lister's contacts with Oldenburg and the wider world of scholarship, mediated through correspondence, or the Republic of Letters, would also be important when he needed to obtain shell specimens for his daughters to draw and engrave.

By this point in his career Lister was a mature naturalist, doing research in his own right. In preparation for future publications, Lister continued to do his fieldwork on insects and arachnids, but he clearly had other things on his mind. Ray wrote to him on 31 October 1668:

> I received your latest and earliest letters, in which you included the lists
> of names of thirty Spiders you had recently observed. Certainly I admire
> the skill and diligence with which you have been able to discover so many
> distinct kinds in so short a time and such a restricted area. Indeed I think

it astonishing how you found the leisure in such a difficult time, when your mind was distracted hither and thither with the worry of manifold cares and anxieties, and it was beyond its power for you to be able to devote yourself entirely to any study whatever.[136]

These anxieties involved Lister leaving Cambridge by 1668. Despite his enthusiasm for natural history and his fellowship that allowed him his 'simpling' tours to gather specimens, Lister was contemplating resigning his fellowship to pursue a more lucrative profession in medicine. Lister's fellowship at St John's was not in medicine, and he may well have been under pressure to leave because he had not taken the holy orders required for ordinary fellows.[137] This pressure upon Lister is borne out by a letter from Ray to Lister, in which Ray wrote:

I too received word of the fellowship. I at once believed that you had received the sacrament(s), for this so-called 'fellowship' demands this as a condition. But ... Mr. South informed me that this had never been either your or your parent's intention, and you too write that you are awaiting your father's instruction at the beginning of spring to be called away from the university to practise medicine.[138]

THE SCIENCE OF LOVE

There was also another reason for Lister's desire to leave Cambridge. If he stayed, he would have had to be a celibate don, and it was clear that he had other plans – namely, marriage. Hannah Parkinson (1645–1695) lived at Carleton Old Hall in Carleton-in-Craven near Skipton in West Yorkshire. Carleton-in-Craven was approximately 5 miles from Winterburne, where Lister owned the estate of Friar's Head Hall, given to him by his great-uncle Dr Matthew Lister. In the summer of 1669 Lister had to travel there on his father's behalf, and it was during his visit to this distinctive house standing alone in the Yorkshire Dales that it is likely he met his bride-to-be, whom he called 'his dear Hart'.

The time was a tragic one for his family. Lister's mother Susannah was dying, and would pass away in November; his father was poorly and clearly thinking about the hereafter, having a year previously given a magnificent solid silver chalice and flagon weighing 3½ lb to St Mary's Parish Church in Thorpe Arnold (Sir Martin died in 1670).[139] So Martin may have felt it was a matter of urgency to marry before his parents'

decease. Perhaps he also realized that without his mother, and without a wife, there would be no more venison pies and female companionship.

Though Martin may have encountered Hannah due to sheer physical proximity, it is more likely he came to her acquaintance through long-established family ties between the Parkinsons and the Listers. When Martin's great-uncle Matthew served as a royal physician at the court of Charles I, he had been a close friend and neighbour of John Parkinson (1567–1650), a royal herbalist, apothecary and gardener. Parkinson was best known for his works *Theatrum Botanicum, The Theater of Plants* (1640), and *Paradisi in sole Paradisus terrestris* (1629), the title being a pun – 'Park-in-sun's earthly paradise'.[140] Matthew Lister, along with Sir Theodore de Mayerne, championed Parkinson's *Theatrum* at court, one of the most significant books published on medicinal plants in the seventeenth century, which represented the 'birth of horticulture and systematic public medicine'.[141] Mayerne remarked that Parkinson's book 'entered the very marrow of plants and the virtues of each for the good of the public. You reveal the ointment of mortals so skillfully so that your English compatriots … will forever after be intimate with the richest part of nature's treasure chamber.'[142] Sir Matthew Lister also provided John Parkinson with seeds of Chinese rhubarb he had obtained from Venice, as the best medicinal rhubarb was Chinese, and it was considered one of the most effective purges, a cornerstone of seventeenth-century medicine.[143] Parkinson was one of the first to describe its cultivation, as it was a goal for seventeenth-century European botanists to grow it successfully at home.[144] Both Sir Matthew Lister and John Parkinson were ardent royalists during the English Civil War, so it is possible that the Lister and Parkinson families were well acquainted due to their past friendship and political allegiances.[145] Hannah would have understood her fiancé's interests in natural history as they ran in her own family, and it seems they were an especially compatible couple. One of Lister's old friends from Cambridge, Thomas Briggs, congratulated him, commenting 'I should not seam to think the ere ever been otherwise [happy] who have as I understand so suitable a Consort.'[146]

News of Martin and Hannah's relationship apparently travelled back to Burwell, as Lister's sister Jane wrote to him on the last day of August 1669, teasingly complaining:

Dear Brother – I cannot but chide you that you have forgot your word so much as not to let us know whether you are alive or no. I believe it is a month since we heard of you, and you promised to write to us every week… I doe not know what to think of it; sure you are bringing of us a nu [new] sister – if that be that which takes up all your thoughts I am satisfied, but nothing else can excuse you.[147]

Jane indeed would have a 'new sister', as Martin and Hannah were married on 15 August 1669 at Saint Sampson in York.

MARTIN LISTER IN YORK

The newly married couple moved to Carleton Old Hall in Carleton-in-Craven in the spring of 1670. The green hills that formed the picturesque banks of the Wharfe and Aire could not fail to be attractive to a natural historian, and the house provided a peaceful family retreat for Lister's wife Hannah, who was pregnant with their first child. Lister remarked to Ray in March 1670 that he 'must carry my wife to ly in at her mothers in Craven, where I shall be most part of this Summer.'[148] Susanna, the older Lister sister and future scientific artist, was born at Carleton Hall and was baptised on 9 June 1670. Lister's friend John Ray noted in his letter of 17 July 1970, 'I shall adde no more but my humble service to your Lady (who I hope ere this time is safely at least delivered if not up again and pulchra fecit te probe parentem [a beautiful baby girl has rightly made you a father])'.[149] After his wife's lying-in period and his daughter's birth, Lister decided that York would be an ideal place to establish a medical practice.

York not only had the advantage of being reasonably near his wife's family, but it was a 'faire large cittie' of 12,000 serving an extensive rural area (see plate 9), with good economic prospects for a doctor's practice.[150] As well as being a centre of consumption, it was also a social hub of fashion and taste in the North, offering intellectual stimulation and companionship to the young doctor. Regular hackney coach services linked it to London by 1660, and its status as an administrative centre with important courts and assizes meant there were a number of ceremonial dinners and the occasional royal visit in the social season. Among its medieval half-timbered houses and shops with projecting upper storeys in narrow cobbled streets were new coffee houses by 1669, and a number

49

of famous inns, including the George in Coney Street and the 'very faire' Talbot in Petersgate.

York had a thriving arts and literary tradition as well. There were two local printers, Alice Broad and Stephen Bulkley, which meant that later Lister would be able to publish, at his own expense, in York itself, rather than having to send his work to London.[151] Local gentry gave their patronage to painters, carvers and sculptors, including Edmond Horsely, Andrew Keane and the woodcarver Grinling Gibbons. Local artisans were also hired to decorate and maintain the magnificent York Minster, described by Aston as 'a very goodly edifice and exceeding lardge, and for lightsomenesse much excells [Saint] Pauls... The chapter house is a very faire round roome on the north side with faire painted glasse windowes.'[152] York indeed had a well-established school of glass painting, led in the seventeenth century by Edmund and Henry Gyles; the Gyles family had been York glaziers since the fifteenth century.

At the time of Lister's arrival, Henry Gyles (1640–1709), addressed as 'Honest Harry' by his friends, had established a literary and artistic salon, the York Virtuosi, at his house in Micklegate (*fig. 15*). This was a group Lister later joined, along with the artists Francis Place, William Lodge and John Lambert; the antiquaries Ralph Thoresby and Miles Gale; George Plaxton, rector of Barwick-in-Elmet; the mathematician Thomas Kirke; Dr John Place (cousin to Francis); and the publisher and print seller Pierce Tempest.[153]

Lister's developing expertise in chemistry and dyes led to collaborations with Gyles regarding pigments and coloured glass at the Royal Society, and some of Gyles's observations were discussed in the Royal Society and published in its journal *Philosophical Transactions*.[154] Gyles apparently attempted to create a more intensely vermilion pigment from the husks of kermes insects, as the vibrant pigment made from cochineal insects from Oaxaca was extraordinarily expensive; in the colonial era, cochineal became Mexico's second most valued export after silver.[155] Processes to create a cheap crimson dye were thus among the desiderata of the early Royal Society.[156] Gyles did several glass paintings for Oxford and Cambridge colleges; Lister wrote of him 'I dare be bold to say he is the most Excellent artist in Europe of the kind, and is able to out doe anything was ever yet seen in Oxford or England ... [he] is a very modest man, and

Glaſs painting for windows, as Armes, Sundyals,
History, Landskipt, &c. Done by Henry Gyles
of the City of York.

fig. 15 A portrait of Lister's neighbour, friend and artist Henry Gyles after Francis Place, published by William Richardson, eighteenth century. The text reads: 'Glass painting for windows, as Armes, Sundyals, History, Landskipt, &c. Done by Henry Gyles of the City of York.'

deserves incouragement.'[157] The 'encouragement' may also have referred to Gyles's experiments with colouring mezzotints and their transfer to glass, described in a manuscript he owned that is now in the Cambridge University Library.[158]

Francis Place, who had apartments in the King's Manor in York, was 'one of the pioneers of mezzotint'. He was involved in experiments regarding the chemistry of pottery and the glazing of stoneware, and was a manufacturer of porcelain, so it is likely that he and Gyles exchanged ideas. Gyles was able to get his friend John Place, who was physician to the Florentine court, to search for chemicals and glass in the Venetian glassworks.[159] John Francis Vigani (*c.*1650–1712), an Italian chemist who became the first professor of chemistry at Cambridge, also made contact with Gyles, commissioning him to make an emblematic pair of painted glass windows featuring his coat of arms. Francis Place was also a skilled topographical draughtsman, watercolourist and copper engraver. Pierce

Tempest was connected to a network of York printers such as John White, royal printer for the northern counties. Lister thus found ready assistance when he decided to illustrate and to publish his works of natural history during his years at York.

It was thus fortuitous that Martin, Hannah and their baby daughter Susanna moved in October 1670 to a house outside Micklegate Bar near that of Gyles; Micklegate was west of the River Ouse, a smaller and less populous area in York than the region east of the river. Most of York's larger public buildings, such as the castle, the city and county halls, the King's Manor, and the Minster and Chapel Close were on the east bank, connecting York to the national organs of church and state. Inhabitants in the eastern part of the city were citizen householders and freemen of the city who had attendant political and economic privileges and responsibilities, as well as professional men and the gentry.[160]

In contrast, the western area of York where Martin lived had more modest homes; its most prominent feature, other than its council chambers and St Thomas's Hospital, which served as an almshouse, was Micklegate Bar itself, a rectangular stone gatehouse guarding one of the most important of York's gateways. The main road to Leeds from York led south-west through the bar or gate; it stands close to the site where the Roman gateway led into Eboracum, the Roman city. Micklegate was a focal point for civic events, such as royal visits; tradition decreed that when the monarch visited York he or she had to stop at Micklegate Bar to ask permission from the Lord Mayor to enter the city, a recognition of its independent civic governance. More gruesome were the heads of traitors displayed on the Bar as a reminder of civic authority. Micklegate itself was, in terms of its wealth, a middling sort of parish, with most households having three hearths in 1672; most of the residents were shopkeepers and craftsmen.[161] It was a prudent choice of area for a young physician with a young family to begin a new practice, with all its attendant business expenses.

THE PRACTISING PHYSICIAN

Lister seems to have been assimilated into professional society quickly, and became part of a community of York physicians who banded together to preserve their rights and privileges.[162] An examination of their collectively written articles reveals that they were under the general jurisdiction of the

Archbishop of York, who had granted their licences. The York Corporation of Physicians also agreed to consult each other on medical matters, and to treat the poor with the same care as more affluent patients. The seven physicians who signed the document also appointed a proctor and held monthly dinners with York apothecaries. These dinners were as much about collegiality as enforcing professional boundaries and privileges. Early modern doctors were in a competitive market in which physicians, surgeons, apothecaries and astrologers contended for business.[163] In this competitive marketplace, licensed physicians were at the top of the professional pyramid, generally regarding apothecaries as their inferiors; the apothecaries for their part often undermined the physicians' authority to deprive them of fees.[164] In York, apothecaries were mixing medicines at the request of their clients without a doctor's prescription; the physicians fought back by prosecuting apothecaries for prescribing medicines, as well as boycotting those practitioners who were prosecuted.[165]

The professional rivalry between apothecaries and physicians did not exist only in York, but was widespread, and in London would become positively vitriolic with the Rose Case of 1701.[166] William Rose was an apothecary with his business in St Martin-in-the-Fields. He treated a local butcher by giving him medicines without acting under a physician's directions, charging only for the prescription and not the advice. The Royal College of Physicians brought an action before the Court of Queen's Bench against Rose that was based on the London Physicians' Charter. The Charter forbade anyone who was not a member of the College from practising medicine in London and for 7 miles around it. Although the judgment was initially in the College's favour, much to their eventual surprise the House of Lords eventually overturned it in favour of Rose and the Society of Apothecaries. The Lords ruled that it was against custom and the public interest to prevent apothecaries from prescribing medicines and giving advice. The case profoundly changed the dynamic between physician and apothecary, encouraging the apothecary's role as a dispenser of medical prescriptions. But when Lister was in York, the relationship between apothecaries and physicians was still one of rivalry.

Five of Lister's account books for his practice in York and in London survive, demonstrating how he ran the practice and detailing his clientele and fees. Lister wrote all of his account books in printed yearly almanacs,

writing a name and fee next to the date. The 1676 almanac shows that Lister received 5–10 shillings per patient (equivalent to about £40–80 per consultation today).[167] For an especially difficult case, as that of one Mr Rippon on 12 January 1676, Lister received 2 guineas (42 shillings), but these high fees were balanced by courtesy consultations for his patients' servants that were 1 shilling each. He also often treated children of patients without charge.[168] Those who were itinerant or less able to pay, such as a 'master of a ship' and the 'oyster-man', also received complimentary care.[169] Lister's fees in 1676 were thus approximately the average rate of 10 shillings for an English physician in the seventeenth century. As a point of comparison, while a top London physician like Richard Mead (1673–1754) charged a guinea (21 shillings) to see illustrious patients like Sir Isaac Newton, Lister was in the provinces and at the beginning of his career.[170]

Lister was seeing approximately 30–40 patients per month from January until June; his business declined in July by about half due to his summer holidays, usually spent in Craven in the 1670s, and Bath or France in the 1680s. His business returned to a frequency of about a patient a day from August until December. Lister's income would thus have been approximately £150 per year from his practice (a labour value equivalent to roughly £250,000 in today's money).[171] According to Gregory King's tables of 1688, this amount gave him the same means as a lawyer (£154), though not as much as a gentleman (£280).[172] With additional income from his family's holdings, he would have been considered to have a gentleman's means.

Although Lister's casebooks do not describe his patients' complaints or their specific treatments, eight pages of notes in his 1676 casebook indicate the day-to-day medicaments that he was prescribing. They were largely a mixture of traditional herbal treatments gleaned from his simpling expeditions and reading of Greek and Latin authorities in Montpellier – Theophrastus' *De Causis Plantarum*, Disocorides' *Materia Medica* and Pliny the Elder – along with some Paracelsian and Helmontian chemical doses. Typical of most learned physicians, Lister bled his patients, followed by purges or emetics to drive out evil humours. If these treatments failed, he would concoct more elaborate herbal and chemical medicaments.

Lister's herbal treatments included *Gallium luteum* or lady's bedstraw, which, when infused, was noted in Culpepper's *Herbal* to staunch external

and internal bleeding, as well as being used to stuff mattresses due to its pleasant smell. The mildly acidic distillation of the plant combined with alum may have served as part of the basis of styptic liquor that Lister invented and sent to the Royal Society for more thorough testing in late 1673. He apparently 'showed the Expt [experiment]' in York to his fellow physicians, opening an artery of a dog and applying the liquor, claiming 'not one only drop of blood fell after the application of the liquour with a single linen dipped in it; soe that it may be said, to staunch blood in a moment'.

Lister also devoted a page in his casebook to a list of 'head and horns', such as those from 'raindeer', hartshorn and the tusks of the 'sea unicorn'. Hartshorn was the early modern chemist's source of ammonia, used much like *sal volatile* to enliven the animal spirits and revive those who had fainted. The beautifully spiralled horn of the 'sea unicorn' was actually the elongated tusk of the narwhal (*Monodon monocerous*), but was often represented as a horn from an equine unicorn (*see plate* 12). Unscrupulous apothecaries employed this deception because the horn of the unicorn was highly prized as an antidote to poison, and royal families fearing assassination had bowls and spoons made from it.

Lister then included four pages of his chemical prescriptions that showed influence from his training at Montpellier. Concoctions including antimony – toxic if taken in large doses – featured several times. Lister used antimony as a purge for evil humours, administered as potassium antimonyl tartrate (tartar emetic), and he also prescribed it as an expectorant. When swallowed, tartar emetic acts directly on the stomach walls, producing vomiting, and after absorption continues this effect by its action on the medulla. After ingestion, antimony is excreted, passing out via the bronchial mucous membrane, increasing the amount of secretion and acting as an expectorant. Antimony's use as advocated by chemical physicians had been a matter of controversy since the late sixteenth century, a focal point of the 'Antimony Wars' between Galenist physicians and Paracelsians favouring iatrochemistry.[173] Many universities had been hostile to its presence in the pharmacopeia. The University of Paris, a bastion of Galenism in fierce rivalry with chemical physicians at Montpellier, forbade their graduates to use antimony until 1660. The ban was, however, relatively ineffective, as it had to be repeated many times.

The Royal College of Physicians in London, led by Lister's great uncle Matthew's friend Turquet de Mayerne, advocated antimony's use in the first half of the seventeenth century. When treating hydrophobia, Lister combined a chemical remedy of butter of antimony with a traditional Galenic concoction of crayfish eyes.[174] Other chemical remedies in his casebook include *sal prunella*, a mixture of refined nitre and soda used for sore throats (*prunella* is a corruption of *brunella* from the German *Breune* – a sore throat); *mercuris dulcis* or calomel (mercury compounds with salt, usually mercurious chloride) as a laxative; and vitriol of copper as an emetic, styptic and escharotic (corrosive cancer salve).

Lister's casebooks witness his establishment of a successful medical practice in York, partially due to his expert knowledge of herbal and chemical *materia medica*. He not only could offer his patients the traditional herbal Galenic cures that they expected, but could also demonstrate his expertise with the more innovative and powerful (if not more efficacious) Paracelsian remedies. And as his reputation in York grew, he attracted a higher-paying clientele. Over time, as his 1692 casebook reveals, his income from his practice increased significantly as his patients became more illustrious and his reputation grew. By the 1690s, when his practice was moved to London, he was receiving nearly 19 shillings per consultation, and his patients included Elias Ashmole (helping his wife to deliver their child), Lords Mountjoy and Strickland, Lord and Lady Kingston and the Bishop of Worcester.[175]

It was not only Lister's practice that was flourishing; his family was also prospering and undergoing changes. Between January and March 1671/2 Lister had moved from his house outside Micklegate into a larger residence in Lendal Street in Stonegate. Stonegate was in more affluent eastern York, among the upper 25 per cent for hearth taxes in 1672.[176] Their move was necessary due to a growing family. On 13 October 1671, Anna (Nancy to her family), the second of the Lister sisters, was born.

NATURAL HISTORY IN YORK

During his years at York, as his family expanded, so too did Lister's research interests. In common with other natural historians of the period he was interested not just in the bare empirical details of the objects of study, but in the connections of the natural world with local legends,

religious lore and practical or industrial uses. In accord with the original mission of the Royal Society, of which Ray had been a member since 1667, nature was to be examined in the context of human purpose and activity.

In 1669 Lister wrote a letter to John Ray which reveals his innermost motivations to become a naturalist. Lister states:

> For my part, I think it absolutely necessary that an exact and minute distinction of things precede our learning by particular experiments, what different parts each body or thing may consist of; likewise concerning the best and most convenient ways of separation of those parts, and their virtues and force upon human bodies as to the uses of life; all these, besides the different textures, are things subsequent to natural history.[177]

In the early 1670s Lister put his convictions to work and used his knowledge of parasitism to create another edition, with corrections, of the Dutch naturalist Jan Goedart's work *On Insects*, although it was not printed until 1682.[178] In the preface Lister writes: 'I have taken great care of the Designes, in transferring them upon Copper Plates, which I dare promise are Exquisitly performed, by the best of our English Artists which was my expence.' He took such care because he thought 'Naturall History is much injured, through the little incouragement, which is given to the Artist, whose Noble performances can never be enough rewarded; being not only necessary, but the very beauty, and life of this kind of learning.'[179] Natural history and sensitive illustration to record the essential characteristics of the organism and 'its very beauty' were, in Lister's eyes, inseparable. Lister's friend Francis Place did the engravings, but Lister probably drew the illustrations himself, either from life or from Goedart's own images, because the original manuscript draft contains sketches of butterflies, bees and developmental cycles of other insects accompanying his notes.[180] Lister apparently then transferred the designs to Place to engrave (*fig.* 16 *a–c*).

It was also during these years at York that Lister extended his interests into the paleontology of sea creatures, in particular sea lilies or crinoid fossils, combining interests in taxonomic classification and the origins of fossil remains and the folklore about them. These investigations, in turn, would influence his interest in shells and his work with his daughters in conchology.

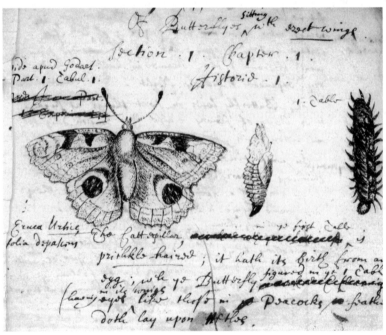

fig. 16 a&b Sketches in Lister's draft workbook for Goedart's *On Insects*.

fig. 16c (*opposite*) Annotated plates for Goedart's *On Insects*, likely by Thomas Kirke. Note how plate 34 matches Lister's sketch.

In a paper published in the *Philosophical Transactions of the Royal Society* in
1673 Lister mentioned having found 'rock plants' in the Yorkshire villages
of Braughton and Stock. As we recall, his wife Hannah had inherited a
house in Carleton-in-Craven in the area, so Lister was well acquainted
with the local geological wonders, such as Malham Cove, the Gordale
Scar and the Craven Fault. (Another notable landmark today is the Lister
Arms, a local pub in Malham that commemorates the naturalist's family.)
The Craven Fault is actually a series of geological faults that run along
the southern and western edges of the Yorkshire Dales, a region composed
of carboniferous limestone, consisting of the folded and faulted layers of
former marine beds and coral atolls.

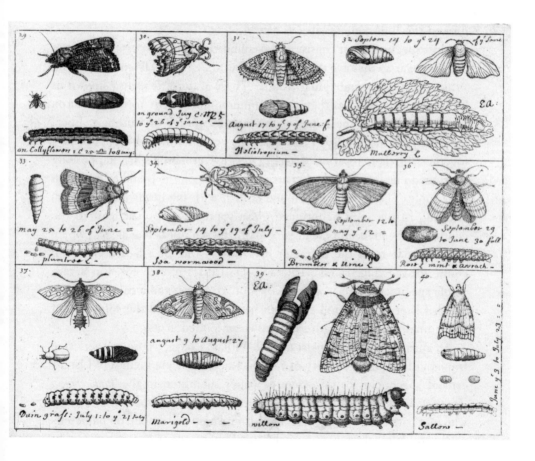

Fossils abound in the exposed rock, particularly the 'rock plants', Lister's name for crinoids. The ancient sea bed had been covered with sea lilies, also known as 'feather stars', echinoderms related to starfish and sea urchins. The base of the lilies was stuck to the sea floor and from it grew a flexible stem of flat plates supporting a head or calyx. From the head grew five branched and moveable arms, which filtered food from the sea water. Cilia in the inside of the arms manipulated the food along the arms down to the mouth, situated at the tegmen at the arms' base. The flexible branches and stem comprised a series of flat plates or wafers piled upon each other, which were strung together by ligaments, and a central coelom, with a nerve cord passing through the entire sea lily. When the crinoids died, their remains accumulated to create a calcium layer cemented together by a carbonate mud, which under heat and pressure formed the limestone fossils (*see plate* II).

Most specimens just consist of the columnar stem – or parts of it. Lister used vinegar to dissolve some of the limestone and break apart the stem sutures to look at individual wafers. These wafers were also known as 'St Cuthbert's beads', as they were common not only in Yorkshire but on Lindisfarne Island, the home of the eighth-century St Cuthbert. Local legend claims that Cuthbert had made the beads for his brethren, to string together for their rosaries. After his death Cuthbert's spirit supposedly continued making nocturnal visits to his 'forge' on the island to replenish the supply. The shore is still found strewn with the beads after a storm, attesting to the saint's continued ghostly presence – or at least to the continued abundance in the area of fossilized sea lilies. The 'beads', which range in size from the diameter of a pea to that of a half-dollar (50p coin), are the ridged and perforated fossil discs of crinoids. But a rare whole specimen also has a radix, or root structure, and a calyx, or head, which Lister called 'a top stone'. In life, the calyx held the soft parts of the animal, from which rose the crown of jointed arms.

An amateur landscape artist named William Lodge, whose mother came from a village in the vicinity of Craven Fault, made engravings of Lister's crinoid specimens for his scientific paper submitted to the *Philosophical Transactions of the Royal Society*. Lodge was a member of the York Virtuosi who met with Henry Gyles. He and Lister would collaborate on numerous papers together, Lister commissioning him to engrave copperplates of

molluscs and arachnids. A talented draughtsman who was independently wealthy, Lodge studied at Jesus College, Cambridge, and Lincoln's Inn, at first painting as a hobby, writing to his mother that 'I make painting only a recreation, an hour after dinner and so no hindrance is it but rather a furtherance to things of greater concernment', though later in the letter he frets about the coverage of his pigments on the canvas.[181] He soon left the legal profession, and in 1669 joined the entourage of Lord Bellasis (Thomas Belasyse) on a diplomatic mission to Venice. Here Lodge visited public and private art collections, for which he admitted a habitual liking, stating to Lister in a letter, 'I love curiosities.'[182] He subsequently published his translation of Giacomo Barri's *Viaggio pittoresco d'Italia*, 'The Painter's Voyage of Italy', which he illustrated with his own etchings of artists' portraits.[183]

Lister quite reasonably thought the branching nature of the crinoids meant they were plant-like, though he confused their arms with their roots. He did not think his finds were actually plants, however, but just shaped like them. His previous publications on fossils noted that because their composition was the same as the stone in which they were embedded, they were *lapides sui generis*, or stones spontaneously created by nature alone – not the remains of living organisms. For his part, Ray commented in an appendix to Lister's paper:

> Those Roots, that you have observed, are a good argument, that these Stones were originally pieces of Vegetables. Wonderful it is, that they should be all broken, and not one plant found remaining entire: And no less wonderful, that there should not at this day be found the like vegetables growing upon the Sub-marine rocks; unless we will suppose them to grow at great depths under water. And who knows but there may be such bodies growing on the rocks at this day, and that the Fishers for Coral may find of them; tho being of no use they neglect and cast them away. Certain it is, there is a sort of Coral jointed.[184]

Taking a cue from Ray's comments, John Beaumont, a Somerset physician and naturalist, also compared the crinoids with coral. In two 1676 letters, also published in *Philosophical Transactions*, Beaumont postulated that corals and crinoids were a kind of stone intermediate between the mineral and vegetable kingdoms. He argued the crinoids were produced

in the same way as the crystallization of cave stalactites and snowflakes. Or, he speculated, perhaps 'mineral steams' and smells arising from ores had a potent force that would spontaneously engender these 'rock-plants'. Beaumont's ideas were not unusual for the time. Iron ore smelled oily, pyritic ore had a sulphurous odour, and miners would use those smells to take them to rich seams of minerals. The German mining theory of *Witterung* (scent) postulated that the smells themselves could produce the ore. Beaumont even suggested that the new 'statical baroscope' invented by chemist Robert Boyle could be used to detect such mineral 'steams' by measuring their effect on atmospheric pressure.

Lister's interest in the crinoids and Beaumont's classification of the rock plants as intermediate species point to the fact that natural historians in this period were primarily interested in collecting a wide variety of specimens, describing and comparing their external particulars, to grasp the wondrous diversity and beauty of nature. With ever-increasing numbers of specimens of plants and animals arriving from the New World, early modern Europe faced its first bioinformation crisis. For natural history was not just about describing flora and fauna: by the seventeenth century, new species required new systems of classification. The philosopher of science Francis Bacon (1561–1626), who had great influence on the Royal Society, advocated the assembling of vast amounts of data about the natural world, creating what he called 'natural histories'. Bacon advised that once all the facts about a particular phenomenon were collected, they would be organized into tables to facilitate theoretical speculation and the creation of hypotheses. Once all the facts about, for example, the nature of air, or the hoverfly, were gathered, then the natural philosopher would be in a position to develop theories about them.[185] This method was developed by the early Royal Society and spread across Europe in the second half of the seventeenth century.

Classification schemes were thus paramount in the minds of natural philosophers in the seventeenth century. Natural historians such as Ray and Lister shaped their own conceptions of a natural order with novel taxonomic methods and information retrieval, as well as the exercise of perceptual skill and collective empiricism. While new taxonomies were created, new subfields in natural history were also being created, and Lister founded the disciplines of conchology (molluscs) and arachnology (spiders).

THE BIRTH OF CONCHOLOGY

One of the most important areas of investigation for natural historians was conchology, particularly due to the fact that shells could be readily collected and visually compared. Generally, description and classification of flora and fauna were accomplished by comparative analysis of external morphology. Visible observations were gathered and systematized. Not only were external or type characteristics easier to examine in the immobile structure of the shell, but as conchology developed into a subdiscipline, from the late seventeenth century, shells were also sought by wealthy collectors as a form of costly status symbol.[186] New World exploration brought unknown species and species of doubtful provenance to Europe.

The scarcity of some of the shells and their inherent beauty, compounded by intense interest in the classification of the natural world, meant

fig. 17 The Old Ashmolean Museum, Oxford. Engraving after Michael Burghers, 1685.

that exchange of such specimens was characterized by patronage networks and rivalry among wealthy collectors. Exotic specimens were displayed in elite collectors' cabinets of curiosities, often housed in their place of residence to impress fellow gentlemen and visiting dignitaries. In the sixteenth century, Danish physician Ole Worm had famous *Wunderkammern* or 'wonder-rooms' in his Copenhagen home, his collection so spectacular that a catalogue was published for fellow virtuosi. By the second half of the seventeenth century the first purpose-built public museums and scientific repositories were created, such as the Ashmolean Museum in Oxford (*fig.* 17) and the Royal Society Repository. Their organization reflected the need to classify the increasing numbers of specimens discovered and to make collections available for research purposes.

In the 1670s there was no general reference work for conchology, and Lister must have realized one was needed. He began modestly enough in the attempt to classify molluscs and shells with his *Historiæ Animalium*, or *History of Animals*, 1678 (*fig.* 18). The *History* comprises three books, the first on spiders, the second on terrestrial and river molluscs, the third on marine molluscs, as well as a fourth section he inserted concerning what we know as mollusc fossils, and what he terms 'English conches or on the stones formed towards the likeness of snails'.[187] Lister notes in the preface that he had taken 'particular care to distinguish genuine species ... by extremely minute but extremely faithful observations pertaining to the habits and life of these animals', and he insisted on a high level of scientific illustration from William Lodge (*fig.* 19).[188]

Though Lodge could be inconsistent in his delivery of the illustrations, their correspondence revealing many frustrating delays in obtaining the copperplates, his talent and good nature led to excellent results.[189] Lodge claimed his sojourns to Scotland, where he drank to Lister's health in a 'stirring cup', provided him with the artistic inspiration for his beautiful engravings, but Lister just considered him irresponsible.[190] On the other hand, so highly regarded were Lister's classifications and illustrations that his rival Nehemiah Grew used the *History of Animals* to compile his catalogue of the Royal Society Repository, where he further developed the description of the species as well as their classification.[191] So Lister remained patient with Lodge, who contributed thirteen new and exquisite plates to the work, including engraving fragments of crinoid fossils.

MARTINI LISTER

E

SOCIETATE REGIA

LONDINI

HISTORIÆ

ANIMALIUM ANGLIÆ
TRES TRACTATUS.

UNUS DE

ARANEIS.

ALTER DE

COCHLEIS

Tum Terreſtribus tum Fluviatilibus.

TERTIÜS DE

COCHLEIS MARINIS.

*Quibus adjeſtus eſt Quartus de Lapidibus ejuſdem In-
ſulæ ad Cochlearum quandam imaginem figuratis.*

Memoriæ & Rationi.

LONDINI,
Apud *Joh. Martyn* Regiæ Societatis Typographum, ad inſigne
Campanæ in Cœmeterio D. *Pauli*, 1678.

fig. 18 Title page of Martin Lister, *Historiæ Animalium* (*History of Animals*) (London: John Martyn, 1678).

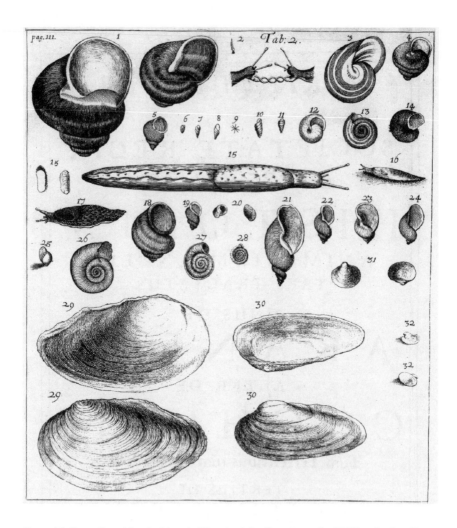

fig. 19 Molluscs from Martin Lister's *Historiæ Animalium*, drawn by William Lodge. Some figures were repurposed from Lister's *Philosophical Transactions* paper of 1674 (*see fig.* 22).

Lister's *History of Animals* was also an enduring success. In the nineteenth century, the eminent conchologists Férussac and Deshayes remarked that Lister in his *History* understood the science of conchology in a broader and higher manner that anyone before him. It took over thirty years of study to produce their own magisterial work on molluscs, *Historie naturelle ... de mollusques* (1819), so that was a worthy compliment indeed; they also noted that Lister was the first to describe particular species, such as *Helix*

66

lapicida (variegated rock snail, known for reddish rays or spots on the shell).[192] Lister also was well ahead of his time in his division of *Pecten* (scallop bivalves) into groups, based on the equality or inequality of the valves and ears in the shells, as well as their number of ribs.[193]

Lister's locality records in his *History* of *Animals* were equally precise. He notes in the *History* that he found a land snail which he describes as *Buccinum parvum sive Trochilius sylvaticus agri Lincolniensis* (the species *Euconulus fulvus*, Brown Hive) in some moss at the roots of trees in the woods near Burwell, as well as a snail now known as *Cyclostoma elegans*.[194] When trekking through the part of the woods at Burwell called Grisel Bottom, I also found both molluscs in the manner Lister describes; the first, which spans 2.0–2.5 × 2.8–3.5 mm is not altogether obvious, but he is correct that it has a fondness for dead or decaying wood. The second snail, with its helical shell, was indeed hiding under stones and roots as Lister observed. Lister was also the first to distinguish more common species of snail, such as *Helix pomatia* (the edible snail) and *Helix aspersa* (the common garden snail).[195] When Linnaeus was trying to create his system of binomial nomenclature to classify molluscs, he cited Lister's locality records for varieties of *Helix* in his *Systema Naturæ* of 1758.

Lister's observations of mollusc fossils in his *History* are also equally noteworthy. Robert Plot in his *Natural History of Oxfordshire* had described fossilized conches, and Lister utilized twenty of his engravings in his book. Though Lister's borrowing of drawings was not uncommon, as naturalists with interests in taxonomy plundered domestic or foreign natural histories for specimens, his work was for an entirely different end than Plot's – it was the first attempt to create a comprehensive account of fossilized molluscs.[196]

The fossils in the *History* are also arranged according to their form rather than their mineralogy, so that Lister's classification for them is similar to those he used for living molluscs; the number and form of valves, the position of the hinge, the number of turns of the spiral of univalves, and the presence or absence of a spine and umbilicus in ammonites were all identifying traits.[197] Such attention to detail meant that Lister could later successfully correct Robert Hooke at a Royal Society meeting concerning what Hooke called 'petrified oysters'. Hooke claimed the oysters were relatives of living species, but Lister countered that these specimens had

'no striæ on the outside going from the valve to the rim', as had living species of European oyster.[198] Lister realized that either the fossils were spontaneous creations of nature – formed stones – or they represented a species that was extinct. He was not sure which path to choose.

This was because Lister was honest about how far his data could take him and thus equivocal about the true origins of fossils. In another publication, after stating that it was possible that fossils were mere 'formed stones', he noted that he did not completely 'disregard the fact that these are much like living things of which nature has wearied. Certainly I have thought about these possibilities.'[199] In other words, he countenanced the extinction of species. This was a development from his crinoid research when he considered the rock plants merely formed stones or sports of nature. Lister followed this comment by stating that he would 'stop these ruminations in the presence of the reader; they [the specimens] may speak for themselves. If yet it is able to be judged what these earthly stones are to be, I will consider it, nor will I make rash judgments.'[200] He even pointed out that on some fossil specimens there were worm tubes on the surface, or fossilized pearls, which might indicate that their origins could be from living creatures.[201] Lister's equivocal comments led the geologist Charles Lyell in his *Principles of Geology* (1830) to note that Lister was one of the first to consider the extinction of species, which was true. But then Lyell went on to say

> that Lister and other English naturalists should long before have declared in favour of the loss of species, while Scilla and most of his countrymen hesitated, was natural, since the Italian museums were filled with fossil shells, belonging to species of which a great portion did actually exist in the Mediterranean, whereas the English collectors could obtain no recent species from their own strata.[202]

In other words, the fossil-bearing rocks in which Lister and other naturalists discovered their shells were largely from the Jurassic and Carboniferous eras, as much as 3 million years old.[203] That means that no species of mollusc from that time is extant today, as England's climate then was tropical and some of the fossil shells are gigantic. This set of circumstances led naturalists like Hooke and Lister to consider species extinction a possibility.

Spurred on by his success with his chapters on molluscs in his *History of Animals*, Lister decided to expand his work on conchology, creating a universal reference work that would encompass all known molluscs in the world. Lister's sustained aesthetic and financial commitment to visual portrayals of living creatures came to its most pronounced fruition with the publication of the first edition of his *Historiæ Conchyliorum* in 1685. This was his seminal work on molluscs that by 1692 encompassed over 1,000 copperplate engravings, but the seeds of his lavish visual presentation of species were sown much earlier. In November 1673 Lister had written to Henry Oldenburg about the necessity for visual, not just verbal, epistemology, claiming:

> Words are but the arbitrary symboles of things, and perhaps I have not used them to the best advantage. Good Design (and such is that I send you, done by that ingenious young Gentleman & excellent Artist, my very good friend Mr William Lodge), or the things themselves, which I have all by me, would make these particulars much more intelligible and plain to you.[204]

By the 1680s his manifesto of the importance of scientific illustration resulted in several obstacles to finishing the *Historiæ Conchyliorum*, not least that William Lodge had moved on to other interests. There were also the practicalities of obtaining adequate numbers of specimens, accurate engravings and printing his works. But, throughout, Lister cultivated a close relationship between his own practice as a natural philosopher and the artists he engaged. After Lodge ceased to be reliable, these illustrators included his teenage daughters Susanna and Anna, who were taught to 'see' in a scientific manner and who created some of the first holotypes of molluscan specimens. Instructing his daughters, the Lister sisters, how to help him create the *Historiæ Conchyliorum* would present several challenges.

TWO

Shell games

Part of being a gentleman natural philosopher or a virtuoso in the early modern period was to cultivate a collection of curiosities or wondrous objects from the natural world. Some of these could be living and set into a magnificent garden. Lister's gardening plans for his retirement years, spent in a fashionable townhouse in Epsom, reveal that he planted over 3,000 bulbs, most typical spring bulbs such as common, major and double snowdrops; 1,675 crocus bulbs; 1,000 common tulips, grape hyacinth, narcissus, hyacinth and campanula. However, there were also less usual specimens that he had collected, such as single and double fritillaries. In the early modern period, a dramatic or multicoloured flower or a double flower was always valued more than a white or single bloom, and the 'dice box' variegation of fritillaries was considered rare and beautiful.[1] Lister's plans for his garden featured desiderata, a wish list, including the exotic crown imperial fritillary from Iran, one of the earliest plants to be cultivated, along with a checklist entitled 'What fritillaries hath you?'[2]

But for his nascent work on conchology, the *Historiæ Conchyliorum*, Lister needed not blooming flowers but shells, and lots of them, to compare, sort, illustrate and describe. Shells were not only important for scientific study, but were aesthetically valued, coming into artistic fashion in the early to mid-seventeenth century, particularly in the Netherlands where wealthy merchants saw the contemplation of shells as part of an exalted humanist enterprise in appreciating the plenitude and wondrous creations of God.[3] Not only did their complex designs offer proof of divine artifice, but the rotation of turbinate shells into themselves suggested a spiritual

70

lesson, as the Calvinist poet Spankhuysen remarked: 'It would be a good thing if man would turn into his own shell and think to himself: What was I before I was born?'[4]

If shells were collected merely for their beauty, their lifelessness and fragility could also make them symbols of *vanitas*. The rich merchant Jan Govertsz of Haarlem (*c.*1545) appears with his shells in his portraits, and Dutch artists Adriaen Coorte (1660–1707) and Ambrosius Bosschaert (1573–1621) introduced shells into their allegorical compositions.[5] In England, the royal gardeners the Tradescants had an exotic shell collection at Lambeth as part of their curiosity cabinet, which Elias Ashmole later acquired to serve as the basis for his Ashmolean Museum at Oxford. Thomas de Critz portrayed Tradescant the Younger next to a table piled high with exotic shells given to him by Roger Friend for his closet of rarieties; coral, patterned turbinates, a cowrie and a marbled cone shell (*Conus marmoreus*) compete for attention with a pearlescent nautilus (*see plate* 13).

Some of Lister's specimens were easy to acquire. Many of the species that would appear in the first chapters of his book (entitled *De Cochleis* and dedicated to exotic land snails) came from Yorkshire and Lincolnshire. In York, Lister had an increasingly busy medical practice, which called him away into 'remote parts', including his estate at Embsay, Yorkshire, at the edge of Barden Moor, where some of his patients were accommodated during convalescence.[6] In between house calls, Lister searched for snails, and he remarked that 'thick bushes and forest yielded treasures, the creatures hiding there so they did not desiccate'. He collected so many English specimens that he donated a cabinet of representative examples of all the shells and fossils that he described in his *Historiæ Animalium Angliæ* of 1678 to the Ashmolean Museum in Oxford.[7] Lister promised the Ashmolean keeper Robert Plot that if the 'Emptie Cabinet be returned me', he would 'fill it with new ones', and noted that a catalogue of the specimens could be 'found in the first drawer, the Key with it'.[8]

THE GIFTS OF FRIENDS (AND RIVALS)

There had to be an easier way to collect specimens. In a letter to his friend Edward Lhwyd (1660–1709), keeper of the Ashmolean Museum, Lister remarked:

I have had the perusal of a collection of shells made on the Coast of Angola
in Africa since I saw you.

 an other at the Islands of Mauroc [Mauritius] & the Island of Ascension
 a 3d at Tunquin [Northern Vietnam] in China, a verie Curious one,
the Cabinet & furniture all from thence.
These three have given me great light into the native places of these
Creatures.[9]

But Lister did not just visit collections personally. Like Charles Darwin
two hundred years later, Lister also corresponded most of his adult life (in
over 1,000 surviving letters) with other virtuosi and explorers who provided
him with specimens, observations and locality records from all over the
world, in a worldwide correspondence network known as the Republic of
Letters. The Republic of Letters, based upon group virtues taken from
the ethos of early modern gentlemanly behaviour, was characterized by
cooperation and modesty, and based upon intellectual tolerance, trust,
honour and self-control. Fulfilling social obligations, bartering intellectual
property or returning favours and sending presents were a means of
mutually paying respect that enhanced a reputation as a gentleman and a
scholar. At least that was the way it was supposed to happen. The Republic
was not always effective at professionalizing its community of scholars, and
cases of insult, plagiarism and even impersonation could occur.[10] Lister,
for the most part, however, found correspondence an effective means to
obtain the shell specimens he craved.

In his *Historiæ*, Lister had illustrated not only English specimens, but
also those from the Mediterranean, Adriatic, Africa, Jamaica, Virginia
and the Carolinas in North America, the Indian Ocean, the North Sea,
Mauritius, France and Ascension Island. Although his own collection
was, as he described it, 'not deficient, either in number or perfection
of species', he had to borrow many specimens of shells from a variety
of his fellow collectors to complete his book.[11] Live snails were sent to
him in strawberry baskets lined with damp moss for safekeeping, ores
were carefully wrapped in paper and put in the post, sketches of shells
and copperplate engravings of their fossils crowded his correspondence.
We know that Lister had three cabinets in his collection, one featuring
sea univalves, one consisting of sea bivalves, and one of river land shells.[12]

From these cabinets Lister sent his own samples, for instance fossil 'cockle-stones of the Iron stone Quarries of Adderton in Yorkshire', or specimens 'picked out of that one Quarrie of Wansford very resemblances of Murices [*Murex*, a tropical sea snail], Telinæ [*Tellinæ*, bivalves], Turbine [turbinates, or molluscs with a turban-like shell shape]'.[13] By sample exchange and the creation of his own small museum of specimens, Lister was participating in a widespread 'culture of collection' and acquisitiveness in the early modern period. His acquisitions, however, were inseparable from the Republic of Letters; his work, education and correspondence rep-resented a cross-cultural exchange of knowledge and specimens between English, French and colonial natural historians. Specimen exchange and collection involved far-reaching networks: traders, apothecaries, physicians, naturalists and collectors all populated a vast intellectual geography to create Lister's conchological collections.

The virtuosi with whom Lister exchanged shells included Edward Lhwyd, John Ray and Sir Hans Sloane. But there were also other sources of *naturalia*. In February 1674/5 William Lodge wrote to Lister that he had examined a London 'closet of curiosities' belonging to one Captain Hicks, 'who gets his liveing by, in furnishing Ladyes Closetts I mean infinite variety of Shells, which he collects from most parts of the world. they did strangely differ in pretty shapes and colours, that I had great pleasure in observing em.'[14] Lodge saw several fossil shells, including a 'large Scallop shell petrified (I think in Wales) with above 200 young ones within it', as well as fossil sea urchins or 'cappstones'. Mr Hicks had other *naturalia* besides shells, such as rattlesnakes, as well as anthropological objects. Lodge wrote:

> Lastly he shewd us divers strange habits, and weapons, used in the East and West Indies and other remote parts, sharks, Aligators, Ratle-Snakes from a ratle in theire tail, which gives the inhabitants notice to stand cleare, strange jawbones and skins of creatures, humming birds, they are about not so big as a wren the colour of a Mallards neck they have a long small beak which they thrust into flowers, feeding there like Bees.[15]

Accompanying his letter were Lodge's pen-and-ink sketches of the sea urchins and the stuffed hummingbird with its curved beak (*fig.* 20).

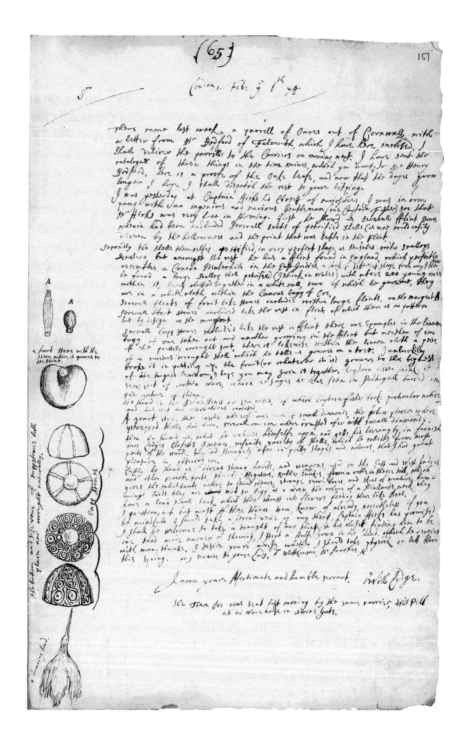

fig. 20 William Lodge to Martin Lister, 6 February 1674/5. Lodge's sketches of hummingbird and urchins are in the margin.

Like the more famous natural philosopher Robert Hooke, Lodge trawled around different London coffeehouses to see natural rarities, mentioning to Lister that he saw specimens of the natural world at John Gill's coffeehouse where exotic animals were displayed for a small fee.[16] However, Gill found the large crowds he drew could be considered public nuisances 'subject to regulation by civic authorities'. Gill and one Mr Lasker in 1685 were 'presented at a Farringdon wardmote "for keeping a crocodile, and ... for shewing a hairy woman which cause a great concourse of people to the great disorder and trouble of all the neighbours"'.[17] (One wonders why he did not show the crocodile and keep the woman.) This tradition of natural philosophers examining unusual animals in coffeehouses, fairs or private collections continued well into the eighteenth century. George Edwards, library-keeper of the Royal College of Physicians, noted in his *Natural History of Birds* (1751), for example, that 'His Grace the Duke of Richmond had a large Chinese Vessel full of [gold]fish', and also mentioned seeing a greater cockatoo being exhibited in Bartholomew Fair.[18]

COLONIAL SHELLS AND SLAVERY

Lister had contacts with merchant seamen who brought back curiosities, and also with a number of professional collectors and naturalists, 'collectors' collectors'. One was the explorer John Banister (1650–1692), engaged in a natural history expedition in the Barbados and Grenada, and then on the Virginian coastal plain (1678–92) for fourteen years before he was accidentally shot and killed by a hunter while collecting plant specimens along the Roanoke riverside in a verdant Virginia May.[19] The magistrate in Henrico County, Virginia, bailed the hunter, one very apologetic James Coulson. Later accounts of Banister glossed over the circumstances of his demise, one source merely stating that he 'fell victim to the fatigue of gathering plants'.[20]

Banister's original letters were sent to the Royal Society, where they were lost, but Lister seemed to have received most of Banister's other catalogues and observations following his death.[21] They had been given for safekeeping to Dr Henry Compton, the Bishop of Oxford, who hoped that the newly formed Oxford University Press would publish a 'history of Insects, more perfect than any yet Extant'.[22] As a tribute to his friend, Lister published in *Philosophical Transactions* excerpts from Banister's surviving

correspondence, 'which else would be in danger to be lost' (Lister was prescient, as at least these excerpts *do* survive in the Royal Society Archives).[23] The excerpted letters indicate that Banister sent Lister his American specimens of 'muscles [mussels] our Freshes [freshwaters] afford', as well as a 'small Ash-coloured and spotted ... naked snail [slug] and milky like yours', which Lister portrayed as *lumor lacti similis* in his *Historiæ Animalium* (1678).[24] Banister had received a copy of this work when he was in Virginia in 1679, and his notes about the species he encountered indicate that Lister inspired him to collect and describe Virginian molluscs.[25] It appears that seventeen molluscs featured in Lister's *Historiæ Conchyliorum* were either Banister's specimens or copied from his drawings, Lister labelling them 'vir' for Virginia. Banister also contributed his descriptions of American plants to John Ray's *Historia Plantarum* (1682), described to Martin Lister by his friend Tancred Robinson as a 'General Herball, which must needs be very accurate'.[26] Banister's plants included some of the first descriptions of American flora such as the passion flower, the agave, hickory trees and sassafras.[27]

In some separate correspondence, Lister reported that Banister also gave him a copy of his fossil catalogue, and indeed some of Banister's fossil records are still extant, in a red morocco volume in the British Library that may have been possessed by Lister (MS. Sloane 4002). Lister thus became the first naturalist to illustrate fossils of any kind from the New World. These were *Chesapecten jerrersonius* and *Venus tridacnoides* [now *Mercenaria corrugata*], fossil clams from the Yorktown Formation of Virginia.[28] Banister, like Lister, also speculated about the origin of fossils, debating whether they were the remains of creatures, or merely formed stones of Nature, created spontaneously out of its generative force. For instance, Banister wrote this about fossilized coral: 'Corallinum is a stony concretion in form of a shrubb, generated from nitro-saline minerall juices impregnated with a sulphurous clamminess elevated by the subterraenous through the pore of the bottom of the sea, whereby the cold and saltiness of the sea-water is congealed'[29] (*see plate* 10). His reasoning was similar to that of John Beaumont on the origins of crinoid fossils (see Chapter 1).

Although we think of fossils as remains of living creatures, many seventeenth-century investigators thought these stones could be created spontaneously by nature as part of her inherent 'generative powers'.

Intriguingly, other stones curiously wrought by nature, such as trilobites, had been found that did not resemble any existing living creatures, giving weight to the idea that fossils were *lapides sui generis* or merely 'formed stones'. Underground aquifers carrying waters with generative seeds or salty juices were thought to form rocks and minerals in the heat below ground. Lister himself, in his later studies of marine bivalves and crinoids, performed microscopic and chemical analysis of the salt crystals both of fossilized shells and of the shells of living molluscs to test for origins of fossilization.[30] He attempted to prepare salt extracts from fossils and the body juices of snails, painting them over the surface of shells to see if there was an increase in weight, and tried to grow pearls from snail juices.[31] Bernard Palissy and Girolamo Cardano had also argued that shells consisted primarily of a salt extracted by the mollusc from the sea and were thus easily petrified, so Lister was attempting to re-create this process. Banister's notes therefore show that both he and Lister had many shared intellectual interests.

Lister also recorded in one of his proof books for the *Historiæ* that he had seen a number of shells from the museum of Daniel van Mildert, a merchant with the East India Company (*see plate* 14). Among listings for more usual goods such as calico and precious metals, Van Mildert is recorded in their ledgers as raising £300 for the sale of cowrie shells (*Cypraeidæ*).[32] Certainly, their wide range of colours, patterns and glossy finish had made these shells a perennial favourite among gentleman collectors, and Van Mildert collected many exotic species. However,

[f]or centuries before European expansion in the 1500s cowries were also used as a form of currency in some areas – hence the term 'money cowrie.' With the advent of the slave trade to the New World, cowries were among the items that Europeans exchanged with coastal West African groups for slaves. By the early 18th century, hundreds of thousands of pounds of cowrie shells were being exported from South Asia to Europe, often as 'packing peanuts' in the China trade, and then re-exported from Europe to Africa.[33]

By the late seventeenth century, there was a distinct stream of cowrie shells 'from the Maldives to Balasore and other Indian ports, and then to Europe, largely London, where the [East India Company] and private dealers sold them to merchants in the African [slave] trade'.[34]

Van Mildert was one of these merchants, and he corresponded with and collected for the wealthy collector, physician and naturalist Sir Hans Sloane. In 1695 Van Mildert became a director of the Scotch East India Company, organized by Act of Parliament in Scotland, with rights to trade in Asia and America, 'some £300000 – one-half of its total capital – being subscribed by Interlopers and independent merchants in London'.[35] The East India Company made such an objection to the formation of this rival organization that the king was forced to suppress the Scottish company. By 1730 Van Mildert was in economic difficulties, writing a begging letter to Sloane to settle a dispute with his landlord, noting Sloane was 'the onley frend to make my humble application for relief'.[36]

When Sir Hans Sloane went to Jamaica in 1687 as personal physician to the 2nd Duke of Albermarle, Lister asked him to bring back specimens not only of shells, but of slugs, which he termed 'naked snails'. Whilst Sloane was in Jamaica, he met Dr Fulke Rose and his wife Elizabeth, Rose being one of Jamaica's early buyers of slaves. Rose was

> one of only six colonists who regularly imported significant quantities from the Royal African Company during the 1670s, which then enjoyed a monopoly on the trade. After Rose died, Sloane married Elizabeth back in London in 1695, and gained access to her one-third share of the income from her husband's estates. Sloane was thus the beneficiary via marriage of income from plantations worked by slaves, a financial arrangement that lasted many years.[37]

Many of the slaves in Jamaica were imported via the West African slave trade and exchanged for cowrie shells. After the Glorious Revolution in 1689, Sloane took up residence in Great Russell Street and offered access to his own 'Museum' or 'Cabinet of Curiosities' of *naturalia* (including shells) and artwork to interested virtuosi like Lister. The money that Sloane was able to accrue from his slave plantations enabled him to build his museum by purchase (sometimes of entire collections) to become 'one of the finest collections in the world – and one of the foundational collections of the British Museum'.[38] To transfer and invest his money from the Jamaican sugarcane plantations, Sloane used the services of Sir Gilbert Heathcote and his sons John and Henry as bankers, agents and trustees (*fig.* 21).[39] Sir Gilbert made his money as a merchant and agent

in the Jamaica and India trade, and he was prominent in the affairs of the refounded East India Company before he became one of the original directors of the Bank of England and Lord Mayor of London.

Sloane and Heathcote also had a family connection. Sir Gilbert's daughter Hester Heathcote married William Sloane Jr, Sir Hans Sloane's nephew. On Hester and William's marriage, they were given a marriage settlement of property in Ireland as well as in Hans Sloane's Chelsea estates, part of which comprised the Chelsea Physic Garden for Apothecaries.[40] Sir Gilbert's son Henry Heathcote was in turn made a fellow of the Royal Society (FRS) in 1720, with Hans Sloane present at the meeting when his admission to fellowship was approved; Henry Heathcote was also

fig. 21 Accounts of Sir Hans Sloane for 1723 with Henry Heathcote as his factor. The Loyal Charles, the Neptune and other names on the register were slave ships which transported slaves from Africa to Jamaica.

on the list of subscribers to Engelbert Kaempfer's posthumous *History of Japan* (1727), its contents translated by Sloane's Swiss-born librarian John Gaspar Scheuchzer from Kaempfer's manuscripts, which Sloane bought for his collection.[41] The work was published under the aegis of the Royal Society with the imprimatur of Sloane as president.

The same sort of patronage ties also bound Sloane and Lister. When Sloane returned to London in 1685 after his medical studies at the University of Orange in Leiden, he was made a fellow of the Royal Society on Lister's recommendation. Sloane returned the favour by making his collection available for Lister to use. Sloane used his own intellectual networks to obtain shell specimens, from which Lister received direct benefit.

THE OBSESSIVE WILLIAM COURTEN

Within Sloane's network, Lister was also able to borrow specimens from the virtuoso and collector William Courten [Curtein] or Charleton (1642–1702), to whom he dedicated his *Historiæ*, and whom he proposed as a candidate for fellowship of the Royal Society.[42] Courten had a public museum of curiosities in a suite of ten rooms in the Temple, London, including artwork, specimens of flora and fauna, and archaeological objects, 'celebrated as one of the finest cabinets of natural and artificial rarities in Europe'. Courten was known to most of the leading virtuosi of the day, including philosopher John Locke. He was born in London in 1642 into a merchant family that, as Gibson-Wood has indicated, 'had previously enjoyed considerable wealth and honour, but subsequently suffered financial ruin. These circumstances meant that, although he came from what had been an extremely wealthy and well-connected family, Courten was of more modest means himself, and much of his life was overshadowed by lawsuits and financial wrangles.'[43] Courten may have adopted the name 'Charleton' to avoid his creditors.

Courten travelled on the Continent intermittently for twenty-five years from 1659 to 1684, sending boxes of art and natural history specimens for safe keeping to Fawsley Lodge, Nottinghamshire, owned by his aunt, Lady Mary Knightly. Some of his protracted absences from England may have been undertaken out of necessity so he could publicly renounce matters that concerned the Courten estates.[44] It was during these lengthy sojourns on the Continent, however, that Courten built up his remarkable

collections of natural and artificial specimens. The diarist John Evelyn noted that on 16 December 1686 he

> carried the Countess of Sunderland to see the rarities of one Mr Charlton in the Middle Temple, who showed us such a collection as I had never seen in all my travels abroad, either of private gentlemen, or princes. It consisted of miniatures, drawings, shells, insects, medals, natural things, animals (of which divers, I think 100, were kept in glasses of spirits of wine), minerals, precious stones, vessels, curiosities in amber, crystal, agate, etc; all being very perfect and rare of their kind, especially his books of birds, fish, flowers, and shells, drawn and miniatured to the life. He told us that one book stood him in £300... This gentleman's whole collection, gathered by himself, travelling over most parts of Europe is estimated at £8000. He appeared to be a modest and obliging person.[45]

Evelyn's description was echoed by Lister, who remarked to his friend Edward Lhwyd that 'I have seen several collections of shells since you was here; but Mr Charleton is now at a stand, & seemes to be wearie of the expence that way yet he hath purchased of late from *Ceylon* 12 or 14 Animals verie well preserved in sp. of wine; rare things!'[46] In the summer of 1691 the naturalist James Petiver, a protégé of Sloane, who visited Lister when he was in London, similarly wrote in his diary of Courten's collection:

> he hath most of not all the Serpents mentioned by Authors, kept in clear glasses full of Spirit of wine, his Medalls, coynes, shells, formed stones, and many other Rarieties, lie upon either black, red or green velvet; here you might have seen divers of the shells called Nautilus, curiously polished, with Venus and Cupid, on one side, and Bacchus and the nine muses on the others, ingraven to the life, he shewed us one Trochus [shell of a sea snail] of which he said he divers times refused Eight Ginnies for it; his Maid told me the Things in this Museum cost Ten Thousand pounds, by this short Account you may see the Excellencie of this Museum.[47]

Courten's rather obsessive collector's habit is shown in some of his private papers.[48] Courten included a lengthy 'catalogue of my plants sent from Montpellier, February 1678', featuring 'lists of plants given to me by Mr Pearl out of Dr Magnol's garden' in Montpellier, as well as flora from the mountains of Provence. Courten also included in his list butterflies that he himself had collected near Fawsley Lodge, with all the prices paid for his specimens enumerated in neat ledgers. When in Montpellier, Courten

also bought for his collection drawings of *naturalia* by Guillaume Toulouze, a master embroiderer and designer who published *Livre de boucquets de fleurs et oyseaux faicts* in 1656 for his fellow professional embroiderers.[49] There was a proliferation of floral pattern books for artisans due to the fashionability of floral motifs in the decorative arts, but wealthy collectors commissioned professional painted images of flora from their gardens or from the celebrated gardens of others.[50] Courten also bought drawings of flowers by Nicolas Robert (1610–1685), an engraver and miniaturist of King Louis XIV and the most successful painter of flower studies. Robert had started out as an embroidery designer and the refined nature of his work brought him to the attention of Gaston d'Orléans, brother of Louis XIII.[51] Robert went on to make engravings for the *Historie des plantes*, an inaugural publication of the French Royal Academy of Science founded by Louis XIV in 1666. Courten clearly collected the best.

Lister subsequently referred to Courten's 'remarkable kindness in giving easy access to myself and other research workers in natural history, and in affording the opportunity of drawing and describing these and objects of the same kind from his abundant resources'.[52] Lister espied not only shells in the collection, but also fossilized shells, remarking for instance 'this is a most beautiful stone of Mr C's collection', comparing it to a living scallop to determine if it was formed by nature or a remnant of an extinct species, concluding: 'the difference of this stone and the scallop is manifold ... the furrow betwixt [the ridges] is very narrow, whereas in the Scallop the Furrows are very deep and broad.'[53]

Lister also used Courten's collections of prints when he could not procure an actual shell. Lister recorded visiting him, scribbling in his casebook for 1683 that 'I saw in Mr. Charlton's collection of prints about 12 single 12° plates of Turben shells very large and most elegantlie done by Hollar, which he bought at Paris.'[54] Lister was thus able to use these plates by the artist Wenceslaus Hollar for his *Historiæ Conchyliorum* (1685–92); and in the *De Cochleis* there are five shells with the label *ad examplar Holleri* (from the example of Hollar). Among them are an unidentified striated *trochus* (number 636), a telescope shell (*Telescopium telelscopium*, number 624), and a bear paw clam (*Hippopus hippopus*, number 350).[55]

Lister's friend and fellow York Virtuoso Francis Place had been a colleague of Wenceslas Hollar; in his correspondence Place mentions that

Hollar was a person whom he was 'intimately acquainted withal'.[56] His friendship with Hollar began when he was a young student at Gray's Inn in London in the 1660s, and Hollar was in his fifties. Place decided to leave the study of law and took art lessons from Hollar, who 'engraved some of Place's drawings of grotesque heads'.[57] Place probably learned the technique of etching in Hollar's studio. Hollar gave Place a portion of his commissions as well, particularly John Ogilby's English edition of Jan Nieuhof's popular book on China, which has many illustrations.[58] The two artists also shared working practices, both etching specimens of natural history – birds, butterflies, moths, beetles and, more importantly for the purpose of our analysis, shells.[59]

The shells were prize specimens, all tropical species, from the Caribbean, South East Asia and Australia, most likely brought back to the Netherlands by explorers and traders.[60] Hollar's shell illustrations have been described as 'marvels of accurate drawing ... little known even to conchologists'. George Vertue remarked of them that they were a 'most curious Book of Shells... Many Collectors of Hollar's works have them not; nor are they to be met with in the most numerous Collections, except Two or Three, where they are esteemed as Great Rarities.'[61] Despite their rarity, it seems that Lister was quite familiar with these sets of plates, obtaining them from Place or Courten. Place had bought several of Hollar's works from his widow and may have lent them to Lister for his daughter to copy.[62] Certainly, the bear paw clam and telescope shell portrayed in Lister's *Historiæ* are identical to Hollar's etchings (*see plate*s 15 & 16).

As Courten's grandfather had financed the colonization of Barbados, there were several species from the Caribbean that would feature in Lister's work. Lister hoped to be able to check these specimens against others brought back by a collector and gardener named James Reed, who was sent to the Madeira Islands and Barbados in 1689–90 on a botanizing expedition. Courten sponsored Reed's journey, along with other members of the Temple House Botany Club, a London club of natural philosophers, of which Lister was a member, that met in a coffeehouse. Reed sailed in the fall of 1689, supplied by Courten with rather prescriptive instructions about what to gather, including 'small dryed birds of fine collours, or with strange beakes, but 2 of each sort take care that they be well dryed and that in the packing of them up they not touch one another'. Courten

also wanted 'butterfly's, grasshoppers, beetles, and spiders of which I have seen some as large as the palm of a mans hand of all which I would have but 2 of a sort thought they differ in their collours or magnitude ... the butterfly's must be stuck with pinns in Boxs, and the spiders put into spirit of wine.'[63] Reed was also given the 'usual brown paper, wide-mouthed bottles, spirits', as well as 100 needles, fish hooks, scissors and '1 Reame paper'.[64] In a separate note, Courten provided him with a recipe for the preserving of reptiles, insects and flowers, which included distilled turpentine, mixed with sage and camphor; the bottles were elaborately stoppered with an oil-soaked bladder, into which was inserted a cork covered with common wax, another piece of bladder, and then he advised to 'take minim [minium or red lead] and colour it [the stopper] round about'.[65] The instructions must have been effective, as Reed returned in October 1690 with 107 seeds and plants, including the intriguingly named 'French physic nutts' (a tropical American shrub, *Jatropha curcas* (family *Euphorbiaceae*), and American pumpkin seeds, besides other specimens of flora and fauna for his sponsors.[66]

However, Lister was ultimately disappointed with Reed's performance.[67] He remarked to Lhwyd that, although 'Read the Quaker ... did verie well performe the commission as to Plants', he was less successful with animal collection, making a 'sorrie collection of seashells of the Barbados'. Lister complained,

> in what I cheiflie imployed him as to me, he did little. I had 4 species of Land Snailes from him of the Barbados: and not one freshwater snail at all. 3 of the 4 species were new, but verie small ones ... of one of the 4 species he brought some hundreds, which shews it to be a verie common Snail there.[68]

This may well have been because Reed did not follow Courten's instructions to 'gather shells of the smaller kind none exce[e]ding the bignesses of a man's closed hand and not above 2 of a sort.'[69]

Lister was more fortunate in the employment of Reverend Mr Hugh Jones, a Welshman who provided specimens from Maryland between 1696 and 1702. Hugh Jones had matriculated at Gloucester Hall in Oxford in 1694, and he served as under-keeper in the Ashmolean Museum for Edward Lhwyd. Jones had been employed by Lhwyd to look for archaeological remains in Wales, including an ancient wooden vessel in Caernarvonshire

and some ancient Roman inscriptions from the thirty graves in Bedheu gwyr Ardudwy. Jones was clearly in need of a more remunerative post, Lhwyd writing 'were you here at present I could find you good Employment under Sir Timothy Tyrrel's son as an Amanuensis', and noting he was trying to get Jones a schoolmaster position, having written 'Jack Davies two days since to secure you Burford Schole if possibly he can'.[70]

Jones, however, would not be a schoolmaster. In 1694 Francis Nicholson was appointed governor of Maryland and he needed a chaplain, possessed funds with which to endow a clergyman, and was interested in natural philosophy.[71] And indeed, on 10 January 1693/4, Lister indicated to Lhwyd, after noting a mutual friend, Mr Samuel Dale, had shown him eight new species of molluscs, that

> Mr London has enquired ... within this day or two of a Person in orders, that may goe into the West Indies to Maryland, to be chaplain to Mr Nicholson the Governour and the Bishop of London, who it is that makes the enquirie, will make him his commissarie [Commissioner] ther[e].[72]

The search for a chaplain who was skilled in natural history continued for several months, because, in Lhwyd's opinion, none of the Oxford divines and few masters of colleges were 'sensible of the value' of natural history'.[73] However, by 1695, Hugh Jones was proposed as chaplain to the governor of Maryland. He was hurriedly ordained and proved very satisfactory in service, providing many examples of flora and fauna to London virtuosi until 1700. As Jones put it: 'Mr Petivir is for shells and Insects, Mr Doody for Mosses Mushrooms & sea weeds, the quaker [James Reed] for trees and plants.'[74] James Petiver and Samuel Doody in turn traded specimens with Lister.[75]

Lister ultimately was quite successful in obtaining specimens for his *Historiæ Conchyliorum*. By 1692 his work, which had been enriched by observations from a variety of collectors and naturalists, grew to 1,073 plates of shells, slugs and molluscan anatomy, as well as titles, subtitles, pages for classification and dedications. Lister amassed a large cabinet of specimens, donating extra shells to the Ashmolean Museum and to the Royal Society Repository, including on 22 March 1679 'The Shells of a large River Muscle [Mussel]'.[76] Now that Lister had specimens and networks for collecting his specimens, he needed artists to illustrate them.

DRAWING UPON ONE'S KNOWLEDGE

After collecting his shells, Lister initially turned to other artists to illustrate them. Previously, the engravings made for his papers in *Philosophical Transactions* and for his *History of Animals* were done by William Lodge. At first, the arrangement worked out well. Lodge assured Lister that his 'utmost ambition is do you any service within the performance of my talents', and York Virtuoso John Brooke affirmed: ''Tis very desirable, that Mr Lodge, should give you his Assistance; that nothing may be omitted to satisfy your own Inclinacions so studious, of what is accurate and choice.'[77] Although we have seen that Lodge's drawings for Lister's paper about crinoids were enthusiastically received, other ventures were not so successful. Lister's attempt to have his table of snails illustrated by Lodge for a 1674 publication was ridden with delays, and when Lodge finally submitted the engravings they were incomplete.[78] On 11 July 1674 Oldenburg wrote to Lister in some panic:

> Reading over again your Tables of Snailes in order to print them this month, I find, that in the Figures of them there are wanting No. 14, 15, 16, viz. *Limax cinereus maximus*, *Limax cinereas alter*, and *Limax alter*. I pray let me know with all possible speed, whether it be an oversight, or not; and if it be, be pleased to supply this defect, if conveniently you can, by the first post, that the Graver, who hath undertaken to grave the rest, may not be stopped too long from finishing the plate. The defect is most certain, and I doubt not of your favor of supplying it...[79]

It was too late for Lister to rectify the mistake, and the finished paper on snails published in *Philosophical Transactions* had the shells numbered from 1 to 13, and then from 17 to 27 (*fig.* 22). Lister made the best of it, describing the numbered figures in the tables and integrating the text and the 'lively figure of each Shell for illustration, done by Mr. Lodge'.[80]

Lodge's residence in the remote hamlet of Arnoldsbiggin, Yorkshire, made it increasingly difficult for Lister to contact him, particularly after he moved to London. Also, Lodge was often away on sketching tours with his friend Francis Place that lasted three to four months.[81] On one journey to Wales in 1678 they crossed the Severn into Wales and journeyed along the south coast from Cardiff and Swansea, through Llanelli, Carmarthen and Haverfordwest to Pembroke and Tenby.[82] Their random itinerary to

Martini Lister,

Historiæ Conchyliorum,

Liber Primus

Qui est

de

Cochleis Terrestribus.

Londini,
ære incisus, Sumptibus authoris.
1685.
Susanna et Anna Lister Figuras pin.

Plate 1 (*previous page*) The frontispiece of *De Cochleis*, the first book of *Historiæ Conchyliorum* (London, 1685–92). We see Susanna and Anna credited with drawing the figures. Decorative borders were added after the initial printing of an image.

Plate 2 Copperplate of decorative border.

Plate 3 Copperplates of the bear paw clam (*Hippopus hippopus*) and the marbled cone (*Conus marmoreus*). The bear paw clam was adapted from a work by Wenceslaus Hollar, the marbled cone from a work by Rembrandt.

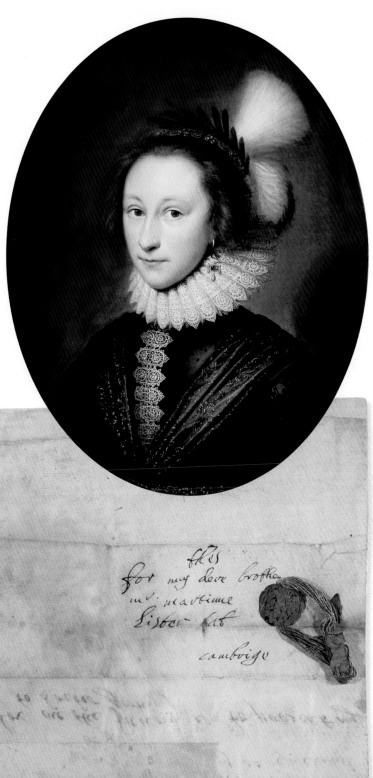

TAB V

FIG. 49.

FIG. 50.

FIG. 50.

FIG. 52.

FIG. 51.

FIG. 52.

FIG. 53.

FIG. 54.

FIG. 54.

FIG. 56.

FIG. 56.

FIG. 55.

FIG. 57.

FIG. 57.

FIG. 49.

FIG. 58.

FIG. 58.

Every Man's
COMPANION:
OR,
An useful
Pocket-Book:
CONTAINING

I. An everlasting Almanack.

II. The Moons age for ever.

III. High-water at *London-Birdge*.

IV. A Table of Interest at 6 *per cent*.

V. The High-ways of *England* and *Wales*.

VI. The Fairs of *England* and *Wales*.

VII. A Paper-Book.

VIII. A Table-Book.

IX. A Letter-Case, or a Comb-Case.

With other useful Things.

LONDON:
Printed for *Francis Cossinet*, at the Anchor and Mariner in *Tower-street*.

Plate 6 (*above*) Frontispiece of MS. Lister 19. The almanac was published *c.*1661; Lister made annotations in it from 1663.

Plate 7 (*left*) Franz Michael Regenfuss, *Auserlesene Schnecken, Muschelen und andre Schaalthiere* (Copenhagen, 1758), plate 5, shows the dorsal and ventral sides of shells arranged symmetrically to make a pleasing design.

Plate 8 Door snail. Drawing by the author.

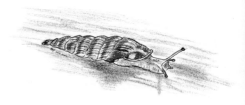

Plate 9 (*below*) *The Ancient and Loyall City of York* (detail) by William Lodge, member of the York Virtuosi and one of Martin Lister's early illustrators for his scientific papers, *c.1675*.

Plate 10 (*right*) American fossilized coral drawn by John Banister. MS. Sloane 4002, fol. 31r, *c.1678–80*.

Plate 11 (*opposite, left*) Crinoid fossil. Note the division of the stalk into separate plates, which when separated were St Cuthbert's beads.

Plate 12 (*opposite, right*) 'Unicorn horns' were believed to have medicinal qualities. Apothecaries usually substituted the horn of a male narwhal, which was ground into a powder to be used in treatments. Mounted on an oak stand, this ivory shop sign was probably made in England or the Netherlands, *c.1700–1800*.

Plate 13 (*overleaf*) *John Tradescant the Younger with Roger Friend and a Collection of Exotic Shells*, 1645, attributed to Thomas de Critz.

Tᵉ: John Tradescant Junᵉᵉˢ his
frind Zythepsa of Lambeth.

Plate 14 (*opposite*) Draft workbook for Martin Lister's *Historiæ Conchyliorum* showing his annotations indicating that he borrowed shells from Daniel van Mildert and William Courten.

Plate 15 (*right*) Etching of bear paw clam (*Hippopus hippopus*), *c*.1645, by Wenceslaus Hollar (1607–1677).

Plate 16 (*below*) The Lister sisters' engraving of the bear paw clam in the *Historiæ Conchyliorum.*

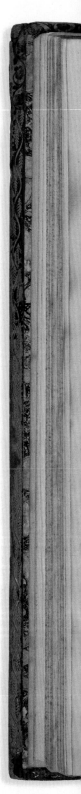

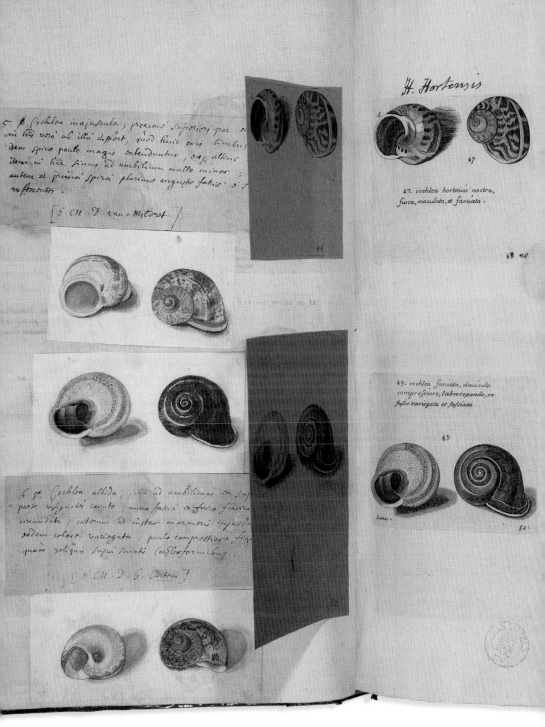

H. Hortensis

5 β. Cochlea majuscula, proxime superiori par ci
in his vero ab illa differt, quod huic oris limbus
item spira paulo magis extenduntur, ex ultimi
item in hac sinus ad umbilicum multo minor
autem et prima spira plurima anguste fabie, ei
restrontus

[5 CM. D. van = Milorst]

47. cochlea hortensis nostra,
fusca, maculata, et fasciata.

47

49. cochlea fasciata, clanicula
compressiore, labrerepando, ex
fusco variegata et fasciata.

49

5 γ. Cochlea albida, sive ad umbilicum se sup
parte insigniter cavato ; unica fascia ex fusco flavica
circundata ; introrim ad instar marmoris cujusda
eodem colore variegata ; paulo compressiore figu
quam reliqui supra scripti Cochleaformibus.

[5 CM. D. G. Cortum]

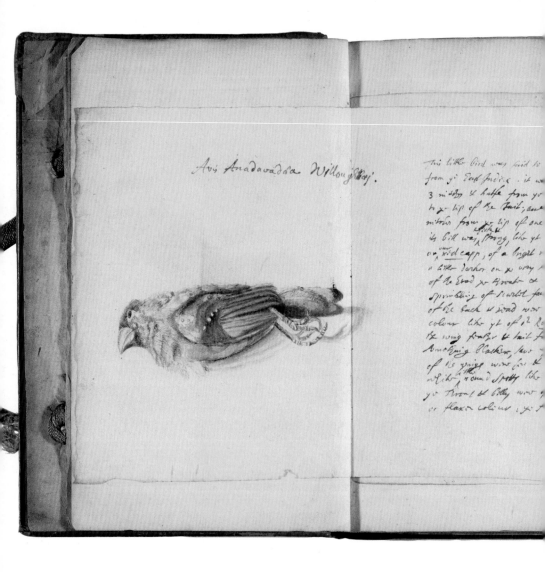

Plate 17 (*above*) Lister's figure of a strawberry finch with his accompanying notes. His heading indicates that some of his description was taken from Francis Willughby's *Ornithologiæ Libri Tres* (London: John Martyn, 1676), p. 194.

Plate 18 (*opposite, bottom*) Martin Lister's drawing and annotation of ammonite sutures.

Plate 19 (*opposite, top*) Ammonite sutures in the published *Historiæ Conchyliorum* (1685–92).

Plate 20 (*overleaf, left*) Hooke's drawings of ammonites showing the sutures.

Plate 21 (*overleaf, right*) Intaglio from R. Hooke, *Posthumous Works* (1705), Table 1a, between pp. 282 and 283, plate size 320 × 200 mm.

19

20

21

22

23

1041

1042

23. b.

1043

Capitum quorundam, cornua ammonis dictorum, variis suturis

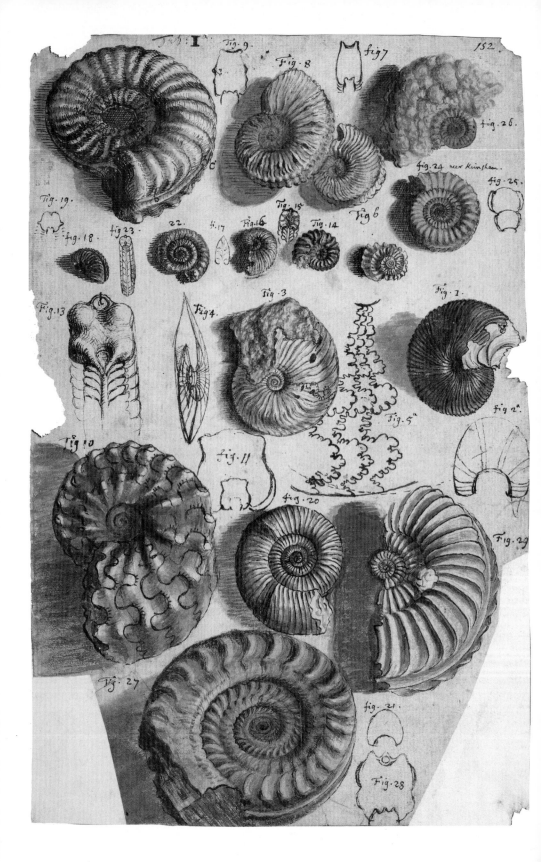

Tab: I. fig 7 152.

Tig. 9. Fig. 8.

fig. 26.

fig. 24 neer Krinsham.

fig. 25.

Tig. 19. Fig. 15. Tig. 6

fig. 18. Tig 23. 22. fi. 17 Fig. 16 Tig. 14

Fig. 13 Fig. 3 Fig. 1.

Fig. 4

Fig. 5.ª Fig. 2.ª

Tig 10 Fig. 11

fig. 20 Fig. 29.

Tig. 27 fig. 21.

Fig. 28

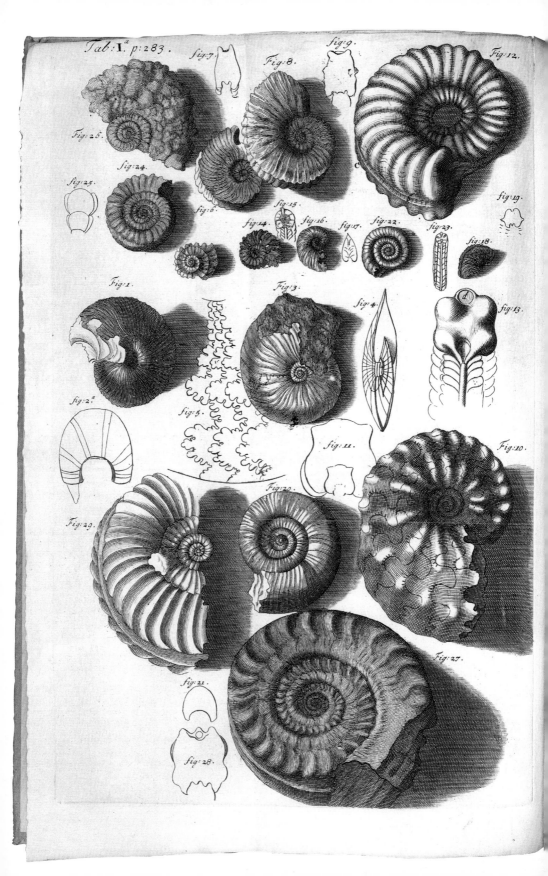

Tab: I.ᵃ p: 283.

Plate 22 (*right*) Lister's corrections of his daughters' drawings of sea urchins, particularly directing them to pay attention to the size of the subluxal plates, noting in this illustration that they should be 'a small matter contracted'. From 'Original Drawings for Lister's Conchology ca. 1690'.

Plate 23 (*below*) Lister's notes indicating corrections needed to his daughters' drawings of sea urchins. From 'Original Drawings for Lister's Conchology ca. 1690'.

Plate 24 (*opposite*) Print and wash drawings of Surinam *buccina*, draft workbook for Martin Lister's *Historiæ Conchyliorum*. Note Lister indicated from the museum of 'D.G[ulielmus]. Curteni' or William Courten.

12. Buccinum majusculum, leve, ex toto leviter purpurascens,
apertura limbo excepto, qui albidus est; intra quintam
spiram finitur.

[o Museo D. G. Curtoni]

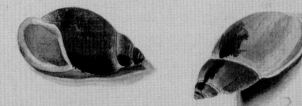
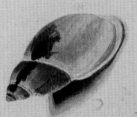

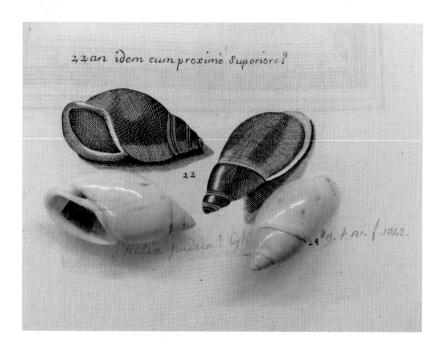

22 an idem cum proximè superiore?

22

Helix pudica? GR

24 D. 7. 121. f. 1042.

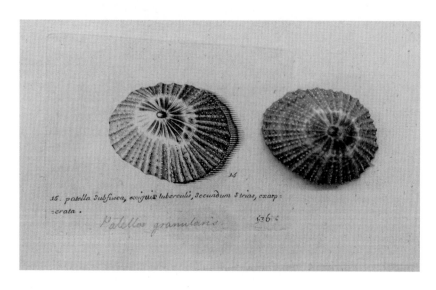

15. patella subfusca, exiguis tuberculis, secundum strias, exasp=
=erata.

Patellæ granularis. 536

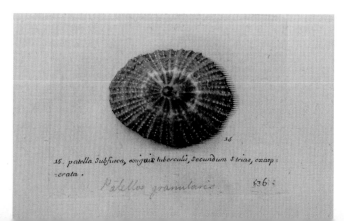

15. patella subfusca, exiguis tuberculis, secundum strias, exasp=
=erata.

Patellæ granularis. 536

Plate 25 (*opposite, top*) Original specimens from the Sloane Collection, Natural History Museum, London.

Plate 26 (*opposite, centre*) A comparison of the original specimen *Patella granularis* with the engraving by the Lister sisters from the *Historiæ Conchyliorum*, Natural History Museum, London.

Plate 27 (*opposite, bottom*) *Patella granularis* specimen placed on top of its engraving in the *Historiæ Conchyliorum*. Note how the Lister sisters traced the original shell's periphery for their illustration for a perfect match.

Plate 28 (*below*) Original specimen of *Melo ætheopica* from the Sloane Collection, Natural History Museum, compared to its portrayal in the *Historiæ Conchyliorum*. The shell must be tilted upwards to see the whorled *umbilicus*, the type characteristic of the species, indicating that the Lister sisters combined perspectival views.

Plate 29 (*right*) Original specimen of *Neverita (Polynices) duplicata*, from the Sloane Collection, Natural History Museum, compared to its portrayal in the *Historiæ Conchyliorum*. The protuberances are most pronounced in the illustration of the shell, its angular margin more felt that seen, but definitely perceptible.

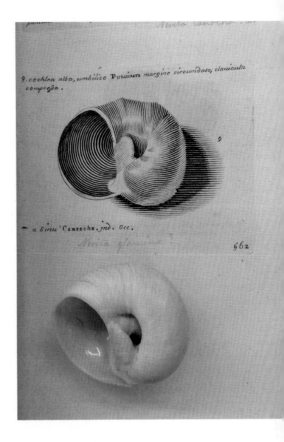

Cochlearum Exoticarum tùm Turbinatarum, quàm
musculorum.

~~Cochlea~~ Fluviatil~~ium~~

i. a.

Aquæ ~~—~~ dulcis

Liber

~~aquæ dulcis~~.

AL f. 66

Plate 30 (*opposite*) Anna Lister's etched floral ornament for *De Cochleis*, the first book of the *Historiæ Conchyliorum*. Note her father's correction of the Latin as species were reclassified and renamed.

Plate 31 Susanna Lister's draft engraving of a nautilus shell *c.*1685, with her signature in the lower left-hand corner. We can see her father's annotation above concerning portrayals of the shell in the work of other naturalists. Martin Lister, *De Cochleis tam terrestribus* (published by the author, London, 1685), Lister L. 95, figure 84a.

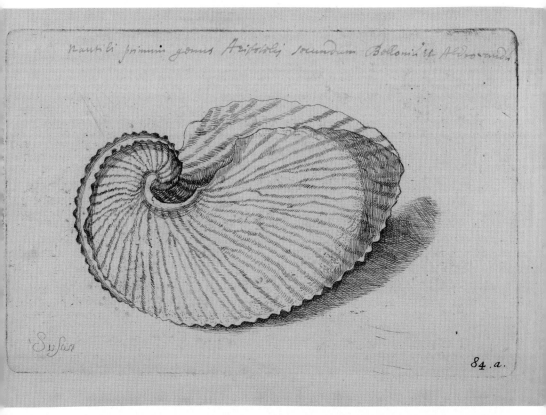

Plate 32 (*below*) Lister repurposed his daughter's engraving of a scallop done for his article in *Philosophical Transactions* for a second edition of the *Historiæ* featuring molluscan anatomy. Copperplate for 'The Anatomy of a Scallop', *Historiæ Conchyliorum*, 2nd edition.

Plate 33 (*bottom*) The verso of the copperplate for 'The Anatomy of a Scallop'. The copperplate shows evidence of alteration of the original title by hammering out and burnishing the plate.

Plate 34 (*opposite, top*) Table 17 from Martin Lister, *Historiæ Conchyliorum*, 2nd edition.

Plate 35 (*opposite, bottom*) Martin Lister, 'The Anatomy of a Scallop', *Philosophical Transactions*, image preceding article on p. 560.

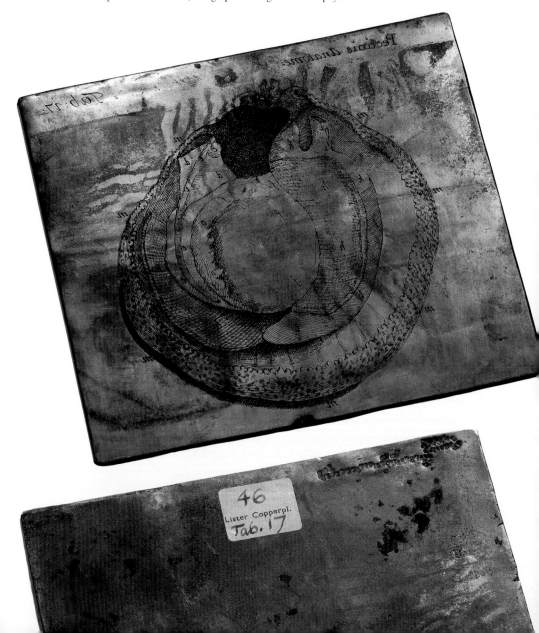

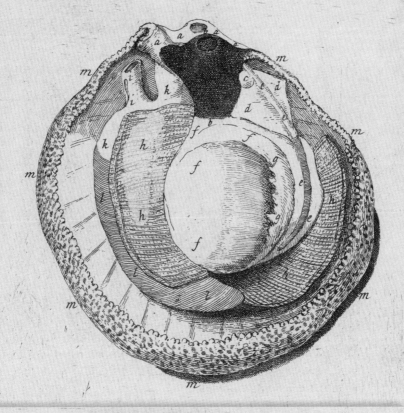

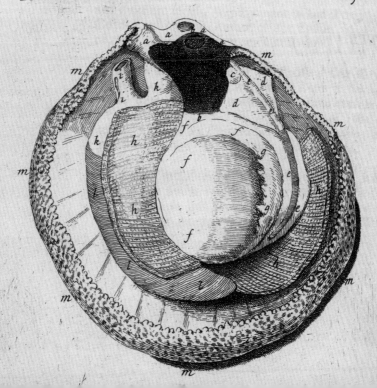

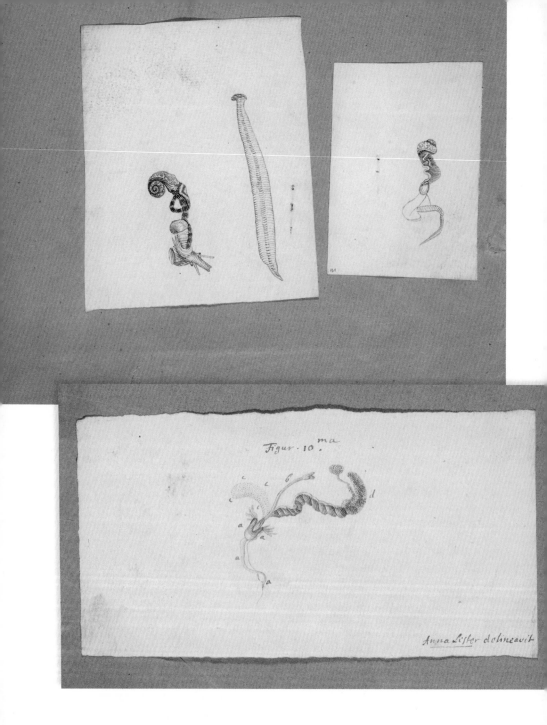

Plate 36 (*top*) Anna Lister's sketches of molluscan anatomy.

Plate 37 (*above*) Anna Lister's sketches of molluscan anatomy. Note her signature: *Anna Lister delineavit.*

Plate 38 (*opposite*) Print of Anna Lister's sketch.

Tab 4.

Dissectio Cochleæ Terrestris striatæ at�q, operculatæ.
Til. 5 H. Nostræ. A.A

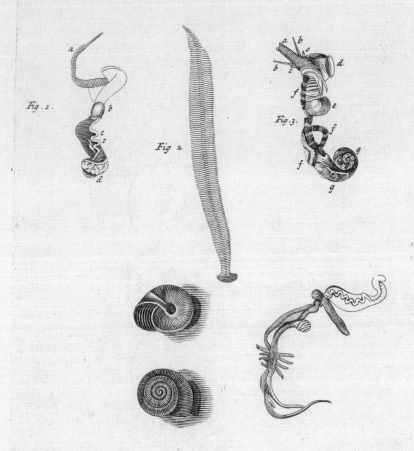

Fig. 1.

Fig. 2.

Fig. 3.

Anna Lister delinea.

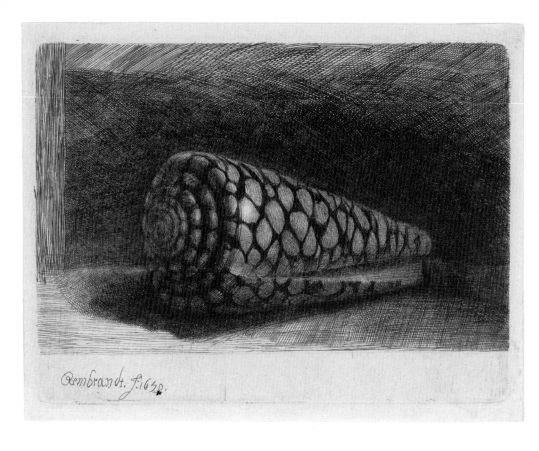

Plate 39 (*above*) Rembrandt van Rijn, *The Shell*, an etching, 1650.

Plate 40 (*opposite, top*) Anna Lister's engraving of the shell in her father's *Historiæ Conchyliorum* (1685–92), figure 787.

Plate 41 (*opposite, bottom*) *Conus marmoreus*.

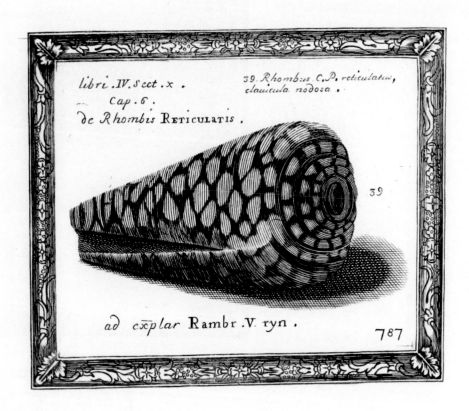

libri .IV. sect .x .
Cap .6 .
de Rhombis RETICULATIS .

39. Rhombus C.P. reticulatus,
clavicula nodosa .

39

ad explar Rambr .V. ryn .

787

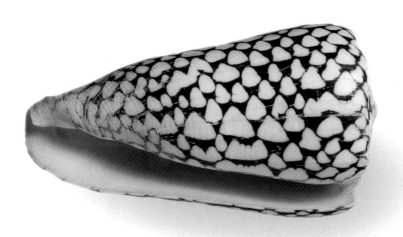

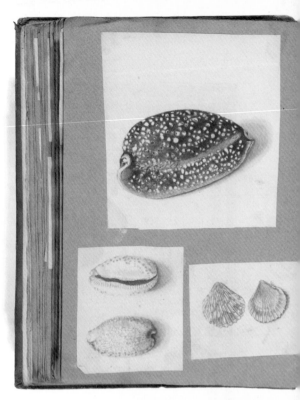

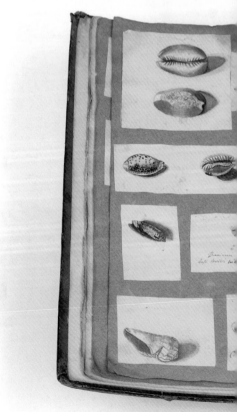

Plate 42 Sample pages
from MS. Lister 9,
Anna Lister's sketchbook.

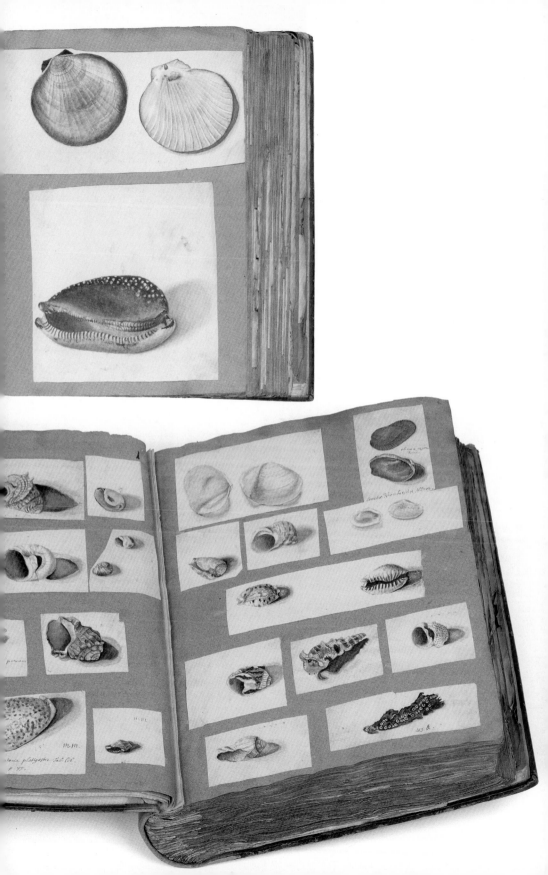

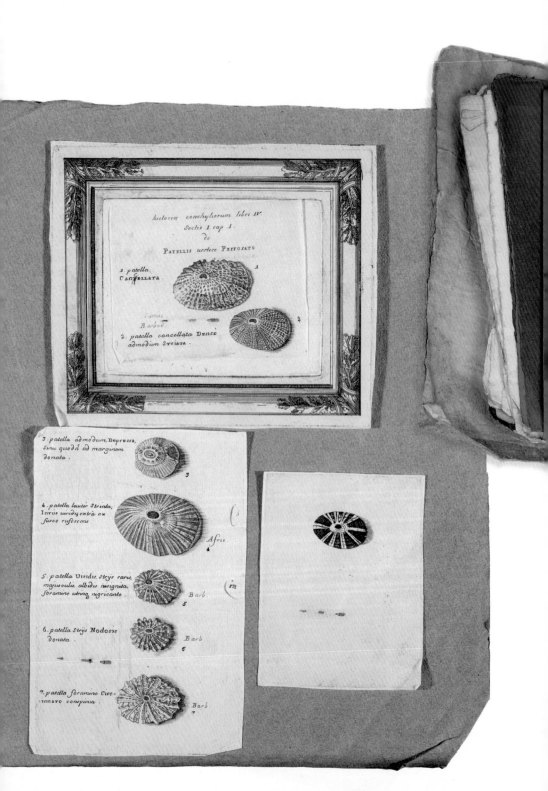

historia conchyliorum libri IV.

Sectio I cap I.

de

PATELLIS vertice PERFOSATO

1. patella CANCELLATA

1

2

amac

Barbad

2. patella cancellata DENSE admodum STRIATA.

3. patella admodum DEPRESSA, sinu quodam ad marginem donata.

3

4. patella lauter STRIATA, Intus viridi, extra ex fusco rufescens.

Afric

4

5. patella Viridis, Stry's rara, majusculis, albidis insignita, foramine utrinq nigricante.

Barb

5

m

6. patella Stry's Nodosis donata.

Barb

6

7. patella foramine Viro sinnato conspicua.

Barb

7

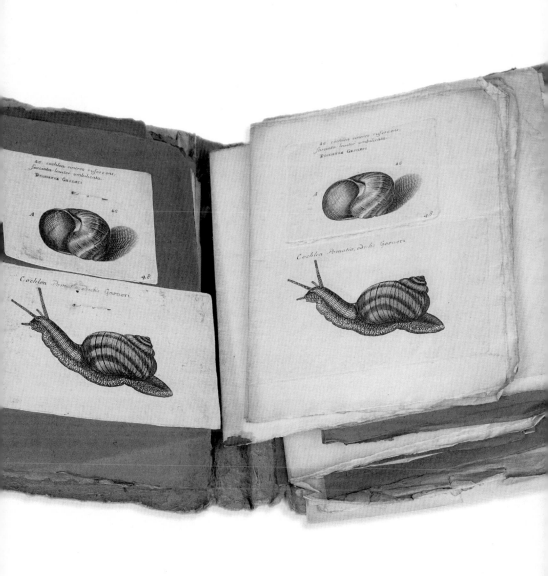

Plate 43 (*opposite*) Shells pinned to blue album paper, The Lister Ephemera, Box 3. Borders were printed separately and they had their own copperplates.

Plate 44 (*above*) Several prints of shells awaiting rearrangement prior to publication.

Plate 45 (*overleaf*) Box 4 of Listeriana with two copperplates.

Prints from
Lister's Cat...

C...

[Copper-plates in basement].

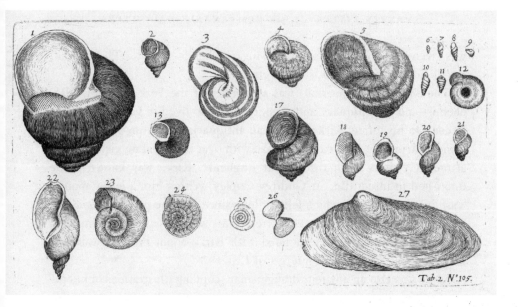

fig. 22 Martin Lister's published snail table in *Philosophical Transactions* (1674), accommodating William Lodge's omission of figures 14, 15 and 16.

draw landscapes brought them under the suspicion of the authorities, particularly as it was the year of the Popish Plot. Place and Lodge were imprisoned as suspected Jesuit spies.[83] Lodge was often incommunicado and unable to fulfil Lister's requests.

In 1681 the artist and member of the York Virtuosi Francis Place took over from Lodge, and did the insect etchings for Lister's annotated version of Johann Goedart's *On Insects*, published the following year.[84] Goedart (or Goedaert) (1617–1668) was a Dutch engraver and painter whose passion was raising insects in glass containers from larvae he found or from those that neighbours, and later other naturalists, sent him.[85] Lister had Goedart's figures etched, but from Lister's notes on the draft manuscript (*see fig.* 16b) we can surmise that he himself redrew some of the creatures that Place etched onto the plates.[86]

The edition of Goedart was a long time coming. In his preface to the 1682 edition, Lister indicates that 'the *Translation* lay by me unfinished, and in the first draught for above Seven Years, and had so done long enough, had not my very good Friend *Mr. T.K. of Cowkreig* [Cookridge] very Obligingly undertaken to Transcribe and perfect it.'[87] And, indeed, at the end of Lister's draft manuscript, we see an annotation: 'This book

was given me by Dr M. Lister being his own handwriting … Thos. Kirke', the 'T.K.' mentioned in Lister's preface.

Thomas Kirke (1650–1706) was a member of the York Virtuosi, FRS, chemist and an antiquary and topographer who lived in Cookridge, near Leeds. On his estate, Kirke created an antiquarian museum and designed a 'most surprizing Labyrinth' or maze with over 300 separate vistas, which attracted visitors from throughout England.[88] Kirke was known to be interested in insect life, Sir Godfrey Copley writing him a letter about a 'vast number of *Beetles* which fell not long since in some part of *Ireland* and eat and *destroyed* all the leaves of trees fruit and grass for many miles'.[89] Sir Hans Sloane also corresponded with Kirke about mineral waters, a subject which was also an interest of Lister's.[90]

Kirke was also an amateur draughtsman, copying illustrations of micro-scopic observations from *Philosophical Transactions of the Royal Society*. He also kept the company of printers and craftsmen linked to the Royal Society, such as Joseph Moxon (1627–1691), a printer and globe-maker, as well as William Faithorne, who published the *Art of Graveing and Etching* (1662).[91] The first work in English on engraving and etching, Faithorne's book was largely a translation of Abraham Bosse's *Tracté des manières de graver en taille douce sur l'airin* (1645). As Kirke also owned a manuscript copy of Edward Norgate's *Miniatura, or, the Art of Limning*, it seems that Lister's gift to him may have acknowledged his interests in natural history and illustration, as well as the artistic interests of the York Virtuosi. On some of the plates of the insects engraved from the drawings in Lister's draft notebook we indeed see Kirke's characteristic handwriting, summarizing the insects' life cycles and food preferences.

In July 1681 Lister showed the fourteen plates depicting 144 insects to the Royal Society when he passed through London on his way to France.[92] *On Insects* was based on observations that Lister made in the 1670s, and it represented an extension of his interests in insect parasitism and the pos-sibility of spontaneous generation. Lister's refinement of Goedart was one of the first treatises accurately describing insect life cycles, the other works being Marcello Malpighi's treatise on the silkworm, *De Bombyce* (1669), and Swammerdam's *Historiæ Insectorum Generalis* (1669).[93] Earlier entomologists, such as Thomas Mouffet, adhered to the concept of metamorphosis, the idea that different life stages of an insect represented a sudden change

from one type of animal to another. He described butterfly larvae as 'worms', different creatures from the pupae and the butterflies, rather than conceptualizing them as three stages of the insect's life cycle.[94] Mouffet thought that each animal owed its existence to the death and corruption of the earlier stages or to spontaneous generation from leaves or dew.[95] Because Mouffet thought that the caterpillar, aurelia and butterfly were distinct animals, he put them in separate chapters in his book.

Lister, saddled with Goedart's organizational structure and a poor translation from the Latin, made the best of it, adding commentaries at the end of each sub-chapter to correct his fellow entomologist. In particular, Lister employed his knowledge of insect parasitism to correct Goedart's work, noting that many of Goedart's 'caterpillars' and their 'offspring' were actually larvae of parasitic wasps or 'by-births', the 'Catterpillar which bore them, serving only as Food to them, not a Mother'.[96] In the preface to his edition, Lister wrote (probably a little unfairly) that Goedart 'seemed rather to have diverted with' his insects 'rather then to have given himselfe the trouble of well understanding them'.[97]

At the same time as Lister was working on *On Insects*, Marcello Malpighi was using the microscope to aid in his dissection of insects and to display their anatomical structure, isolating the animal from the environment; Lister, however, thought it necessary to have the insect portrayed as much as possible in its ecological niche.[98] In particular he notes 'how necessary it is, in order to the compleating of Naturall History, that our Naturallist shou'd be well skilled in Plants: Viz the Food of most Insects.'[99] As Goedart had 'left us in the darke' about the food sources of some of the insects, for 'want of a more particular Title of this Plant',[100] where the plants could be specifically identified he portrayed the butterflies with the caterpillar feeding on its favoured food source.[101] Not only did Lister's illustrations provide a more complete natural history of insects, but it was also regarded as an exercise in identifying which caterpillars or 'river worms infested which types of wood, as well as the determination of 'what kind of Wood is best, for Sheathing of Ships'. As 'the Indies are stored with greater variety of Timber, then Europe, so that it would be very probable there may be some found, which that kind of River Worme will absolutely refuse to Eat.'[102] Detailed illustrations of insect life cycles could help this early venture in economic botany, and at the same time

their 'exquisite' rendering and sensitive placement on the page elevated these small creatures into objects of beauty.

Why did Lister insist that the images be beautiful as well as scientifically accurate? It was partly down to his own artistic sensitivity, but partly to the nature of the specimens he portrayed. Playwright Thomas Shadwell satirized Lister in his work *The Virtuoso* (1676) for his work in arachnology. Shadwell's main character, the virtuoso Sir Nicholas Gimcrack, was a combination of the personality traits of several virtuosi, such as Robert Hooke and Robert Boyle, but Gimcrack was also referred to as one 'who has broken his brains about the nature of Magots; who has studi'd these twenty years to find out the several sorts of Spiders, and never cares for understanding Mankind'.[103] Shadwell's comment was a clear dig at Lister. Lister in fact admitted in the preface to his *Exercitatio Anatomica in qua de Cochleis* (1694), a comprehensive anatomical guide to land shells and slugs, that he was aware that his biological work might 'provoke the laughter of spectators'.[104] He also wrote to Edward Lhwyd that that there were 'censorious mouthes who think and say a man that writes on Insects can be but a trifler in Phisic', and that he hoped he would be left 'alone to pursue Philosophie amongst the inferiour sort of beings'.[105] As at the time molluscs were also considered insects along with the more usual species and spiders, Lister was referring to his work in arachnology and conchology.

Lister also had moved to London from York in 1683 and established a lucrative medical practice in which public perception of his activities was important to securing professional respect. Visually pleasing images of insects and molluscs would help overcome the public perception that his study of them was trivial, an exemplar of the madness of a virtuoso; through beautiful illustrations, these 'inferior' beings were elevated into important specimens of natural philosophy. So, the illustrations for his books can be seen as an example of his self-fashioning as a skilled physician, artist, connoisseur and collector, as well as a natural historian concerned with taxonomy.

As time went on, however, Place's aesthetic attention shifted away from portraying the naturalist's specimens. His interests always had been eclectic, shifting from horse racing to angling to the pursuit of good company; he jokingly told his friend Thomas Kirke, 'We trudge here on

at the old rate never inquiring after anything but where the best ale is.'[106] Under the influence of Hollar, Place indeed changed artistic genres, and began doing topographical mezzotints and ink drawings of ruined buildings in landscapes, such as Bamburgh Castle on the Northumberland coast, a reflection of the antiquarian bent of the York Virtuosi and of Hollar's extensive œuvre, which included a variety of antiquarian projects.[107] Furthermore, on his father's death in 1681, Place inherited £500 and an annual income of £30.[108] So it is not surprising that illustrations for Lister's scientific papers became less of a priority as Place pursued his own artistic vision.

Lister now no longer had access to good artists, but even once he had the drawings and engravings he faced the laborious task of negotiating with the printers. Printing houses were often reluctant to take on books of natural history because their detailed images were expensive to create, and their markets small.[109] In 1681, Nehemiah Grew, in his role as secretary of the Royal Society, did the legwork to print some of Lister's illustrations for *Philosophical Transactions*, recommending a particular printer, 'the best of 7 or 8 whome I tryd'. Unfortunately, the printer was not cheap, though Grew related that he promised he would print the plates 'for eight pence per hundred, with as good Ink as any, & very fair … much cheaper than I can find els where'.[110] The projected costs of etching the images and printing the edition of Goedart's *Of Insects* ultimately were so high that Lister delayed its publication. Francis Aston, another secretary of the Royal Society, subsequently wrote that 'the [Royal] Society is concerned that you seem to be at a stand in the putting out your book, and I perceive are willing to take of 50 copies if that would be an Inducement to you to goe forward, nor do I doubt but the University will take of a greater Number.'[111] Lister replied that Aston's offer was 'very obliging', and he indeed 'went forward', engaging John White of York (active 1680–1718), a 'typographer of renown', for his limited edition of '150 bokes [books] printed for the curious'.[112]

ART AND FAMILY TIES

Clearly Lister needed another solution, and he hit upon the idea of training his daughters as illustrators of his works in natural philosophy, and printing his work himself.[113] This was not necessarily unusual, as a 'fair share of

women's invisible work has been performed outside the institutions of academic and professional science'.[114] In the seventeenth century, before the creation of professional scientific laboratories, domestic spaces were often the sites of investigations. As Anita Guerrini has shown, 'philosophical kitchens' or 'ghastly kitchens' (depending on your mindset) were used for anatomical dissections in the home, and 'the tools and techniques employed in these activities overlapped considerably with those of animal and human dissection; the preparation of food and medicines occurred in tandem with experimental natural philosophy, sharing tools as well as the sensory apparatus of cooking, including tasting and smelling.'[115] The kitchen was also a site for chemical experimentation, the distillation of cordials and medicines going hand in hand with more theoretical investigations.[116] Aristocratic houses could also be botanical research laboratories. Badminton House, the aristocratic home of Mary Somerset, Duchess of Beaufort (1630–1715), provided a base for an international network of botanical exchange, where plant collections were 'processed, illustrated, catalogued, and publicised' resulting in Somerset's production of a 'significant 12-volume herbarium', the flowers illustrated by the artist Everard Kickius.[117] Kickius did the botanical illustrations for Hans Sloane's *Natural History of Jamaica*, the earliest portrayals of the island's fauna and flora; his original paintings were characterized by the use of opaque gouache white highlights to give the specimens depth.

> Defying every painterly and botanical convention, 'Kick' pictured flowers in compelling visual partnerships, right down to their dissected roots in the soil. They seemed to obey a taxonomy not of nature but of the imagination, and it is not surprising that the Duchess found in them and her plantings a new sensibility: solace in her melancholies or depressions (then called 'mopishness').[118]

Thus Lister's idea to make his home a site of scientific illustration was not out of line with early modern practice of natural philosophy. To have his daughters draw and limn shells was also perceived as in keeping with feminine sensibilities, as ladies collected these beautiful specimens, and applied arts such as limning were seen as appropriate feminine pursuits. Lister's employment of his daughters also foreshadowed the relatively common eighteenth-century practice of having women working

as assistants in the pursuit of natural philosophy; Mary Terrall for instance has analysed Hélène Dumoustier's work in natural history illustration at the Hôtel de Uzès, the private mansion of the naturalist René-Antoine Ferchault de Réaumur.[119] 'The sketches and natural studies she did for Réaumur were remunerated for the Académie des sciences in Paris from 1736 onwards, and she received upwards of 8750 livres [approx. £380] over 11 years.'[120] For his work on conchology, *Auserlesene Schnecken, Muschelen und andre Schaalthiere* (Copenhagen, 1758), Franz Michael Regenfuss employed his wife Margaretha Helena to hand-colour the exquisite plates (*see plate 7*). The edition was later printed for King Frederick V of Denmark and Norway, a rare and royal publication.[121]

At the beginning of this book we noted that Lister sent a letter to his wife Hannah in 1681 instructing her to set aside colours in shells, or watercolour cakes stored in mussel shells, for his 11-year-old and 8-year-old daughters, Susanna and Anna (Nancy). After the problems with having other artists engrave his edition of Goedart, Lister began in earnest to teach his two daughters how to draw, watercolour or limn, and likely and more notably to etch and engrave, specimens of natural history to create his *Historiæ Conchyliorum*. Most of the text was engraved directly on the plates to avoid paying typesetters, most likely to draw as much of the production process as possible into the unpaid network of the family. The daughters' instruction probably started in their home in York, and continued when his family moved to Old Palace Yard, Westminster, in 1683 to further his ambitions as a physician to the great and the good in London.

And Lister had the skills to be an excellent teacher to his daughters. Although he employed Lodge and Place to make etchings and engravings, he was a proficient artist himself, something not just evidenced by his work with Goedart's insects. Lister's abilities as an artist and skilful naturalist were well indicated in his mixed manuscript and print draft book for the first section of the *Historiæ Conchyliorum* published in 1685: *De Cochleis*, devoted to exotic land snails. The annotation on the endpapers by William Huddesford (1732–1772), the Ashmolean Museum keeper, state: 'This book belonged to Dr M. Lister, it was probably, a Pocket book, in use, during the compilation of his Book of Shells', and 'in this Book was found the Picture, which is supposed to be the Portrait of Anna or Susan Lister, Daughters of Dr. L. who drew the Shells for the Synopsis.'[122]

Although unfortunately there is no portrait, there are other illustrations: the first page shows Lister's annotated drawing of a dead 'Anadavad' bird (red munia, *Amandava amandava*), 'said to be brought from the East Indies', with his detailed empirical description of its size and coloration 'like that of a Robbing red-breast', and an annotation that the species was in Francis Willughby's *Ornithology*, 1678.[123] Lister's illustration of the 'Anadavad' or strawberry finch (*see plate* 17), native to Pakistan, India, Nepal and Bangladesh, carefully elucidated its finch-like beak and lark-like claws that made it a distinctive species, its uniquely spotted plumage rendered beautifully in pencil shading. Lister's keen understanding of surface features necessary for ornithological classification was not surprising, because he had worked with Ray to complete Willughby's posthumous work and contributed bird species to it. He therefore had extensive interests in avians; for instance, correspondence with Ray in 1670 shows that Lister provided a definitive identification of 'heath throstles' (ring ouzels) that he spotted in Carleton-in-Craven, Yorkshire. Ray also provided in the preface to *Ornithology* 'two or three Observations communicated by Mr. Martin Lister of York, my honoured Friend', which included feeding habits of buntings and robins, and an experiment in which Lister 'subtracted daily' a swallow's egg, spurring her to lay 'nineteen successively'.

This draft sketchbook also contained three other drawings that would appear as engravings for two of Lister's papers for *Philosophical Transactions*.

fig. 23a Drawing of the Shields Altar donated by Martin Lister to the Ashmolean Museum.

IS MAR
B PROSALV
EM RE
ANTONINI
AVG IM

LV B·NSM
OBREDITV

Fig.3.

The first two illustrations were sketches by William Lodge of 'trochaitae et entrochi', or crinoids, done for a paper Lister authored in 1673.[124] The third, however, was produced for Lister's paper about a Roman altar that he wrote in 1683, long after he had stopped using Lodge or Place as draughtsmen (*fig.* 23). This indicates that Lister himself may have been the artist, or perhaps it was a joint effort with his elder daughter. The sketch of a Roman altar has the following inscription:

fig. 23b Engraving of the altar in *Philosophical Transactions* (1683).

Illustri admodum atque Ornatissimo Viro D.D. IOHANNI HOSKINS Baronetto, nec non S.R Lond. Præsidi dignissimo hoc Altare, nuper repertum, propè ab ostio Tinæ et australi ripa ejusdem, juxta SHEILDS, oppidulum in Episcopatu Dunelmensi, ad summam rei fidem et elegantiam æri incisum D.D. M. LISTER Excu-Eboraci 1683

Dr Lister presented this altar as a gift to the exceedingly famous and most accomplished John Hoskins Baronet, Doctor of Divinity and most worthy President of the Royal Society. It was lately discovered near the mouth of the Tyne, on its southern bank, next to Shields, a little town in the diocese of Durham. It [the illustration of the altar] was engraved in copper with the greatest attention to accuracy and elegance. Printed in York 1682

Although the engraving of the altar was donated to the Royal Society, Lister donated the altar itself to the fledgling Ashmolean Museum, where, 'together with another ancient Roman one', it was 'speedily ... set up, together with some others of the Worshipful Elias Ashmole Esquire, in the Court before the Musæum by Him lately furnished'.[125]

The altar was part of a long series of donations. The first indication we have that Lister was giving the Museum specimens from his own

cabinet of antiquities and natural history was in September 1682. After mentioning to Lister that he was busy 'sending the Ray-grass or plants that I promised to take care of for you here', Robert Plot, the keeper of the Museum, wrote:

> In the meantime I hope you have also taken good care about sending us the Altar stone which you promised to add to that noble collection we have already, nor have you (I dare say) been unmindfull of laying aside such things as you can spare towards the better furniture of my poore Cabinet.[126]

Lister donated not only the altar, but also a large collection of Roman coins, urns and pottery, which were the subject of several articles he wrote for *Philosophical Transactions*. (The Roman altar, dedicated during the joint reign of Caracalla and Geta, following the death of Septimus Severus in York in 211, is still part of the Ashmolean Collection, now on permanent loan to the Arbeia Roman Fort Museum.[127])

Lister was ultimately awarded an honorary MD by Oxford in 1684 for his generosity, which may be why he gave the Shields altar to the Ashmolean rather than the Royal Society! It was placed on the side of the Museum's entrance. Because Lister also donated a large collection of books, his name was painted in gold alongside that of Ashmole's above the door to the library at the top of the stairs: *Libri Impressi & Manuscripti e donis Clariss. Virorum D. Elias Ashmole & Martini Lister.* Until the eighteenth century, the Ashmolean also featured a *Scrinium Listerianum*, or Lister Cabinet, housing all his treasures, in a small upper room. In his donation to the Ashmolean, Lister made the conscious decision to traverse the boundary from a private collection to a public declaration of his significant contributions to natural history, as well as antiquarianism – what we would come to know as archaeology. In creating his work on shells, he also had the same objectives in mind.

It is not surprising that there was in Lister's mind such a close relation-ship between antiquarianism and natural history; he was reflecting common opinion among virtuosi in the late seventeenth century. As Woolf has shown, a form of antiquarianism that became more prevalent by the end of the seventeenth century consisted of those scholars who considered natural history and the landscape in their analysis of ancient objects and buried artefacts.[128] Lister's colleague Robert Hooke also applied these methods

of the antiquarian to natural history, and in particular to the study of fossils and geology.[129] In a lecture to the Royal Society, Hooke remarked:

> There is no Coin can so well inform an Antiquary that there has been such or such a place subject to such a Prince, as these [fossil shells] will certify a Natural Antiquary, that such and such places have been under the Water, that there have been such kind of Animals, that there have been such and such preceding Alterations and Changes of the superficial Parts of the Earth. And methinks Providence does seem to have design'd these permanent shapes. As Monuments and Records to instruct succeeding Ages of what past in preceiding [ages].[130]

The work of a natural historian or antiquary, in Hooke's eyes, was similar to an antiquarian studying man-made objects. And, like Hooke, Lister also entertained the idea of extinction: he did not completely disregard the possibility that 'fossils are much like living things of which nature has wearied'.

After donating the Roman altar to the Ashmolean, Lister then gave his drawing and his engraving of the altar to the Royal Society for his article, noting 'I have carefully designed it in all it's sides, and have given the Plane of the Top also.'[131] When compared to the actual altar, Lister's portrayal is extremely accurate, something he also evinced in his natural history illustrations, and a skill he would impart to his daughters.

THE DRAWINGS OF THE LISTER SISTERS

Past appraisals of the Lister sisters' work have been fairly unenthusiastic. In the *Historiæ Conchyliorum*, Anna and Susanna Lister framed their illustrations with intricately engraved borders and created unabashedly feminine motifs of flowers and fruits for chapter headings. It could be argued that by placing each shell within an elaborate baroque printed 'frame' Anna and Susanna (with their father's guidance) were simply highlighting the shell's beauty as a self-referential curiosity taken out of nature. After all, for most collectors and early modern natural historians, the living mollusc's role was secondary to its visually pleasing casing. In this manner, the sisters were demonstrating an aesthetic impulse that drove an older Renaissance tradition of natural history where rare things were collected simply out of wonder or for their beauty.

As a result, some historians have characterized the *Historiæ Conchyliorum* as primarily a work of decorative arts, rather than a scientific study. As historian Barbara Stafford states,

> Although [he was] a Fellow of the Royal Society, [Lister's work] belonged to a baroque optical epistemology... Richly sculpted gilt borders and compositions calculated to accentuate randomness presented shells as picturesque sketches, not as textualizable documents of once-living marine animals ... a colossal ammonite [was] shown literally without scale and beyond comparison.[132]

The evidence seems, however, to contradict this assessment, made perhaps, as historian Emma Spary states, because 'it has become impossible to entertain a representation of nature that is both scientific and decorative ... [it is] difficult to assimilate interpretations of such works which treat the ornamental as a subject of expertise, especially learned expertise.'[133] But interpret we must and expertise there was.

Simply stated, Lister taught Susanna and Anna the craft skills and careful empiricism necessary for natural history illustration. He guided their artistic development closely, and imparted standards of accuracy necessary to identify type characteristics that would distinguish one species of mollusc shell or fossil from another. Evidence suggests that Lister may also have sat with his daughters while they drew the specimens; he certainly pointed out the features they were to record. When Lister commissioned the artist William Lodge to do illustrations for his work *Historiæ Animalium* (1678), he noted in the preface that he had taken 'particular care to distinguish genuine species ... by extremely minute but extremely faithful observations pertaining to the habits and life of these animals', and he insisted on a high level of proficiency. Lister indicated that he made sure

> that practically all the drawings of the animals were carried out in my presence. My aim was to see that the excellent artist did not merely ... express his own personal conception. To facilitate this I first of all indicated with my finger the characteristics of each species that I most particularly wished to have depicted.[134]

In the Science Museum Archives there is a sketchbook for Lister's *Historiæ Conchyliorum* featuring the work of his daughters in pencil and ink. The sketchbook seems to be prefaced by a crude map indicating the location of

fossilized shells and ammonites with symbols that correspond to the finished sketches. Some drawings are also annotated with a + sign, indicating that they passed inspection to be engraved and put in the final book.[135]

In a drawing of fossilized shark's teeth, one of his daughters corrected the curve on an incisor, the faint preliminary sketch next to the final drawing. Sometimes one of the daughters had an incomplete or damaged specimen with which to work and had to 'fill in' the missing parts. A wash drawing of a chambered nautilus shell (*Nautilus pompilius*) shows what the specimen looked like on its surface, but also has a 'cut away' projection to reveal its chambers; a dotted line indicates the rest of the specimen. It is unclear if this was a recent or fossilized shell, although several other sketches show fossilized shells impressed into rock formations, including Lister's beloved crinoids. Sometimes a fossilized shell, such as a patella, was illustrated next to a more recent specimen, as Lister was trying to determine if fossilized creatures had counterparts in current species.

Some of the later drawings of ammonites show considerable sophistica-tion in three-dimensional projection, indicating the different patterns of ammonite sutures, the featured line that makes contact with the septa or divisions and the interior of the shell. Robert Hooke's illustrations of ammonite sutures were published in his *Posthumous Works* (1705), but sutures appeared in Lister's works from 1685 to 1697[136] (*see plates* 18–21). In modern paleontological studies, it is known that from the Triassic to the Cretaceous ammonoids developed more complex sutures with many saddles and lobes. It is interesting to speculate if Lister or his daughters were noticing such trends; certainly their engravings show a progression from simpler to more complex patterns.

Martin Lister also annotated one of his daughter's wash drawings of a sea urchin, indicating needed corrections to its bottom border and shape. For instance, he wrote 'the plates between the subluxis a:b:c:d* are somewhat less at the bottom than they are in the life.' And 'a.b.c.d.e.f. in fig 2 ought to be a small matter contracted' (*see plates* 22 & 23). With such detailed guidance, no doubt pointing out the animal's features, he taught her an 'ontology of perceptual habit'.[137] In other words, whereas a novice sees general outward forms and obvious coloration, experience and training are required to discern important surface features, type characteristics and subtle differences that allow one to distinguish, to classify and to portray

the specimen accurately. This habit was reinforced by an evident pleasure of skilful perception that Susanna and Anna experienced that manifested on the page as they gained experience in training their eyes to observe and their hands to illustrate. As each book of *Historiæ* came out between 1685 and 1692, Lister's daughters' skills as illustrators grew keener, their seeing *well* intertwined with the ability to see *as*.[138]

We know that Susanna and Anna were drawing shells for their father by the time they were teenagers, because their names and intertwined initials appear on the title page of the first book of *Historiæ*, the *De Cochleis* (1685). In a presentation copy to Lister's friend Hans Sloane there was also careful handwritten elaboration of the fact that Susanna and Anna 'delineaverunt' or drew the illustrations; subsequent editions of *Historiæ* had variations of these attributions – 'Susanna et Anna Lister Figura pin[xerunt]' or 'delineaverunt'.[49]

Some of the actual shells that Lister's daughters illustrated still exist.[139] William Courten, the collector from whom Lister borrowed shells for his daughters to draw, kept an inventory of what he bought from 1689 to 1702.[140] On Courten's decease, Sloane not only wrote Courten's epitaph (and helped restore his funeral monument in Kensington when the lettering became eroded by weather), but also bought Courten's collections, including the shells.[141] Many of the shells are in the collections of the Natural History Museum in London. (Some objects of *vertu* from Courten's collection may also be in the British Museum, which Sloane founded; Sloane recorded in his Miscellanies Catalogue the possession of a 'crabtree' wooden club, or mace, with Courten's arms upon it.[142]) Sloane subsequently kept his own inventory of shells that he collected, which describes their geographic and commercial origins.[143]

When he catalogued the Sloane Shell collection, Guy Wilkins (1905–1957), the curator of molluscs at the Natural History Museum, was thus able to trace the provenance of the original specimens that were used by the Listers to create *Historiæ*. Wilkins had been a commercial artist and an enthusiastic amateur conchologist before his appointment to the Museum. His keen eye, scientific knowledge and sense of aesthetics were crucial to his identifications. There were no set rules for scientific illustration in the seventeenth century, and it was an era before the development of binomial nomenclature to classify species taxonomically. Tracing the provenance of

the shells as well as the techniques that Susanna and Lister used to portray the specimens thus assists in understanding the standards that Lister and his daughters were creating for classification and identification of species.

A means of classification was to portray the adult, juvenile and egg of the species together. One of the shells in the Natural History Museum collection that the Lister sisters drew in this manner is *Borus oblongus.* This species is a buccinum from Surinam, a large ventricose shell with a spine shorter than the body whorl and of four volutions. It is unusual in having especially large white eggs, about the size of a blackbird's (*see plate*s 24 *&* 25).[144] In his inventory, William Courten recorded in an entry for 4 July 1689 having paid £1 5s for the specimen with its eggs, noting 'they are found at the bottom of the Hedges about an inch under ground the yolke of the egg is of a kind of glewy substance.'[145] Courten was prescient in his observations, as in the early twentieth century the white of fresh snail eggs was widely used as an adhesive for mending china and glass, being superior, it is stated, to any manufactured substance.[146]

The shell is referred to again in a letter from Martin Lister to Edward Lhwyd of 8 April 1690. Lister wrote: 'The governour of *Syrinam* [Surinam] presented Mr Charleton the other day with a land snail not bigger than a hens egg. yet it layes eggs with *hard* shells as bigg a sparrows egg full; & the yong ones that are hatched of them, are as large again as the egg that holds them. The egg is finelie strieated length wayes.'[147] The puzzle of the size of the egg continued to be a source of discussion, as Lhwyd in turn reported to the naturalist John Ray: 'Dr Lister acquaints me that Mr. Charlton has lately received a land-snail from Surinam, not bigger than a hen's egg, which yet lays eggs as big as those of a sparrow; and the snails that are hatched of them are, he says, twice as large as the eggs.'[148] Ray considered the specimen 'very remarkable. But how the young Snayl hatched of the egges sould be so big of the eggs, I understand not.'[149]

The shell's illustration in Lister's *Historiæ* also features a pronounced lip in the operculum, a variable trait in this species, perhaps indicating sexual maturity. The accompanying fragile eggs and young snail drawn by Lister's daughters also are, not surprisingly, missing in the Natural History Museum collection, perhaps already destroyed when Sloane bought Courten's collection. (Sloane recorded his purchase in his inventory as number 1895: 'Buccinum admodum crassum ingens læviter purpurascens

a Surinam vivarum' [a slightly purple, thick and very large buccinum from Surinam], noting its placement in table 23 in Lister's *Historiæ*.[150]) 'Lister's figure of the young shell is a little larger than the egg figured on the same plate, and it is quite possible that some of the eggs sent to Courten hatched out, and increased the size of their shells in transit.'[151] Lister also recorded that he received another specimen of the same type, *idem cum proxime*, as the buccinum with the egg, illustrating it in the next table in *Historiæ*. One of his draft notebooks for *Historiæ* reveals this copy of the specimen was also borrowed from Courten's museum. Lister subsequently gave his daughters' engraving of Courten's shells to him in thanks; Courten recorded in his inventory in April 1690 '1 Sheet of the ovum Testaceum a Surinam'.[152]

In this specimen's itinerary we also a slight discrepancy in how Courten procured the shell; Lister was given the impression it was a gift from the governor of Surinam, when the reality was that it was a purely commercial transaction. A gift would have been more prestigious, so it is possible Courten misled Lister, or Lister misunderstood, about the provenance of the specimen. As we have seen, much of Courten's life was overshadowed by financial problems, and he spent lavishly upon his collection, nearly £8,000. It is interesting to speculate whether Courten wished to hide the fact he was still spending on his collection whilst in a precarious financial position.

Lister and his daughters also borrowed other specimens from Hans Sloane's collection that did not have a Courten provenance, such as *Patella granularis* from the genus *Patella*, the true limpet. Sloane's manuscript inventory of his shells in the Natural History Museum collection indicated that the shell was originally 'From Guinea by Mr Staphorst would have asperities' (unevenness of surface or roughness).[153] The *Patella* is indeed quite ridged. 'Staphorst' was possibly Nicholas Staphorst, who was the Society of Apothecaries' fourth Chemical Operator and author of *Officina Chymica Londinensis* (1685). Sloane lodged with Staphorst in Walter Lane, London, while he studied chemistry at the Apothecaries Hall, and Staphorst was probably his instructor and housemate.[154] It is also possible that 'Mr Staphorst' was Nicholas's brother, Barthold Staphorst, a merchant of Rotterdam. In a letter to Sloane, Pieter Hotton (Petrus Houttuyn, 1648–1709), the Professor of Botany and Medicine at Leiden University,

advised Sloane that Nicholaus Staphorst could get books or specimens through his brother Barthold.[155]

When Susanna and Anna Lister illustrated the *Patella*, they portrayed it in a 1:1 scale for ready identification. They laid the shell flat on the page, tracing around its periphery to portray its margins accurately in the final illustration (*see plates* 26 & 27). It is thus possible to place the shell down on the drawing and get a perfect match. We also see the same 1:1 technique utilized in the Listers' portrayal of a Natural History Museum specimen, the scallop shell *Chlamys squamosa* (formerly *Ostrea squamosa* Gmelin, 1791). This shell is the lectotype, a biological specimen selected to serve as a definitive 'type' example of a species, as Lister's *Historiæ* is the earliest record of an identified specimen.[156] Lister describes it in marginal notes in the Linnean Library's draft copy of *Historiæ* as the 'toothless under shell of a Scallop with a flat rib; it is smooth and curiously marbled with a white and dark hair colour'. Anna Lister portrayed the markings on the surface of the shell absolutely accurately, paying special attention to the number of ribs, and equality or inequality of the valves and ears of the shells, which are the type characteristics for dividing the species *Pecten* into groups.[157]

The Lister sisters also used tricks of artists' perspective to bring out type characteristics. *Melo ætheopica* has a distinctive *umbilicus*, the origin from which the whorls of the shell grew. However, looking down upon the shell hides this feature that is of great use in classification. As a result, the Lister sisters traced its outline to obtain the general shape and then portrayed it as tilted upwards to reveal the *umbilicus* (*see plate* 28). Their use of perspective construction was thus not 'strictly correct' but opportunistic, entirely in keeping with what Martin Kemp has demonstrated in his work concerning the historical uses of perspective construction. Their artistic judgement went beyond copying the shell, to featuring it as a taxonomic specimen of use in identification. In a letter of Reverend George Ashby to William Huddesford (who in the eighteenth century published another edition of Lister's *Historiæ* using the original plates), Ashby noted much the same thing. Ashby states that the copy of the *Historiæ* that St Johns College, Cambridge, had in its possession 'has many imperfect shells, which look like sketches only; but perhaps they are compleat and were intended to shew the remarkable part of the shell, as the *Hinge*'.[158]

The Lister sisters also simply exaggerated taxonomic type character-istics in their illustrations to distinguish between different specimens. *Neverita duplicata*, the shark eye, is a moon snail from the Bay of Campeche in the Gulf of Mexico; its circumference is often not completely smooth, and there can be two slightly angular protuberances, which generally can only be detected by holding the specimen (*plate* 29). These protuberances are most pronounced in the illustration of the shell, its angular margin more felt than seen, but definitely perceptible. Although in early modern natural philosophy we tend to see a Platonic and Aristotelian privileging of sight as the noblest of senses, the training, in Robert Hooke's words, 'of a sincere Hand and a faithful eye' to accomplish illustration is accomplished by observing and doing, an interplay between sight and touch.[159] Ideas of touch became increasingly visual in the early modern period, giving rise to the 'fantasy of "seeing" the sense of touch'.[160] Lister in his medical practice also performed a type of embodied empiricism; just as early modern anatomical illustrations translated the dissector's manual touch into a visual touch for the audience of anatomy books, Lister's *Historiæ Conchyliorum* did not just put his daughters' handiwork before the reader's eyes.[161] The images of the shells developed a tactile dynamic of their own; seeing became a form of touching, of holding the specimens to classify them.

THE ENGRAVINGS OF THE LISTERS

Although it is not unusual, as Woodley has noted, for 'exceptional children to draw skilfully at an early age', it seems that the daughters were not only holding and drawing the shells, but were etching them; it is likely Lister also 'encouraged his talented daughters to practice engraving'.[162] Lister had not only bequeathed to the Ashmolean Museum 'a Booke of drawings pasted of my childes' and 'few more of the Original drawings of my daughters'; in 1712 his collection of more than 1,000 copperplates for the *Historiæ* were given to the University of Oxford.[163]

How did the daughters etch and engrave? There were few seventeenth-century manuals on the subject. Although virtuoso and founding member of the Royal Society John Evelyn published his *Sculptura* concerning copperplate engraving, he did not include a translation of Abraham Bosse's *Tracté des manières de graver en taille douce sur l'airin* (1645). Evelyn reasoned

that engraver William Faithorne had already done the translation.[164] Evelyn stated: 'understanding it to be also the design of Mr *Faithorn*, who had (it seems) translated the first part of it, and is himself by Profession a *Graver* and an excellent *Artist* … I desisted from printing my *Copy*, and subjoyning it to this *discourse*.'[165] Evelyn claimed that Faithorne's status as a professional engraver and artist made him more qualified to translate Bosse's text and present it to an English-speaking audience.[166] Indeed, Faithorne's *Art of Graveing and Etching* (1662) was the dominant publication for nearly a century. In the mid-eighteenth century, natural history illustrator George Edwards claimed he 'could find little or nothing' written on the topic of engraving and etching, and so expanded on Faithorne's account about the process in an appendix to his *Natural History of Uncommon Birds* (1751).[167]

In engraving, the image is engraved or cut into the surface of a plate of soft metal, usually copper, using a burin, which usually has a square shank, sharpened diagonally at one end. By cutting lines of different depths and widths, the engraver can reproduce the shadows and tones of the artist's original work because deep lines hold more ink than surface lines and produce darker tones when printed. The composition of the plate is thus of some importance.

According to Faithorne, 'here in England you must buy your Copper ready forged from the Brasiers', and he advised 'that Copper is best which is free from flaws, and not too hard … and if it be too soft, you may some what perceiv it by its too much pliableness in bending.'[168] Too much zinc added to the copperplate resulted in a brass alloy which was more durable, but also more difficult to engrave. A plate of pure copper was easier to carve, but would have to be thick to withstand wear from repeated use in the rolling press. A technique called X-ray fluorescence was performed on two dozen of the Lister plates, revealing them to be made of 98 per cent copper, the rest composed of impurities from the copper ore rather than deliberate additions.[169] This composition permitted Lister and his daughters easier engraving and corrections, but as the plates were fairly thick, averaging 2–3 mm, they would have been expensive to produce. Lister probably especially commissioned them from the braziers, because plates such as these would be made outside the normal production process.[170] It is little wonder that Lister commented on the expense he

incurred for them, but it was evidently important for him secure the best possible materials.

Those to be taught engraving, however, usually started with learning how to etch, as the process of creating the design on the plate was easier and more forgiving. Etching is similar to engraving, as both techniques produce lines and crevices below a metal plate that will be inked and rolled through a press to transfer the design onto paper. Rather than cut into the surface with a burin, as in engraving, etching instead involves the use of acid (in the early modern period *aqua fortis*, or nitric acid) to remove the metal. A layer of what is called a ground, which is resistant to the acid, is applied to the plate; the image is drawn through the ground using a metal tool called an etching needle to expose the metal through gaps in the surface. The ground can be wax or, in the early modern period, bitumen. Then acid is applied, which etches the lines drawn through the ground, creating the lines corresponding to the desired image. The etcher thus only has to draw a design through a soft ground rather than use a burin with some force to cut into metal. Etching thus allows for more freedom and ease when drawing and is more forgiving of mistakes than engraving.

In the draft workbook for *De Cochleis* there is a signed and etched floral ornament signed by Anna Lister, with her father's editing of the calligraphic captions above (*plate* 30).[171] The eighteenth-century engraver George Vertue remarked that engraving 'requires much Labour study juvenile strength & sight, to arrive at any excellence', whereas etching could be 'mastered with less experience, great speed, and far less expense'.[172] Keynes has speculated, upon examining the final print of this work, that Anna Lister etched the ornament as it was an easier technique than engraving, so she may have begun with that before learning engraving for her father's *Historiæ*.[173]

After the plates were prepared, the next step in etching was to prepare a ground or varnish on the plate, to protect it from the action of the acid mordant. The ground contained bitumen or asphaltum (also called Jew's pitch), which was imported from Trinidad in large gourd shells 'containing, more or less, about forty Pounds' and available from English apothecaries'.[174] William Salmon's *Polygraphice* (1673) indicates that a soft varnish for etching could be made from one ounce of asphaltum, three ounces of beeswax and a few drops of mastic.[175] Edwards had a slightly

different recipe for the ground, adding rosin and common pitch to the mixture. The material was melted over the fire in a pipkin, and poured off into a basin of water, leaving the dregs behind, then when cooled rolled into a form the thickness of a thumb and cut into pieces a few inches long. The ground could be put aside or used immediately. The copperplate was then heated over a charcoal fire; the ground, contained in a thin silk bag, was passed over the plate to coat it. As Edwards states, 'take a little Wad of Cotton tied up in a thin Piece of Silk, and pass it all over your Plate, to spread your Varnish even.'[176]

It was advised to dot the ground with even spacing on the plate first, and then to spread the ground so the plate was evenly coated (*fig.* 24). The varnished side of the plate was then held over a candle and moved evenly to make it uniformly black, and then cooled. At this point the plate was ready to etch.

The design was then transferred onto the plate. A print or drawing could be rubbed on the wrong side with red chalk or ochre and laid on the plate and its outlines traced with an ivory stick with a smooth point, so as not to break through the print or raise the plate's ground. If the drawing was valuable then the red colour could be rubbed onto another piece

fig. 24 Dotting the plate with ground and heating the varnished side of the plate with a candle to prepare it for etching. William Faithorne's *The Art of Graveing and Etching* (1662).

of paper, placed on the plate, and the drawing laid over that and traced with the ivory stick.

After the transfer of the design, it was necessary to use a needle to inscribe the design into the ground and reveal the copper below. Lister wrote to Henry Gyles in 1685 asking him to 'pray get Mr. Massenger to make me 6 etching sticks as formerlie & putt good and fine needles in them, neatlie after his fashion, & send them by the Carrier', indicating that some sort of etching was being done at or near his London home.[177] Needles were typically stuck into small cedar sticks for handles, their points ground on a hone or oilstone (*fig. 25*).

A piece of soft linen rag was placed under the working hand to keep the heat and sweat off the plate, and to prevent nicking the ground with fingernails. As Faithorne indicates, 'the sweat mixing with the Varnish, wil cause

littel bubbles, when it is applied to the fire, which will become little holes in the Varnish.'[178] A midsize needle would trace over the outlines, cutting through the ground, after which a soft wet sponge would be used to wipe the plate 'to see what you have traced with your Needle more distinctly'.[179] The plate was then tilted upwards and the lesser lines were copied in with a fine pointed needle and a light hand. Generally shadows

fig. 25 Etching and engraving needles or burins. From William Faithorne's *The Art of Graveing and Etching.*

were indicated by cross-hatching and thicker strokes; an oval pointed needle would allow for a line that was varied in thickness, much as a calligraphic pen (*fig.* 26). If there were any places on the ground that were mistakenly rubbed off, a mixture of oil and grease was applied to cover them so the acid etch would not eat into the ground; the back of the plate was also oiled to serve as an acid resist.

Techniques for pouring the acid, or *aqua fortis*, onto the plate varied. Faithorne favoured an easel with a trough to catch the acid (*fig.* 27); Edwards recommended making a mixture of rosin and beeswax into a roll and putting it on the borders of the plate, building up an edge of ½ inch, and then pouring the acid in. The amount of time the acid would be on the plate was not an exact science and would depend on the desired thickness of the line, as a line exposed for a lengthier time in the acid would be deeper and broader. Edwards indicated that 'Few of my Plates have had the Aqua Fortis on them less than half an Hour on the lighter part, or more than an Hour and a half on the darker Parts.'[180] After the artist was satisfied the plate was etched sufficiently, it was rinsed to remove the acid, and then rubbed with solvent, usually oil, to remove the ground. As Lister was also a practising 'chymist', his home laboratory regularly infecting his

fig. 26 Lines of varied thickness accomplished with oval pointed needles. From William Faithorne's *The Art of Graveing and Etching.*

York neighbourhood with fumes, he would have certainly been familiar with the procedure for making *aqua fortis* for the purpose of etching.[181]

In engraving, rather than using acid, one used the needle or burin to engrave lines directly on the copperplate. In both techniques the plates were covered with ink, and then wiped clean with a rag or 'slapped' with the hand so that ink remained only in the engraved or etched grooves. Different artistic effects could be obtained by wiping various areas of the plate more vigorously or lightly. Paper was then pressed onto the plates to produce prints that appeared as a mirror image of the engraving. The paper employed can also make a difference to the final result, some printmakers in the seventeenth century experimenting by using Japanese *gampi* paper, which although thin produce superior inking and fine image resolution.[182]

Engraved lines result in a cleaner and more precise image, flow smoothly and swell before tapering to a point. Etched lines tend to look spidery and shakier, have the same width throughout their length, and have rounded ends.

In practice, both techniques could be combined, and Faithorne even advised that it was possible to make an etching look like an engraving by employing deep biting on the important lines where the 'Aqua fortis eats in full and deep'. The artist could also put pressure on the needle to cut through the ground into the plate; indeed Faithorne illustrated

How to poure y.̲ Aqua Fortis upon y.̲ Plate.

fig. 27 Easel and trough to catch the acid when etching. From William Faithorne's *The Art of Graveing and Etching.*

a plate 'showing heavy scoring in the foreground which, though etched, could pass for engraved lines'.[183]

In the *Historiæ* we see an etched figure of a nautilus shell, plate 556, signed 'Susan', which also appears in the printed book (*plate* 31), and we can see her signature scratched on the original copperplate.[184] Keynes and Wilkins had noted the final print of the shell, but in the draft copy of *De Cochleis* we also see Lister's annotation next to his daughter's work indicating the taxonomic information about the species and the shell's presence in the work of Pierre Belon (1517–1564) and Ulysse Aldrovandi (1522–1605). This annotation in the final print edition was engraved, not etched, onto the copperplate.

The artistic skills of Lister's daughters may also have been employed for the Royal Society. Keynes and Woodley have noted that by 1685 Susanna Lister was illustrating papers for *Philosophical Transactions*.[185] Their argument is based upon a signature which they attribute to her – a plainly styled and intertwined set of initials 'SL sculp' – in volume 15, no. 172, 1685 of the journal. This signature resembles the one engraved on the copy of *De Cochleis* presented to Sir Hans Sloane, also dated 1685.[186] 'SL sculp' is also below a variety of drawings in *Philosophical Transactions*: a honeycomb sent to the Royal Society by Lister's friend the geographer Monsieur Cabart de Villermont, an asbestos cloth provided by Lister's colleague Robert Plot and a hygroscope. Woodley and Keynes also mention a set of illustrations signed 'S. sculp.' for volume 15, no. 175, 1685, below several images engraved on one plate to accompany a series of articles, one of which concerned Lister's work in ornithology. And in their 2005 exhibition *Women's Work: Portraits of 12 Scientific Illustrators*, the curators of the Linda Hall Library in Kansas City, Missouri attribute to Susanna Lister other illustrations for articles in the *Philosophical Transactions*. The curators identified an article from the Royal Society's journal dated 1685 which includes engravings of Anton von Leeuwenhoek's wine salts signed 'SL sculp'.[187] Another article, Leeuwenhoek's discussion of wood histology (1683), also has the characteristic signature.

Could a young woman such as Susanna, aged 13 in 1683,[188] have had the artistic maturity to engrave plates for *Philosophical Transactions*? This type of chronological reasoning was behind Keynes's incorrect identification of the drawings and engravings of Anna Lister in Lister's *Historiæ* as being

fig. 28 Reversed signature, a beginner engraver's mistake. *Philosophical Transactions* 15, 172 (1685), between pages 1026 and 1027.

engraved by Lister's wife Hannah, whom he surmised was nicknamed 'Anna'; Woodley corrected this speculation and, from Lister's correspondence, clearly demonstrates that the artists were the two sisters.[189] We know from the draft workbook of *De Cochleis* that at least by 1685 the 15-year-old Susanna was etching, and the 13-year-old Anna was etching with her father's assistance. Lastly, the signature of 'S and L sculp' in volume 15, no. 172, 1685, of *Philosophical Transactions* is 'in reversed writing as if by an amateur hand'; an engraver of mature years would be unlikely to make such an error (*fig.* 28).[190]

A later article published by Lister in *Philosophical Transactions*, 'The Anatomy of a Scallop' (1695–97), provides clearer evidence of the sisters' work for the Royal Society.[191] This article is illustrated with a molluscan dissection from a copperplate engraving that was later used for the *Historiæ Conchyliorum*'s second edition (1692–97) (*see plates* 32–35). In the *Historiæ,*

the scallop was part of a series of depictions of molluscan anatomy done by Anna Lister. Many of her drawings of these dissections are in her sketchbook for the *Historiæ*,[192] and she signed some anatomical prints as well (*see plate*s 36 & 37). It is thus probable that Anna was the artist of the anatomy of the scallop printed in *Philosophical Transactions* (*plate 35*). In other parts of volume 19 of *Philosophical Transactions* Lister published articles that had been printed in his earlier books or that were the subject of past experiments, so it is characteristic of his behaviour that he used a copperplate for two publications.[193] Indeed, in the *Philosophical Transactions* article the plate of the scallop is accompanied by Latin text that was copied verbatim for the figure legend for the *Historiæ*.

The only change to the printed figure of the scallop in the *Historiæ* was an alteration in its title heading: from '*Philosophical Transactions* no. 229' (for the journal article) to 'Table 17' (for the *Historiæ*). On the back of the copperplate there was rubbing in the area of the title, indicating it was altered using a scraper and burnisher. The plate was also beaten out from the back with a punch or small hammer to knock out the old title and achieve a smooth surface that could be cut again – a common technique among engravers.[194] The Listers employed this technique in the *Historiæ*. As Wilkins has noted:

> Constant additions to the numerous plates contained in the various books and sections of the growing *Historiæ* made it impossible for them to be numbered consecutively with any certainty … it appears from the many erased plate numbers still to be faintly seen that this attempt was soon abandoned, and it was not until the second edition, some time after 1697, that the whole of the plates were satisfactorily numbered in sequence.[195]

Because (as mentioned above) the copperplates for *Philosophical Transactions* were surrendered to the nation in the Great War, it also is likely that this engraving may be one of the few surviving plates, if not the only one, from the early era of the Royal Society's journal.

One of these illustrations of molluscan dissections, signed 'Anna Lister delineat', shows that she was using a microscope to indicate clearly molluscan anatomy. As I have previously demonstrated in my biography of Lister, we do know without doubt that from 1694 Lister and his daughters were regularly using a microscope for their conchological illustrations.[196] In

the preface of his *Exercitatio Anatomica in qua de Cochleis* (1694), Lister notes that to aid him in the 'dissection of minute animalcules ... I am now for the first time, owing to defective vision, compelled to use a microscope, I rejoice greatly that I can by its aid again enjoy the same studies which were long denied to unassisted eyes.'[197] Though simple microscopes based on Leeuwenhoek's design, with their tiny bead-like spherical lenses, 'surpassed all others in both distinctness and magnification', magnifying 200–300 times, their use was only viable for those, as Hooke noted, 'whose eyes could well endure it'.[198] Because it had a very short focal length, the simple microscope had to be brought very close to the object it was viewing, and it provided a very constricted field of view. From 1650, pocket microscopes, 'flea glasses' and compound instruments were widely available; by the early eighteenth century many of Lister's colleagues throughout Europe used the compound instrument for observations at lower magnification simply because it was easier to employ, only turning to the simple microscope to explore the very small.[199] Because Lister used the microscope as an aid to dissection of molluscs and his poor vision prevented the use of a simple microscope, an early compound instrument in conjunction with a hand lens would have been more than sufficient for his needs. Despite the lavishly decorated image of the compound instrument in his *Micrographia*, Hooke turned to the single-lens microscope to produce his spectacularly magnified and detailed engravings of insects, including fleas and his own hair lice, to show the power of the instruments to mitigate the Baconian idols of the senses. His aim was to provide 'a *full* sensation of the Object' (stress added); he succeeded in his aim, as his flea image, as big as a cat, made ladies faint. Lister's objective was rather to demonstrate *essential* features of the molluscan external structure and internal anatomy for the purposes of classification and aesthetics.

More practically, a very powerful microscope would have reduced the accurate depth perception necessary to the creation of taxonomic illustrations. In a modern analogy, in microsurgical technique use of the lowest level of magnification necessary for manipulation is recommended. Neurophysiological studies also show a critical relationship between depth perception and visually guided hand movements.[200] These hand movements would include not only surgical manipulation but also the fine hand–eye coordination required for the use of the microscope and the

subsequent sketching, etchings and engravings by Lister and his daughters. It is important to remember that when Robert Hooke discussed the coordination of hand and eye, he was not concerned with the production of illustrations using a microscope. A novel, and often difficult, series of coordinated movements had to be mastered.[201] A lower-magnification microscope would make it easier to learn such techniques.

Susanna's younger sister Anna was certainly using a lower-magnification microscope in the early 1690s in a coordinated fashion; her notebook with original drawings for the *Historiæ Conchyliorum* include a close comparison of the shells of the species *Patellidæ* labelled *ex microscopio*, as well as a depiction of a brachiopod gill and dissected mollusc penises.[202] In the latter case, the image was transferred to copperplate, and the printed work also carried the label indicating her use of the instrument. It is possible that the sisters were some of the first women, and certainly among the youngest women, doing scientific illustrations using a microscope.[203]

The *Historiæ Conchyliorum* was also one of the first publications to recognize that the chirality of shells was important, portraying their symmetry as they appeared in nature. Although most organisms are bilaterally symmetrical, with the left and right halves as mirror images, most gastropod shells are not. As mentioned earlier, previous illustrators had often reversed the images of gastropod shells. Sometimes this was done by mistake because for the printed image of the specimen to be accurate the plate must be a mirror image of the specimen to be portrayed.[204] To save time, the illustrators would carve the shell as it appeared, which produced a reversed image when printed. But sometimes images were reversed arbitrarily to create aesthetically pleasing patterns. Rembrandt selected the most interesting angle for his only etching of a shell, a depiction of a specimen from the Indian Ocean, *Conus marmoreus*, portraying the opening at the side and the spiral at the top (*see plates* 39–41).[205] The impression in the picture, however, is reversed, as the whorl of the shell is counter-clockwise in the etching, and it is not a sinistral shell. For Rembrandt the reversal was an aesthetic choice, as he remembered to sign and date the work in mirror image on the plate.

Lister's daughter Anna was well aware of Rembrandt's tricks.[206] Her notebook contains a fresh print of Rembrandt's engraving in mirror image, but the shell was portrayed correctly when it was engraved for her father's

publication. It was also identified in the caption in the *Historiæ* as following the example of the Dutch master.[207] The image for the *Historiæ Conchyliorum* was probably drawn on the plate by means of a mirror, or on a piece of thin paper, which would be placed face down on the page and the image engraved through the paper. Lister had written his first scientific paper on rare left-handed or 'sinistral' shells that appear as mutations, mirror images unable to mate with their dextral cousins, so he would have been sensitive to such symmetries and conveyed them to his daughters. In fact, Lister's *Historiæ* seems to have been the first work to note and illustrate the existence of actual sinistrally coiled shells.[208]

After 1,000 illustrations, it was not surprising that Susanna and Anna were able to see the shells well, in an expert manner representing each one as the essence of a species or an entire genus. Even in their initial book of exotic land shells, Susanna's and Anna's keen observations meant that the varieties of *Conchæ veneris* – (i) unicoloured, (ii) black streaked, (iii) transversely waved, (iv) ringed or banded, (v) black spotted – were identified correctly instead of being assumed to be separate species.[209] Lister's daughters also noted the subtle differences between the two species of *Viviparus*, freshwater river snails – a more ventricose type with a thinner shell and more rounded whorls, which Lister reported as being in the River Cam – and a more common species with a narrower, thicker shell and more angular aperture.[210] Although Linnaeus used Lister's classification of the narrower species in his taxonomy, in 1955 taxonomists were still confused about the two species' different traits until they started afresh by going back to Lister's original publication.[211]

As the *Historiæ* progressed and went through several editions, more of the molluscs appeared along with their shells. A comparison of the 1685 edition to the posthumous 1770 edition, reprinted from the final plates Anna Lister illustrated, shows that she added images of living snails.[212] To set her illustrations in context, it was not until 1757 that Adanson's *Histoire naturelle du Sénégal* and d'Argenville's *Conchyliologie* were devoted to any study of the mollusc itself; until that point the natural historian's eyes were fixed firmly on the shell.[213] Much like Place's portrayal of the butterfly with its caterpillar, chrysalis and preferred food source in Lister's edition of Goedart, Anna's image of the living snail with its shell was also an attempt to capture the essence of a species in a single image.

In addition to the published *Historiæ*, there are in the Bodleian Library's archives several boxes of Lister ephemera that further tell us about Lister and his daughters' working practices in creating their masterpiece. Not only do these slips and scraps of paper help us visualize the process of creating an early modern text, but their provenance demonstrates the larger influence of the *Historiæ Conchyliorum* among naturalists and the legacy of the Lister family.

THREE

The legacy of the Listers

I N ADDITION to the visual evidence provided by his daughters, Lister's practices of processing and creating written information in the *Historiæ Conchyliorum* shaped his conceptions of a natural order.[1] By 1692 his work, which had been enriched by observations from a variety of collectors and naturalists, had grown to 1,067 plates of shells, slugs and molluscan anatomy. The four books are arranged and dated as follows:

BOOK I	1685	pp. 1–105	Exotic land shells and slugs
BOOK II	1686	106–60	Freshwater shells, snails [turbinates[2]] and bivalves
BOOK III	1687	161–445	Marine bivalves
APPENDIX	1688	446–523	Fossil [*lapidus*] bivalves
BOOK IV	1688	524–1025	Marine molluscs, marine snails [*Buccina*], molluscan anatomy
APPENDIX	1692	1026–54	Fossil snails [*Buccina*]
APPENDIX	1692	1055–9	Minor addition to text [mantissa] and synopses

Lister's *Historiæ Conchyliorum* is divided into books, sections and headings, which approximate to some degree the orders, families and genera that Linnaeus employed years later.[3] Despite the richness of the visual illustrations, there is no text other than sectional headings and specific descriptions engraved on the plates. Lister had intended to follow his volume of plates with anatomical descriptions of every family in the proper order, but he did not carry out his plan; he later did include

a small typeset index of some anatomical drawings of molluscs at the end of the book. In essence, Lister and his daughters had created one enormous engraved book of lavish proportions on a scale similar to other contemporaneous works of natural history, such as John Ray and Francis Willughby's lavish works of ornithology and ichthyology. As Lister's work was almost entirely engraved and privately printed, it gave him freedom to alter the book as new shells were discovered and newly classified, a freedom other natural historians did not have with their more traditionally printed works.

An examination of four boxes of ephemera directly related to the *Historiæ*'s production shows us how Lister organized his daughters' illustrations to classify species. The boxes were rediscovered by Diane Bergman, the Griffith Librarian at the Sackler Library at the University of Oxford, archival remains that were not lost in a physical sense, but were un-catalogued.[4] Although, in 1712, Lister bequeathed over 1,000 copperplates for the *Historiæ* to the University of Oxford, these boxes were not, however, donated by Lister. They instead arrived at Oxford along with a mass of his unpublished papers and correspondence through a much more circuitous route that involved the eighteenth-century keeper of the Ashmolean Museum, William Huddesford (1732–1772), who set them aside to create his own editions of Lister's work. Their survival also helps us understand the archival afterlives of these ephemera, as well as how future scholars interpreted the Listers' works.[5]

WILLIAM HUDDESFORD: SAVIOUR

Although Lister had donated some of his collection to Oxford in the form of printed books and plates, we have Huddesford to thank for the survival of the bulk of the Lister manuscript collection.[6] Huddesford, described as the only 'eighteenth-century Keeper known to be active in his office', took up his post when the 'museum was in decline, and immediately set to work to re-form the geological collections which were in disarray and to lay the foundations of new collections'; he also searched out new manuscript collections of past donors to the Ashmolean, such as those of Lister.[7] In doing so, Huddesford wished to repair the reputation of the Museum, so 'it did not appear the nasty confused heap of trifles it has been invidiously represented to be'.[8]

On 20 July 1758 Emanuel Mendes Da Costa (1717–1791), botanist, conchologist and antiquarian, wrote to Huddesford stating that 'about a year ago at a sale of a gentleman's effects, who it seems was a distant relation of Dr. Lister's, there were found put up in band-boxes, confused like waste paper, several bundles of Dr. Lister's papers, consisting ... of letters from several learned men to him... All these papers were bought by, and are now in the custody of Dr. John Fothergill.'[9] Fothergill (1712–1780), a Quaker doctor and FRS, had an interest in the manuscript collection as he studied conchology and botany in his spare hours. He subsequently wrote to Huddesford that he bought the papers, which 'had been thrown aside in the dirt as wast[e] paper', to save them from destruction in the 'pastrycooks oven'. The papers consisted of correspondence but also a 'collection of many, (not all) of the drawings of the Land Snails. They are coarsely done, but extensive.'[10] However, he thought that he would 'never have the leisure to peruse them' and wondered 'what to do with them?'[11] Fothergill thought that he 'had best give them to some public Body – either to the Universities or to the Royal Society', closing his letter to Huddesford with the query 'What dost Thee think?'[12] Huddesford quickly responded, 'You ask Dr an interested Man. I say to the University of Oxford and to the Ashmolean therein. But I will give you a reason also – The Papers consist of letters to ... Lister ... a very great Benefactor.'[13]

Fothergill readily agreed to the proposal, explaining to Huddesford that he hoped that the correspondence would impress upon its readers 'the solid virtue of learned men of the past century in contrast to this frivolous age'. Fothergill admitted that he hoped in making this 'little present to the University' he had raised himself into 'some little consequence'. Lastly, he recommended to Huddesford the creation of a new edition of Lister's *Historiæ*: 'let the plates be retouched from as many originals as can be procured. You have some shells no doubt in the Musaeum at Oxford. Procure an able engraver to compare the plates with these originals, and amend them when necessary.'[14] Huddesford took his advice, and subsequently gleefully recorded:

[O]ne large Box, near a hundred weight [50 kg]. The contents as followeth
1. 3 large Vols of letters to Lhwyd, folio
2. Several Bundles of Letters to Lister:

3. Near 40 Books in 4to [quarto] of MSS annotations on, and extracts from various Authors – Lister's hand.
4. Several Private Pocket Books in which Lister kept an account of the Fees He received in Practise.[15]

In the mid-nineteenth century these collections were transferred from the Ashmolean Museum to the Bodleian Library. Most of the papers were kept together, forming MSS. Lister. The collections of drawings of land snails that Huddesford mentioned, for instance, probably comprise MS. Lister 12, the first draft of book I of Lister's *Historiæ*.

However, the four boxes of ephemera, consisting primarily of loose papers and two stray copperplates, were separated from the bulk of MSS. Lister, disappearing into the Sackler Library until they were unearthed a few years ago. Why were the ephemera there? The Sackler Library, a principal research library at the University of Oxford which specializes in Archaeology, Art History and Classics, opened in 2001. The Library incorporates the former holdings of the Ashmolean Library, which of course had been under Huddesford's control. Huddesford indexed all the correspondence he received from Fothergill, having it bound into folio volumes, and he incorporated the already bound books and casebooks into the Ashmolean Library. It seems, however, that Huddesford may have set aside some of the miscellaneous loose papers, not only because the nature of these ephemera was more challenging to catalogue, but because their content related to a very specific interest of his: creating another edition of Lister's *Historiæ Conchyliorum*, which he accomplished in 1770.[16] Huddesford wished not only to pay homage to Lister, but to update the *Historiæ*, particularly its taxonomic classifications.

Huddesford had a long-held interest in Lister, his research a refuge from town-and-gown politics. For instance, Huddesford had engaged in a long and frustrating campaign to get Oxford's streets properly lit and cleaned, even publishing a tongue-in-cheek tract on the matter, where he revealed he had been fighting the public prejudice that did 'not know what Service the lamps were of, except to light a Pack of drunken Gownsmen home'.[17] Appropriately, Huddesford's pamphlet was published in 'Lucern' by 'Abraham Lightholder'.

However, his scholarly work was even more of a tonic; he remarked that when 'conversing with Lister and the old Nat[ural] Historians I scarce

know who is minister of state'.[18] He was so concerned with Listeriana that his friend James Granger (1723–1776) penned a fantasy in his honour. Granger imagines Venus,

> in all her Charms, just risen from the Sea, and seated in an ample shell. She was preceded by Tritons sounding their Buccinums [whelk shells] and attended by Nereids, adorned with Chains and Bracelets of Couris [cowries], intermixed with Pearls... Go, said she, with a significant, but ineffable Smile, to the nimblest Diver of all her train, and fetch me one of my own Shells. I intend it as a present to the Editor of the Synopsis Conchyliorum who is a great Lover of *natural Curiosities.*[19]

Venus then went with Huddesford to heaven where he is able to talk with the 'respectable Shade of Dr Martin Lister, who expressed the greatest Joy upon the Discovery of a large Ventletrap' (a 'staircase shell' in the family of gastropods *Epitoniidæ*).[20]

Huddesford wished to add a biography of the conchologist to his new edition of Lister's *Historiæ*. In 1769 he wrote to Granger:

> In your work you mention a Mr Gregory as your acquaintance, who has pictures, &c. of the Lister family. I could wish you would make known to him, that I am engaged in a work that will do honour to Dr Martin Lister ... having in my possession a considerable deal of his Philosophical correspondence, given us by Dr Fothergill.[21]

In return, he gave Granger's wife 'a little addition to her Collection of Fossils'. Huddesford then sent a series of questions to Lister's descendants, as well as to the president of St John's College, Cambridge, Lister's alma mater.[22] Huddesford subsequently remarked to Granger, 'I think from the Materials which I have at present ... I might be able to prefix some sort of Life to the *Conchyliorum*, and do his Worthy Ancestor some little Credit.'[23]

Although Huddesford's premature death at the age of 40 meant he never did finish Lister's biography, he did publish another edition of Lister's *Historiæ Conchyliorum* in 1770. For this work, he used the original copperplates, Lister's notes, and records of Lister's donations to the Ashmolean Museum.[24] A previous keeper of the Ashmolean, John Whiteside (bap. 1679, d.1729), requested permission from the University of Oxford to have thirty copies of Lister's 1685 edition printed from the original

copperplates, probably due to requests from scholars.[25] In his new edition, however, Huddesford did more than just reuse the plates. He provided updated indexes and transcriptions of Lister's relevant marginalia as well. With some success, Huddesford used for taxonomic reference the renowned shell collections of the Duchess of Portland and the expertise of eminent conchologist John Lightfoot (1735–1788). When writing to Huddesford, Lightfoot noted he was engaged in a painstaking and sometimes frustrating process to compare the Duchess's shell collection to Huddesford's new index for the *Historiæ* and Linneaus's new taxonomy, finding Huddesford's references 'very correct and just'.[26]

THE LISTER EPHEMERA

The boxes of Lister ephemera set aside by Huddesford further our knowledge about the *Historiæ*'s original construction and publication, which was of great interest to Huddesford. In the first three boxes were stacks of draft engravings of shells on white paper, some pinned to blue and chocolate-brown paper. The blue paper was employed for early modern scrapbooks, similar to that used for Anna Lister's sketchbook (MS. Lister 9), her sketches pasted down (*see plate* 42). There are also shell drawings on the same kind of paper in another draft workbook for Lister's *Historiæ*.[27] William Courten's inventory shows that in addition to buying Lister's *De Cochleis* and the *Historiæ* in 1689 and 1690 he also acquired 'Draughts of shells on blew paper g[iven] by Dr Lister', indicating that these drawings were in circulation among virtuosi and collectors.[28]

The pins were sewing pins made of brass so they would not rust, coated with tin, with wrapped wire heads.[29] These artefacts demonstrate the domestic sphere in which Lister's daughters created the *Historiæ*. Sewing pins were used by those who could not afford costly buttons to fasten clothes together, but also employed in elite dressing in large numbers for elaborate costumes. In 1565, Queen Elizabeth I used 10,000 pins of various sorts.[30] The ephemera show that pins were instead used for arranging specimens to classify them, and for the aesthetic arrangement of the book. Engravings were pinned to various decorative borders. The work was also printed on Lister's correspondence paper, perhaps at his home or at a nearby printing shop.[31] The engravings in the boxes of ephemera have the same watermarks as his stationery, dating them as draft images printed for

the first or second seventeenth-century editions. The decorative baroque borders around the frontispieces and shell specimens that Susanna and Anna created added an extra step in the printing process. Guy Wilkins surmises that 'borders of all sizes and designs were run off in quantity, to be over-printed with plates of figures, and varied at will'.[32] When printing the final copies, as the sheets were run through the rolling press twice, the strain on the thin paper meant the surface was sometimes cut through, and strips had to be pasted on the back of the sheets.

Lister created a huge number of copies of the *Historiæ*, as he gave the drafts to friends and fellow naturalists, inviting their opinion. These multiple variants makes the book's bibliographic history complicated. Lister's acquisition of new species of shells meant frequent rearrangement of the draft engravings as they were reclassified. He used this technique in a variety of draft notebooks, including one in the Linnean Society Library using wheat-paste glue instead of pins.[33] The Lister ephemera in the Bodleian Library also employs different numbering systems to keep track of arrangements and rearrangements, some numbers printed and pasted onto the draft engraving, or just engraved on the copperplates themselves.[34] Several prints of the same image were also made so they could be cut, pinned, pasted and rearranged to suit new taxonomic schemes (*see plate* 44).

Susanna's and Anna's illustrations were often the results of the distillation of many individual molluscs. Guy Wilkins's studies of Hans Sloane's collection of shells correlate several of these still extant specimens with engravings in Lister's *Historiæ Conchyliorum*.

When illustrating the shells, Anna and Susanna based their portrayals, when they could, on observations of several adult and juvenile specimens in Sloane's collection, as well as already extant figures and descriptions of the species in question.[35] The young women's creation of type specimens was quite different from recording one rare or wondrous representative of the natural world, as was done in the Renaissance. Their designs meant their father was able to classify molluscs in the *Historiæ Conchyliorum* according to specific criteria. This technique was parallel to that used by Robert Hooke to generate the illustrations for his famous *Micrographia*, which were made from dozens of separate observations.[36]

In his molluscan work, Lister arguably anticipated taxonomic schemes more advanced than those of Linnaeus. With molluscs, Lister and his

daughters utilized features that we would recognize as comprising a biological definition of species, of interbreeding natural populations.[37] For instance, in Lister's *History of Animals* he recognized that his large and small grey slugs, *Limax cenereus maximus* and *Limax cenereus parvus*, were distinct species, each mating with only their own kind.[38] They were not just the big and little varieties within a species type.

In their use of visual evidence, and even what we could term a 'paper technology' to create a new natural order for shells and molluscs, Lister and his daughters blurred the definitions of what constituted a written work, and what constituted a manuscript. From the early 1750s onward, Linnaeus did his work similarly by interleaving copies of his own publications, a method recommended by Renaissance scholars, and used by lawyers and historians to create revisions of their work; Linnaeus brought this method to perfection for his taxonomic publications.[39] He then later used paper slips for botanical organization, cross-referencing them with his herbarium sheets. It seems Lister may have pre-empted him in some of these techniques in interleaving, and in slip making, but in Lister's case the image of the shell rather than a Linnean *hortus siccus* was his reference point.

On one of his annotated prints of the *Historiæ*, Lister wrote in sepia ink a quotation from Cicero's *Tusculan Questions*: 'imposition of names on things is the highest part of wisdom'.[40] As he accumulated new molluscs through the Republic of Letters, his 'paper technologies' permitted him to improve his classificatory schemes. For example, Lister annotated the engravings with notes about the shells' subtleties in tone, colour and their slightly different patterning as they matured sexually, differentiating between what we would called hybrids or variants within a given specie.[41] Because shells were seen not only as biological specimens, but also as desirable works of Nature's art, for Lister the visual and textual were seamlessly interconnected.

When the fourth box of Listeriana (*see plate 45*) was opened by the author, it not only contained more draft engravings pinned to blue album paper, but also copperplates. (These have since been removed to be housed with the other Lister plates.) The engravings were of specimens 495 in his *Historiæ* (now named *Pholadomya margaritacea*, a fossil bivalve specimen belonging to naturalist John Woodward) and 156 (the freshwater bivalve

now named *Mytilus cygneus*, the figure also taken from the appendix to Lister's *Historiæ Animalium Angliae*, table 1, fig. 3). The plates were wrapped by either Lister or Huddesford in paper, and there are two copies in French and English of Huddesford's advertisement of his plan to create a new edition of the *Historiæ*. Huddesford was on the hunt for different variants of the *Historiæ*, indicating he would be greatly 'obliged to any Person who would favour him with the Use of any good Copy of his Work, which shall be carefully and punctually returned' (*fig.* 29). He was apparently successful, indicating to his friend John Loveday in 1769, 'You are to know then I lately spent in London near a month in search of copies of Listers Synopsis. My labours were crowned with success – I saw, with my own eyes, sixteen; many very good...'[42]

Huddesford had an extensive correspondence network, cultivating several contacts to help him with his edition. Reverend George Ashby

fig. 29 William Huddesford's notice to reprint Lister's *Historiæ*. Box 4 of Listeriana.

(1724–1808) of St John's College, Cambridge, allowed Huddesford to research John Woodward's letters about Lister and fossils.[43] James Granger arranged for the introduction of Huddesford to the Duchess of Portland, and she subsequently wrote that she anticipated showing Huddesford her conchological collections with great pleasure.[44] As previously mentioned, Lightfoot used this collection to confirm Huddesford's taxonomic classifications.[45] Mr Evenus Hammer, a Danish medical student and friend of Huddesford's studying in France, distributed Huddesford's advertisement to French natural philosophers such as Joseph Mary Anne Gros de Besplas, Rector of the Sorbonne (1734–1783), and Abbé Jean-Antoine Nollet (1700–1770), Director of the Académie des Sciences.[46] As a result of this assistance, Huddesford's 1770 edition was overall considered a great success, and in 1771 the kings of France and Spain received handsomely bound presentation copies, as did the elderly Carl Linnaeus the following year.[47] Lister's work and its legacy were ensured their place in the natural philosophical world.

FAMILY LEGACIES

By the last decade of the seventeenth century, Lister had achieved many of his professional goals. His medical practice was thriving, with clients from the great and good of London, such as Edward Stillingfleet, Bishop of Worcester; and the Lords and Ladies Belmont, Carbury, Kingston, Montjoy, Strickland and Thanet.[48] Lister's niece Sarah Churchill, and her husband John, Duke of Marlborough, were also listed in his casebooks, as were Lord William Brouncker, president of the Royal Society, and Richard Talbot, the Earl of Tirconnell, Lord Lieutenant of Ireland and husband of Lister's niece Frances. The Royal College of Physicians honoured him as well, electing him as a censor in 1694. Lister continued examining young candidates for election to the College well into his old age.[49] He had largely completed his *Historiæ Conchyliorum*, which was critically acclaimed.

Lister accompanied it with a work dedicated to the anatomical dissection of conches, the *Exercitatio Anatomica in qua de Cochleis* (1694), which also received a fine review in *Philosophical Transactions of the Royal Society*. The review notes his description of the hermaphroditic reproductive system of snails, and its 'exact and curious figures, designed by the Life'.[50] He had clearly kept his daughters Anna and Susanna busy for many years. In

1692 Edward Lhwyd wrote to Lister: 'I do not wonder your workw[omen] begin to be tired, you have held them so long to it.'[51]

By this time his first wife Hannah had died, passing away in the summer of 1695; she was buried in Clapham near the north wall of the chancel. The church was rebuilt in the eighteenth century and her tablet moved. Now on the south wall, it features the Lister arms with the following inscription: 'Hannah Lister, Deare Wife! Died the 1st day of August 1695, and left six children in teares for a most indulgent mother.'[52] In memory of Hannah, Lister gave to the Clapham Parish £5 per annum in perpetuity to provide:

> £2 to the minister for a commemoration sermon the Sunday following the 1st day of August, on which day she died; the other £3 for two blue cloth gowns for two old women of the said parish, and every other year the said £3 to be laid out in bread in equal portions to the poor for five Sundays, two before and three after the day of her death, the disposition thereof to be made by the minister and churchwardens of the said parish of Clapham.[53]

It appears Lister's daughters – particularly the eldest, Susanna – were expected to care for their father until his remarriage in 1698. Lister's second wife was Jane Cullen (1650–1736) from the London ward of St Mildred in the Poultry. A genealogy of her family, in Lister's handwriting among his private papers, indicates that that she was from a Flemish merchant family who came to England due to religious persecution. Jane was the sister of Lister's solicitor, Richard Cullen, who managed his finances, ensuring his sister was provided a £2,400 bond after Lister's death (about £380,000 in today's money).[54] Jane was a treasured companion to the old physician and naturalist, caring for his ills, and providing domestic comforts. Many of their letters discuss or enclose receipts for things she ordered for their house in Epsom, like flower bulbs or draperies, as well as sugar or tea.

Lister's elder daughter Susanna, finally freed from shell work and caring for her father, married Sir Gilbert Knowler (1663–1730) of Herne in Kent, to become his third wife.[55] She had one daughter, Susanna (1708–1768), who subsequently married Reverend William Bedford (1702–1783) of Bekesbourne, Canterbury in 1730.[56] Nothing more, however, is known definitively about Lister's younger daughter and illustrator Anna. Only

two of her brothers and sisters had died by 1695, so Anna was still alive when her mother's memorial tablet recorded 'six children in teares'.[57] Nevertheless, she was not mentioned in her father's will, made in 1704. This may have been because Anna had married, perhaps against her father's wishes. The parish records of St Martin-in-the-Fields in Westminster do show a marriage between Anne Lister and John Bristow in 1701, and the birth of a daughter named Elizabeth to John and Anne Bristow in 1712.[58] As Anne grew up in Lister's residence in London, the Old Palace Yard in Westminster, the location is correct. If Anne Bristow was Lister's daughter, she would have been 41 when her daughter Elizabeth was born; however, this is quite possible – Susanna Lister also became a mother quite late.

Despite the fact that Lister's daughters disappeared from history, their work did not. In a letter of 16 May 1694, John Place, the physician of the Grand Duke of Tuscany, told Lister of 'the Great Duke's singular satisfaction ... especially with your ingenious, and elaborate booke [the *Historiæ*]. I told him that the figures were the work of your daughters, which surprises him extremely.' Place then wrote, 'I believe he will present you with a parsell of his Florence wine.'[59] This analysis of the significance of the Lister sisters was similarly rewarding. These sources reveal the employment of an embodied empiricism in the determination of type characteristics of species, and the migration of knowledge of nature which occurred from one medium to another, from object to drawing to printed image. The archival sources on the *Historiæ* are also witness to the important and often hidden role of intellectual networks, women's work, archival provenance and the history and bibliography of early scientific book production.

The work of Lister and his daughters set a new standard for conchology, such that the *Historiæ* ended up in constant use by taxonomists of the seventeenth, eighteenth and nineteenth centuries. The masterwork was used (among others) by the explorer, botanist and entomologist James Petiver (1663–1718); Scottish physician and antiquarian Sir Robert Sibbald (1641–1722); Sir Hans Sloane, founder of the British Library; Belgian humanist and natural historian Carolus Langius (1670–1741); John Morton, the eighteenth-century natural historian of Northamptonshire; and Linnaeus. Even when F.W. Martini and J.H. Cheanitz published their *Conchyliorum Cabinet* between 1769 and 1795, which became the standard text in the field,

it was still seen, even as late as 1823, as crucial to compile and publish an index to Lister's *Historiæ*. The editor remarked that it was a work 'which has been so long and universally referred to by every naturalist who has published on either recent or fossil shells'.[60]

When Lister died in 1713, the poet Elkanah Settle (1648–1724) published his funeral poem, the *Threnodia Apollinaris*. This work probably refers to Apollo, but knowing Lister's œnological interests, it is a possible humorous reference to St Apollinaris of Ravenna, the patron saint of wine. Funeral poems were a reliable form of business for a jobbing writer like Settle, his works characteristically decorated with representations of black mourning bunting and bound in gilded leather as *memento mori* for friends and families of the deceased. Not one to waste efforts, Settle thriftily recycled the same title for two other threnodies, paeans to the memory of Joseph Addison (1719) and to William Cowper (1723). Lister's *Threnodia* also featured an oft-used quote from Juvenal: 'Mors sola fatetur quantula sint hominum corpuscula' or 'Death alone proclaims the true dimensions of our puny frames'. Though most of Settle's poem praised Lister's 'most darling study, MEDICINE', and his career as a royal physician to Queen Anne, he also wrote of his studies in natural history:

> when, lo, his *Pen* ev'n NEPTUNE's Depths t'explore,
> Pourtraid the very *Shells* that spangle on the Shore.
> See next the Tour he made through *Earth* and *Air* ...
> In quest of NATURE's *Works*, a Chace so fair,
> Down to her poorest *Reptile Wanderer.*[61]

More laconically (and humorously), another contemporary of Lister's wrote: 'Age called at length his active mind to rest, Safe from the tart lampoon and stinging jest.'[62] Lister would no more face being ridiculed for his study of slugs, snails and molluscs, and their 'humble Nests', but was now a lamented hero for creatures great and small. His contemporaries acknowledged him to be pre-eminent both in his knowledge of natural history and in his practice of medicine, recognition that lasted for more than a century after his death.[63] It seemed somehow appropriate that, in light of his twin interests, his name was given to *Listera ovata*, an entire genus of orchids known as twayblades, the flowers all prominently forked or two-lobed (*fig.* 30). Of course, several molluscs were named after him

fig. 30 *Neottia ovata*, or the common twayblade orchid was, for 200 years, named after Lister as *Listera ovata*. This sketch was done in 1850 by Joseph Dalton Hooker (1817–1911), president of the Royal Society and director of the Royal Botanical Gardens at Kew, for his paper 'On the Function and Structures of the Rostellum of *Lister ovata*' in *Philosophical Transactions* (1854).

as well, among them a tiny exquisitely coiled land snail inhabiting the Philippines, *Obba listeri listeri*. Considering the significant – and yet, until this point, hidden – contributions that Susanna and Anna Lister made to the study, perhaps we should amend this taxonomical name to *Obba filiarum listeri*. It would seem only just.

Notes

A NOTE ON DATES

Although we now use the Gregorian calendar, until 1752 England relied on the Julian calendar, in which a new year started on 25 March. For dates between 1 January and 24 March it is customary to used combined Julian/Gregorian date forms (e.g. 1 January 1674/5, the equivalent in the modern Gregorian calendar to 1 January 1675).

INTRODUCTION

1. Oxford, Bodleian Library, MS. Lister 4, f. 78.
2. Kim Sloan, 'A Noble Art': Amateur Artists and Drawing Masters, c.1600–1800, British Museum Press, London, 2000, pp. 23, 42.
3. Timea Tallian, 'John White's Materials and Techniques', in Kim Sloan (ed.), European Visions: American Voices, British Museum Press, London, 2009, p. 72; see also R.D. Harley, Artists' Pigments c.1600–1835: A Study in English Documentary Sources, Archetype Publications, London, 2001; R.K.R. Thornton and T.G.S. Cain (eds), A Treatise Concerning the Arte of Limning by Nicholas Hilliard together with a 'A more compendious Discourse Concerning ye Art of Limning', Manchester University Press, Manchester, 1992; Anna Marie Roos, 'The Sixteenth-Century Portrait Miniatures of Nicholas Hilliard: The Interconnections of Media', Master of Humanities thesis, University of Colorado, 1991.
4. Edward Norgate, Miniatura, or the Art of Limning (1627–8), Clarendon Press, Oxford, 1919, p. 10.
5. L.W. Dillwyn, Preface to An Index to the Historiæ Conchyliorum of Lister, Clarendon Press, Oxford, 1823, p. 221.
6. See Guy L. Wilkins, A Catalogue and Historical Account of the Sloane Shell Collection, British Museum, London, 1953.
7. Oxford, Bodleian Library, MS. Lister 3, f. 228. A full transcription of this letter can be found in Anna Marie Roos, The Correspondence of Dr. Martin Lister (1639–1712), Volume 1: 1662–1677, Brill, Leiden, 2015, p. 700.

8. Townes's promise of his gifts of the booby and jimson weed seeds are in a letter he sent to Lister of August 1674: Roos, *The Correspondence of Dr. Martin Lister*, vol. 1, pp. 713–15. Townes's snail shells were sent in a letter of 26 March 1675, which can be found transcribed in ibid., pp. 780–84.

9. Oxford, Bodleian Library, MS. Lister 36, ff. 72–73.

10. See for instance Samuel Dale's letter to Lister in London, British Library, MS. Stowe 747, f. 24.

11. The author has calendared Lister's correspondence and is currently editing it for publication. See Roos, *The Correspondence of Dr. Martin Lister*, vol. 1.

12. See Florike Egmond, *Eye for Detail: Images of Plants and Animals in Art and Science, 1500–1630*, University of Chicago Press, Chicago, 2017, for a discussion of the evolution of such techniques.

13. Adrian Johns, *The Nature of the Book: Print and Knowledge in the Making*, University of Chicago Press, Chicago, 1998, p. 47.

14. Unwin in fact analyses how the artists Lister used for earlier works in natural history, such as William Lodge and Francis Place, often produced illustrations that were not accurate or were incomplete. See Robert Unwin, 'A Provincial Man of Science at Work: Martin Lister, F.R.S., and His Illustrators, 1670–1683', *Notes and Records of the Royal Society of London* 49, 1995, pp. 209–30.

15. See, for instance, Steven Shapin and Simon Schaffer, *Leviathan and the Air Pump: Hobbes, Boyle and the Experimental Life*, Princeton University Press, Princeton NJ, 1985.

16. Johns, *The Nature of the Book*, p. 475.

17. Martin Lister, *A Journey to Paris in the Year 1698*, ed. Raymond Phineus Stearns, University of Illinois Press, Urbana, 1967, p. 107.

18. The watermark is extant on several pages of the 1685–88 edition of the *Historiæ Conchyliorum* (Oxford, Bodleian Library, Gough Nat. Hist. 57), as well as in several pages of Lister's letters. The watermark of three circles, Griffins, Cross and Crown and Arms of Genoa, is similar to ARMS.099.1 from the Thomas Gravell Watermark Archive, www.gravell.org. The source of the Gravell watermark was a 1666 London imprint from Washington DC, Folger Shakespeare Library, L.F. WM Coll 1.

19. Arthur MacGregor, 'William Huddesford (1732–1772): His Role in Reanimating the Ashmolean Museum, His Collections, Researches, and Support Network', *Archives of Natural History* 34, 2007, pp. 47–68.

20. Oxford, Ashmolean Museum, AMS 19, f. 1r, '*Viri Clarissimi Martinus Lister M.D. Conchæ et fossillia Quæ in Historiæ Animalium Anglicarum Describuntur* [Shells and Fossils which are described in the *Historiæ Animalium Angliæ* of that distinguished man, Martin Lister, MD]', The catalogue has been reprinted in Arthur MacGregor, Melanie Mendonça and Julie White (eds), *Manuscript Catalogues of the Early Museum Collections, 1683–1886, Part I*, Ashmolean Museum, Oxford, 2000, pp. 153–8.

21. See J.D. Woodley, 'Anne Lister, Illustrator of Martin Lister's *Historiæ Conchyliorum* (1685–1692)', *Archives of Natural History* 21, 1994, pp. 225–9. Jeremy Woodley also wrote the *Oxford DNB* entry on Lister.

22. Email communication to author, 2 November 2010.

ONE

1. Lyndal Roper, 'Witchcraft and Fantasy in Early Modern Germany', in Jonathan Barry, Marianne Hester and Gareth Robert (eds), *Witchcraft in Early Modern Europe: Studies in Culture and Belief,* Cambridge University Press, Cambridge, 1998, pp. 207–36; p. 223. This short biographical chapter about Lister is based upon my more substantial monograph on him: *Web of Nature: Martin Lister (1639–1712): The First Arachnologist,* Brill, Leiden, 2011.

2. Oxford, Bodleian Library, MS. Lister 4, f. 93r. A complete transcription of this letter can be found in Roos, *The Correspondence of Dr. Martin Lister,* vol. 1, pp. 141–2.

3. Karen Hearn, *Cornelius Johnson,* Paul Holberton Publishing, London, 2015, pp. 8, 15.

4. Mark Weiss, 'Cornelius Johnson: Robert, Lord Bruce, later 2nd Earl of Elgin and 1st Earl of Ailesbury (1626-1685)', *Tudor and Stuart Portraits: From the Collections of the English Nobility and Their Great Country Houses,* London, The Weiss Gallery, 2012, pp. 56–7; 56.

5. Hearn, *Cornelius Johnson,* p. 8.

6. Eric Chamberlain, *Catalogue of the Pepys Library at Magdalene College, Cambridge: Prints and Drawings, Portraits,* Boydell & Brewer, London 1993, vol. 3, pt 2, pp. 95–6.

7. Brian Nance, 'Lister, Sir Matthew (*bap.* 1571, *d.*1656),' *Oxford Dictionary of National Biography,* Oxford University Press, Oxford, 2004.

8. Matthew Lister's friend and colleague Turquet de Mayerne questioned van Somer about his artistic techniques, and recorded the responses in his manuscript about painting and sculpture, the 'Pictorja sculptorja & quæ subalternarum artium' (London, British Library, MS. Sloane 2052). Van Somer painted Mayerne so it is little wonder Matthew Lister also gave him his patronage. See Karen Hearn, 'Somer, Paul van (1577/8–1621/2)', *Oxford Dictionary of National Biography,* Oxford University Press, Oxford, 2004.

9. John Aubrey, *Aubrey's Brief Lives,* ed. Richard W. Barber, Boydell & Brewer, Woodbridge, 1982, pp. 140, 192.

10. Calendar of State Papers Domestic, James I, 1611–1618 (5 April 1617), Her Majesty's Stationery Office, London, 1858, p. 458. For more information about Lister's relationship with the countess, see Josephine Roberts, 'The Huntington Manuscript of Lady Mary Wroth's Play, Love's Victorie', *Huntington Library Quarterly,* vol. 46, no. 2, Spring 1983, pp. 156–74; p. 167. As Nance has indicated, Lister was indeed not married to the countess, for in his will made on 18 August 1656 he referred to 'my loving wife the Ladie Anne Lister'. See Will of Sir Matthew Lister, 18 August 1656, PROB 11/261, sig. 9, National Archives, Kew; Nance, 'Lister, Sir Matthew', *Oxford Dictionary of National Biography.*

11. Anthony Wood, *Athenæ oxonienses ... to which are added the Fasti oxonienses,* ed. Philip Bliss, 4 vols, F.C. and J. Rivington, London, 1815, vol. 2, p. 307.

12. Alison Findlay, *Playing Spaces in Early Women's Drama,* Cambridge University Press, Cambridge, 2006, p. 92. *Love's Victorie* has as its source two authorial manuscripts, one owned by Lord De L'Isle and currently housed at Penshurst Place.

13. Margaret P. Hannay, *Mary Sidney, Lady Wroth*, Ashgate, Farnham, 2013, p. 213.

14. Findlay, *Playing Spaces*, p. 92. In 2014 the play was performed again at Penshurst Place in the Great Hall by the Globe Shakespeare's Read Not Dead company.

15. Anonymous, 'The Progresse', Washington DC, Folger Shakespeare Library, MS. V.b.110, ff. 88–90; 89. http://luna.folger.edu/luna/servlet/s/814y6z (accessed 15 April 2018).

16. Glister: clyster, or enema, suppository. Pipe: literally, clyster pipe, used for administering a clyster; however, the bawdy connotation here is obvious.

17. Dr. Matthew Lister, 'Collectanea medica et chemica', London, British Library, MS. Sloane 3426, ff. 29–72b; Aubrey, *Brief Lives*, p. 140.

18. Duane H.D. Roller, *The De Magnete of William Gilbert*, Menno Hertzberger, Amsterdam, 1959.

19. M.P. Hannay, 'The Countess of Pembroke and Elizabethan Science', in Lynette Hunter and Sarah Hutton (eds), *Women, Science and Medicine, 1500–1700*, Sutton Publishing, Stroud, 1997, pp. 108–21; p. 111; Aubrey, *Brief Lives*, pp. 138–9.

20. Aubrey, *Brief Lives*, p. 139.

21. Brian Nance, 'Lister, Sir Matthew (*bap.* 1571, *d.*1656)', *Oxford Dictionary of National Biography*; T. Turquet de Mayerne, 'Recipes from Lister', London, British Library, MS. Sloane 3505, ff. 25–42, 57–67.

22. London, British Library, MS. Sloane 2052. Mayerne recorded information about pigments used by leading painters of the day, notably Rubens, Van Dyck, Mytens, Paul van Somer and Johnson. The portrait of Mayerne was sold privately, Christie's Sale 8631, Old Masters and British Painting, 11 April 2013, lot 45.

23. 'Overseers of the Parish Rate Books, St Martin-in-the-Fields, 1623, 1625, 1629, 1632, in Westminster Archive, London and Before Estate Rental Returns, 1625', in London Metropolitan Archives, as quoted in Anna Parkinson, *Nature's Alchemist: John Parkinson, Herbalist to Charles I*, Frances Lincoln, London, 2007, pp. 214–15.

24. Harold J. Cook, 'Policing the Health of London: The College of Physicians and the Early Stuart Monarchy', *Social History of Medicine*, vol. 2, no. 1, 1989, pp. 1–33; pp. 25–6, particularly note 111. Mayerne's paper was translated into English by order of the Privy Council of 30 March 1631. See *Acts of the Privy Council, June 1630 to June 1631* London, 1964, p. 274.

25. Cook, 'Policing the Health of London', p. 25.

26. Nance, 'Lister, Sir Matthew (*bap.* 1571, *d.*1656)'.

27. Mary Anne Everett Green (ed.), *Letters of Queen Henrietta Maria*, Richard Bentley, London, 1857, p. 243. Mayerne's transcription of Charles I's letter to him is in one of his case books, London, British Library, Sloane MS. 1679, f. 72.

28. Parkinson, *Nature's Alchemist*, p. 280.

29. Brian Nance, *Turquet de Mayerne as Baroque Physician: The Art of Medical Portraiture*, Wellcome, London, 2001, p. 15; also in E. Hamilton, *Henrietta Maria*, Coward, McCann & Geoghegan, New York, 1976, p. 208.

30. James Gleick, *Isaac Newton*, Harper Perennial, New York, 2004, p. 34.

31. See J.D. Twigg, 'The Parliamentary Visitation of the University of Cambridge, 1644–1645', *English Historical Review*, vol. 98, no. 287, 1983, pp. 513–28.

32. Walter Charleton, *The Immortality of the Human Soul*, William Wilson, London, 1657, p. 50.

33. 'Cartularies and registers of college lands and goods, 1250–1841', Cambridge, St John's College Archives, C7.16, f. 420. The letter of royal mandate in the archives is a copy made for the College's letter books. Elizabeth Leedham-Green, *A Short History of the University of Cambridge*, Cambridge University Press, Cambridge, 1996, p. 84.

34. Oxford, Bodleian Library, MS. Lister 3, f. 30r. A full transcription can be found in Roos, *The Correspondence of Dr. Martin Lister*, vol. 1, pp. 158–60.

35. Silas Weir Mitchell, *Some Recently Discovered Letters of William Harvey with Other Miscellanea*, College of Physicians, Philadelphia, 1912, p. 42; Robert Grovii [Robert Grove], *Carmen de Sanguinis Circuitu, A Gulielmo Harvæo Anglo, Primum Invento. Adjecta sunt, Miscellanea Quædam*, Walter Kettilby, London, 1685.

36. Oxford, Bodleian Library, MS. Lister 3, f. 93r. A full transcription can be found in Roos, *The Correspondence of Dr. Martin Lister*, vol. 1, pp. 141–2.

37. Oxford, Bodleian Library, MS. Lister 4, f. 95; Roos, *The Correspondence of Dr. Martin Lister*, vol. 1, pp. 133–5, 141–2.

38. Oxford, Bodleian Library, MS. Lister 4, f. 84r, and MS. Lister 4, f. 93r; Roos, *The Correspondence of Dr. Martin Lister*, vol. 1, pp. 146–7.

39. Oxford, Bodleian Library, MS. Lister 4, ff. 47–48; Roos, *The Correspondence of Dr. Martin Lister*, vol. 1, pp. 94–6.

40. Oxford, Bodleian Library, MS. Lister 4, f. 10r.

41. Oxford, Bodleian Library, MS. Lister 4, f. 57r; Roos, *The Correspondence of Dr. Martin Lister*, vol. 1, p. 135.

42. Robert G. Frank Jr. 'Science, Medicine, and the Universities of Early Modern England: Background and Sources, Part I', *History of Science*, vol. 11, no. 3, 1973, pp. 194–216; p. 207.

43. James L. Axtell, 'Education and Status in Stuart England: The London Physician', *History of Education Quarterly*, vol. 10, no. 2, 1970, pp. 141–59; p. 144.

44. Frank, 'Science, Medicine, and the Universities of Early Modern England', p. 208.

45. Axtell, 'Education and Status in Stuart England: The London Physician', p. 144.

46. Reid Barbour, *Sir Thomas Browne: A Life*, Oxford University Press, Oxford, 2013, p. 185.

47. Thomas Bartholin, *On Medical Travel*, trans. C.D. O'Malley, Kansas University Press, Lawrence, 1961, p. 47.

48. Sara Warneke, *Images of the Educational Traveller in Early Modern England*, Brill, Leiden, 1995, p. 49.

49. Elizabeth Williams, 'Medical Education in Eighteenth-century Montpellier', in Ole Peter Grell and Andrew Cunningham (eds), *Centres of Medical Excellence? Medical Travel and Education in Europe, 1500–1789*, Ashgate, Farnham, 2010, pp. 247–68; p. 249.

50. See Pierre Magnol, *Hortus Regius Monspeliensis sive Catalogus plantarum quæ in Horto Regio Monspeliense demonstratur*, Montpellier, 1697.

51. Charles Plumier (1646–1704) first named a flowering tree from Martinique after Magnol (*Magnolia dodecapetala*), though Linnaeus applied the name to *M*.

grandiflora. See Jean-Antoine Rioux. *Le Jardin des plantes de Montpellier: les leçons de l'histoire*, Sauramps Medical, Montpellier, 2004.

52. Cook, 'Physicians and Natural History', p. 96.
53. Williams, 'Medical Education', pp. 249–50.
54. S.A. Mellick, 'Thomas Browne: Physician 1605–1682 and the *Religio Medici*', *Australian and New Zealand Journal of Surgery*, vol. 73, no. 6, 2003, pp. 431–7; p. 432.
55. Hilde de Ridder-Symoens, 'The Mobility of Medical Students from the Fifteenth to the Eighteenth Centuries: The Institutional Context', in Peter Grell, Andrew Cunningham and Jon Arrizabalaga (eds), *Centres of Medical Excellence? Medical Travel and Education in Europe, 1500–1789*, Ashgate, Farnham, 2010, p. 64.
56. Tim McHugh, *Hospital Politics in Seventeenth-Century France: The Crown, Urban Elites and the Poor*, Ashgate, Farnham, 2007, p. 112.
57. Gillian Lewis, 'The Debt of John Ray and Martin Lister to Guillaume Rondelet of Montpellier', *Notes and Records of the Royal Society*, vol. 66, no. 4, December 2012, pp. 324–5.
58. Oxford, Bodleian Library, MS. Lister 19.
59. Peter Stallybrass, 'Benjamin Franklin: Printed Corrections and Erasable Writing', *Proceedings of the American Philosophical Society*, vol. 150, no. 4, December 2006, pp. 553–67; p. 559.
60. Richard Yeo, 'Between Memory and Paperbooks: Baconianism and Natural History in Seventeenth-century England', *History of Science* 45, March 2007, pp. 1–46; p. 8. See also Richard Yeo, *Notebooks, English Virtuosi, and Early Modern Science*, University of Chicago Press, Chicago, 2014.
61. Cook, 'Natural History', p. 254.
62. Oxford, Bodleian Library, MS. Lister 19, ff. 15–17. Lister's reading material is also noted in John Stoye, *English Travellers Abroad, 1604–1667*, Yale University Press, New Haven CT and London, 1989, p. 296. Petronius was an adviser to Nero; his work satirized those around him and their way of life.
63. Oxford, Bodleian Library, Lister I 70.
64. Simon Haslett, *Coastal Systems*, Routledge, Abingdon, 2008, p. 51; John R. Packham and Arthur J. Willis, *Ecology of Dunes, Salt Marsh and Shingle*, Chapman & Hall, London, 1997, p. 244; Christopher Tilley, *Metaphor and Material Culture*, Wiley, Oxford, 1999, p. 191.
65. Tilley, *Metaphor and Material Culture*, p. 191.
66. Oxford, Bodleian Library, MS. Lister 19, ff. 15, 19, 17.
67. Oxford, Bodleian Library, MS. Lister 3, f. 261r; Roos, *The Correspondence of Dr. Martin Lister*, vol. 1, pp. 69–71.
68. Oxford, Bodleian Library, MS. Lister 3, f. 261r; Roos, *The Correspondence of Dr. Martin Lister*, vol. 1, pp. 69–71.
69. Warneke, *Images of the Educational Traveller*, p. 181.
70. Oxford, Bodleian Library, MS. Lister 19, f. 18v.
71. Andrew Cunningham, 'The Bartholins, the Platters, and Laurentius Gryllus: The *peregrinatio medica* in the Sixteenth and Seventeenth Centuries', in Grell, Cunningham and Arrizabalanga (eds), *Centres of Medical Excellence*, p. 8.
72. Lister, *Journey to Paris*, pp. 163–6.

73. Oxford, Bodleian Library, MS. Lister 19, ff. 17–18.
74. Chris Kissack, *Bordeaux Wine Guide*, Introduction, www.thewinedoctor.com/regionalguides/bordeaux.shtml.
75. For a description of the Roman roads in southern France, see H. Benedict Coleman, 'The Romans in Southern Gaul', *American Journal of Philology*, vol. 63, no. 1, 1942, pp. 47–8. The Canal du Midi, which follows the route of the *Via Aquitania*, did not open until 1681. For Lister's itinerary, see my website 'Every Man's Companion: Or, An Useful Pocket-Book', http://lister.history.ox.ac.uk. The author and her husband traced Lister's route from Burwell, Lincolnshire, to Montpellier and back by car and caravan.
76. Oxford, Bodleian Library, MS. Lister 19, f. 18.
77. John Ray, *Observations Topographical, Moral and Physiological; Made in a Journey Through part of the Low Countries, Germany, Italy, and France*, John Martyn, London, 1673, p. 454.
78. The master apothecary Henri Verchant arranged Lister's stay with Fargeon, and helped him track down a hat lost in transit. See Oxford, Bodleian Library, MS. Lister 2, f. 173. The Protestant Verchant hosted many Englishmen; both John Locke and Hans Sloane stayed with him in Montpellier. See T.D. Whittet, 'Apothecaries and Their Lodgers: Their Part in the Development of the Sciences and Medicine', *Journal of the Royal Society of Medicine* 76, Supplement 2, 1983, pp. 1–32; pp. 5–6.
79. Elizabeth de Feydeau, *A Scented Palace: The Secret History of Marie Antoinette's Perfumer*, I.B. Tauris, London and New York, 2006, p. 9.
80. Jonathan Reinarz, *Past Scents: Historical Perspectives on Smell*, University of Illinois Press, Urbana-Champaign, 2014, p. 69.
81. Jean Fargeon, *Catalogue des Marchandises Rares, Curieuses, et Particulieres, qui se sont et debitent à Montpelier*, Jean Martel, Pezenas, 1665.
82. Ian Maclean, *Logic, Signs and Nature in the Renaissance: The Case of Learned Medicine*, Cambridge University Press, Cambridge, 2002, p. 30.
83. Jean-Louis Guez de Balzac, *Letters of Monsieur de Balzac. 1. 2. 3. and 4th Parts. Translated out of French into English. by Sir Richard Baker Knight, and Others*, John Williams and Francis Eaglesfield, London, 1654, p. 389.
84. Oxford, Bodleian Library, MS. Lister 4, f. 66r; Roos, *The Correspondence of Dr. Martin Lister*, vol. 1, pp. 91–2.
85. Oxford, Bodleian Library, MS. Lister 19, ff. 44–49, contains Lister's reading list.
86. Stephen Jay Gould, 'The Jew and the Jew Stone', *Natural History Magazine*, vol. 109, no. 5, June 2000, pp. 26–9; p. 26.
87. Charles Raven, *John Ray: Naturalist*, Cambridge University Press, Cambridge, 1986, p. 157.
88. Willis's work would later influence Lister's theories of the iatrochemistry of syphilis and smallpox, published in his *Octo exercitationes medicinalis* (1698). Lister would firmly reject Willis's view that putrified menstrual blood was a primary cause of venereal disease, attributing it instead to insect bites!
89. Stoye, *English Travellers Abroad*, p. 298.
90. Stoye lists and classifies Lister's notes on his reading in Oxford, Bodleian Library, MS. Lister 19. See ibid., pp. 298–301.

91. George A. Kennedy, 'The Contributions of Rhetoric to Literary Criticism', *The Cambridge History of Literary Criticism*, Volume 4: *The Eighteenth Century*, Cambridge University Press, Cambridge, 1997, p. 352.

92. Oxford, Bodleian Library, MS. Lister 5, f. 218. The edition was Hardouin de Beaumont de Péréfixe's *Histoire du Roi Henri le Grand*, which was published in 1662. Péréfixe was a tutor to Louis XIV.

93. Oxford, Bodleian Library, MS. Lister 5, f. 218. Lister refers to Henriette de Balzac d'Entraigues, the Marquise de Verneuil (1579–1633), who was mistress of King Henry IV and a central figure of plots and counterplots in the French courts. Madame Gabrielle was Gabrielle d'Estrées, Marquise de Monceaux and Duchesse de Beaufort en Champagne (d.1593).

94. London, Natural History Museum, MS. Ray 1, f. 18, letter 44. This is a letter from Lister to the naturalist John Ray, whom he met in Montpellier, dated 22 December 1670. It is printed in part in *The Correspondence of John Ray*, ed. Edwin Lankester, The Ray Society, London, 1848, pp. 73–4, though Lankester omitted most personal material in his edition. A complete transcription can be found in Roos, *The Correspondence of Dr. Martin Lister*, vol. 1, pp. 284–7.

95. Troels Kardel, 'Introduction', *Steno on Muscles*, American Philosophical Society, Philadelphia PA, 1994, p. 25.

96. Robert Iliffe, 'Foreign Bodies: Travel, Empire and the Early Royal Society of London', *Canadian Journal of History* 33, 1998, pp. 358–85; p. 300. The 'Adversaria' constitute Oxford, Bodleian Library, MS. Lister 5.

97. Oxford, Bodleian Library, MS. Lister 5, ff. 223v–226v.

98. Oxford, Bodleian Library, MS. Lister 5, f. 225. Martin Lister, 'An Extract of a Letter, Relating an Experiment Made for Altering the Colour of the Chyle in the Lacteal Veins', *Philosophical Transactions* 13 (143), 1683, pp. 6–9; William Musgrave, 'A Letter … to the Learned Dr. Martin Lister wherein He Endeavors to Prove That the Lacteals Frequently Convey Liquors That are Not White', *Philosophical Transactions* 14 (166), 1684, pp. 812–19.

99. Willughby's manorial home, Wollaton Hall in Nottinghamshire, is still extant and houses, appropriately enough, a fine natural-history collection. The University of Nottingham Archives have Willughby's personal papers and notes in the Middleton Collection. See also Tim Birkhead, *Virtuoso by Nature: The Scientific Worlds of Francis Willughby FRS (1635–1672)*, Brill, Leiden, 2016.

100. David Cram, Jeffrey L. Forgeng and Dorothy Johnston, *Francis Willughby's Book of Games*, Ashgate, Farnham, 2003, p. 287.

101. William Derham, *Select Remains of the Learned John Ray with His Life*, George Scott, London, 1760, p. 24.

102. Oxford, Bodleian Library, MS. Lister 5, ff. 215r–v, as quoted in Iliffe, 'Foreign Bodies', pp. 360–61.

103. Philip Skippon, 'An Account of a Journey Made Thro' Part of the Low-Countries, Germany, Italy, and France', in *A Collection of Voyages and Travels*, vol. 6, Churchill, London, 1732, p. 714. Skippon is describing the Étang de Thau, one of a string of lakes or *étangs* that stretch along the Languedoc-Roussillon coast.

104. Ibid., p. 733.

105. Londa Schiebinger, *Plants and Empire: Colonial Bioprospecting in the Atlantic World*, Harvard University Press, Cambridge MA, 2004, p. 36.

106. Martin Lister, *A Journey to Paris in the Year 1698*, Jacob Tonson, London, 1699, p. 1.

107. Skippon, 'An Account', pp. 733–5.

108. 'Mademoiselle Je ne sçaurois quitter la France, sans vous dire adieu derechef par escrit. tant vous ay-je à coeur et vos civilites me seront eternellement dans ma memoire en quel pais qui ce soit, ou je vay demeurer. Si je me retire tout a faict chez moy, j'y attenderois de vos nouvelles avec passion. maudite guerre! que tu me donnez de chagrin en m'arrachent de mes delices; ce transport est pour vous et pour ce qu'il y a de beau à Montpelier. ne soyez pas satisfé de partager mes inclinations avec une si belle ville. me voudriez vous faire l'honneur de votre souvenance de temps en temps. je verrois si il y aura moyen de vous faire tenir de mes lettres. je finis. Mademoiselle votre tres humble tres obeissant et tres passioné serviteur.' My thanks to Vivienne Larminie for the translation.

109. See www.measuringworth.com for a purchasing power calculator.

110. Oxford, Bodleian Library, MS. Lister 19, f. 7.

111. London, Natural History Museum, MS. Ray, f. 4. The letter is also partially transcribed in *The Correspondence of John Ray*, ed. Lankester, pp. 13–14, as well as in *Further Correspondence of John Ray*, ed. Robert T. Gunther, The Ray Society, London, 1928, pp. 111–12. The letter to Lister from Ray is dated 18 June 1667. A complete transcription can be found in Roos, *The Correspondence of Dr. Martin Lister*, vol. 1, pp. 96–100.

112. London, Natural History Museum, MS. Ray, Derham Abstracts. Among the Ray letters in the Natural History Museum is a lengthy list of briefly abstracted letters to and from Ray in the handwriting of William Derham, who edited Ray's *Philosophical Letters* (1718). Though these letters were available to Derham at the time, many have been lost, and his abstract inventory is now the only clue to their former existence. *Further Correspondence of John Ray*, ed. Gunther, includes these abstracts; that of this particular letter is on p. 111.

113. Oxford, Bodleian Library, MS. Lister 3, f. 19r; Roos, *The Correspondence of Dr. Martin Lister*, vol. 1, pp. 77–9.

114. Leedham-Green, *A Concise History of the University of Cambridge*, p. 74.

115. Oxford, Bodleian Library, MS. Lister 39, ff. 421r, 432r, 433v.

116. See note 112.

117. Harold J. Cook, 'The Cutting Edge of a Revolution? Medicine and Natural History near the Shores of the North Sea', in J.V. Field and Frank A.J.L. James (eds), *Renaissance and Revolution: Humanists, Scholars, Craftsmen and Natural Philosophers in Early Modern Europe*, Cambridge University Press, Cambridge, 1993, pp. 45–61; p. 48.

118. *Johannes Godartius, Of Insects: Done into English and Methodized, with the Addition of Notes*, John White for Martin Lister, York, 1682, p. 41.

119. Harold J. Cook, 'Physicians and Natural History', in Nicolas Jardine, James Secord and Emma Spary (eds), *Cultures of Natural History*, Cambridge University Press, Cambridge, 1996, pp. 91–105; pp. 100–101.

120. Oxford, Bodleian Library, MS. Lister 5, f. 24 r. Ff. 24–26 appear to comprise

an unprinted preface to Martin Lister's *Letters & divers other Mixt Discourses in Natural Philosophy*, Martin Lister, York, 1683.

121. London, Natural History Museum, MS. Ray, f. 3, letter 4. A complete transcription can be found in Roos, *The Correspondence of Dr. Martin Lister*, vol. 1, pp. 82–8. Lister is referring to the Jesuit polymath Athanasius Kircher (1602–1680) and his *Mundus Subterraneus*, published in twelve volumes between 1664 and 1678. The work is largely devoted to volcanology, but it also contains speculations on a variety of subjects, including tidal mechanisms and spontaneous generation. See Hiro Hirai, 'Kircher's Chymical Interpretation of the Creation and Spontaneous Generation', in Lawrence M. Principe (ed.), *Chymists and Chymistry: Studies in the History of Alchemy and Early Modern Chemistry*, Chemical Heritage Foundation and Science History Publications, Sagamore Beach MA, pp. 77–87.

122. London, Natural History Museum, MS. Ray, f. 9, letter 25. The original letter in Latin is missing in MS. Ray; all that remains is notes about parts of the letter not published in the Lankester edition. See *The Correspondence of John Ray*, ed. Lankester, p. 24 [*Kircheri judicium nihili facio; an verò Insecta quædam spontè oriantur nécne, determinare nequo*]. A complete transcription can be found in Roos, *The Correspondence of Dr. Martin Lister*, vol. 1, pp. 163–5.

123. Athanasius Kircher, *Athanasii Kircheri Mundus subterraneus in XII libros digestus*, Janssonio-Wæsbergiana, Amsterdam, 1678, vol. 2, bk 8.

124. Hirai, 'Kircher's Chymical Interpretation', p. 84.

125. Thomas Birch, *The History of the Royal Society of London*, 4 vols, A. Millar, London, 1756–7, vol. 1, pp. 23, 213.

126. Ibid., vol. 2, pp. 48–9.

127. Peter Anstey, 'Boyle on Seminal Principles', *Studies in the History and Philosophy of Biology and Biomedical Sciences* 33, 2002, pp. 597–630; p. 618.

128. Martin Lister, 'Some Observations Concerning the Odd Turn of Some Shell-Snailes, and the Darting of Spiders...', *Philosophical Transactions* 4,(50), 1669, pp. 1011–16.

129. A. Sturtevant, 'Inheritance of Direction of Coiling in *Limnæa*', *Science* 58, 1923, pp. 269–70. Sturtevant was the first to provide a genetic model for the incidence of sinistral snails.

130. E.C. Spary, 'Rococo Readings of the Book of Nature', in Marina Frasca-Spada and Nick Jardine (eds), *Books and the Sciences in History*, Cambridge University Press, Cambridge, 2000, pp. 255–75; p. 259.

131. London, Natural History Museum, MS. Ray 1, f. 6, letter 14; Roos, *The Correspondence of Dr. Martin Lister*, vol. 1, pp. 136–40.

132. Lister, 'Some Observations Concerning the Odd Turn of Some Shell-Snailes', p. 1012.

133. Aldrovandi's figure of the snails to which Lister refers may be found in Ulisse Aldrovandi, *De reliquis animalibus exanquibus libri quatuor, post mortem euis editi: nempe de mollibus, crustaceis, testaceis, et zoophytis*, Johannes Baptista Ballagambam, Bologna, 1606), bk 3, 'De Testaceis', p. 359. The work may be found online at the Biblioteca Digitale dell' Università di Bologna, amshistorica.unibo.it/18.

134. Oxford, Bodleian Library, MS. Lister 34, f. 7r, published in *The Correspondence of*

Henry Oldenburg, ed. A. Rupert Hall and Marie Boas Hall, 13 vols, University of Wisconsin Press, Madison, 1965–86, vol. 7, pp. 452–3, letter 1632.

135. Marie Boas Hall, *Henry Oldenburg: Shaping the Royal Society*, Oxford University Press, Oxford, 2002, pp. 131, 133.

136. London, Natural History Museum, MS. Ray, f. 8, letter 20. The original letter is missing in MS. Ray, though it is partially transcribed in *The Correspondence of John Ray*, ed. Lankester, pp. 29–30, and in *Further Correspondence of John Ray*, ed. Gunther, p. 119. It was written on 31 October 1668. 'Literas tuas et novissimas et superioris accepi, quibus Araneorum 30 à te nuper observatorum nomenclaturas inseruisti. Miror sanè quâ arte et industriâ usus, tam brevi temporis spatio, tam angustis loci limitibus tot distinctas species investigare potueris: At verò satìs mirari nequeo, unde tibi tantum otii tam alieno tempore cum curis et solicitudinibus variis perturbatus huc illuc fluctuaret animus, nec sui juris esset, ut posit cuiquam studio se totum impendere.' A complete transcription can be found in Roos, *The Correspondence of Dr. Martin Lister*, vol. 1, pp. 191–6.

137. Jeff Carr, 'The Biological Work of Martin Lister (1639–1712)', Ph.D. thesis, University of Leeds, 1974, p. 16.

138. The original from London, Natural History Museum, MSS. Ray, is lost. A partial transcription can be found in *The Correspondence of John Ray*, ed. Lankester, pp. 29–30.

139. Reverend Michael T.H. Banks, *Thorpe Arnold: The Story of Its Church and People*, privately printed, 1980. My thanks to Gillian Lane for alerting me to this source.

140. Parkinson, *Nature's Alchemist*, pp. 215, 185.

141. Anna Parkinson, 'John Parkinson: An Ancient Alchemist's Wisdom', *Daily Telegraph*, 16 November 2007.

142. Parkinson, *Nature's Alchemist*, p. 261.

143. Lisa Jardine, *Ingenious Pursuits: Building the Scientific Revolution*, Little, Brown, London, 1999, pp. 284–5. See also C.M. Foust, *Rhubarb: The Wondrous Drug*, Princeton University Press, Princeton NJ, 1992.

144. Parkinson, *Nature's Alchemist*, p. 185; Jardine, *Ingenious Pursuits*, p. 285.

145. Hannah's father Thomas was John Parkinson's nephew. See J.D. Woodley, 'Anne Lister, Illustrator of Martin Lister's *Historiæ Conchyliorum (1685–1692)*', *Archives of Natural History*, vol. 21, no. 2, 1994, pp. 225–9; p. 228 n3.

146. Oxford, Bodleian Library, MS. Lister 3, f. 23r.

147. Oxford, Bodleian Library, MS. Lister 4, f. 63r.

148. London, Natural History Museum, MS. Ray 1, f. 9, letter 25b. The letter is partially printed in *The Correspondence of John Ray*, ed. Lankester, pp. 53–4.

149. London, Natural History Museum, MS. Ray 1, f. 16, no. 38.

150. John Aston, 'The Journal of John Aston 1639', in *Six North Country Diaries*, ed. John Crawford Hodgson, Surtees Society, Edinburgh, 1910, pp. 1–34; p. 4. Aston was a 'younger son of the ancient family of Aston of Aston, in Cheshire, who was attached to the suite of Charles I on his expedition through the counties of York, Durham and Northumberland in the first Bishops' War of 1639' (ibid., p. viii). The original journal is London, British Library, Additional MS. 28566. One of the best studies of demographics is Chris Galley, 'A Never-ending Succession

of Epidemics? Mortality in Early-Modern York', *Social History of Medicine*, vol. 7, no. 1, 1994, pp. 29–57.

151. I would like to thank the anonymous reader of the book manuscript for this point.

152. Aston, 'The Journal of John Aston 1639', p. 4.

153. Trevor Brighton, 'Gyles, Henry (*bap.* 1646, *d.*1709)', *Oxford Dictionary of National Biography*, Oxford University Press, Oxford, 2004.

154. J.T. Brighton, 'Henry Gyles: Virtuoso and Glasspainter of York, 1645–1709', *York Historian* 4, 1984, pp. 1–59; p. 9.

155. Amy Butler Greenfield, *A Perfect Red: Empire, Espionage and the Quest for the Color of Desire*, Harper Perennial, New York, 2006, p. 113.

156. My thanks to Vera Keller for this point.

157. Robert T. Gunther, *Early Science in Oxford*, 14 vols, Volume 12: *Dr. Plot and the Correspondence of the Philosophical Society of Oxford*, Clarendon Press, Oxford, 1939, pp. 279–80.

158. 'Treatise in autograph of Henry Gyles, Glasspainter, colouring Mezzotinto and transferring them to glass', Cambridge, Cambridge University Library, Add. MS. 4024.

159. Simon Schaffer and Larry Stewart, 'Vigani and After: Chemical Enterprise in Cambridge 1680–1780', in Mary D. Archer and Christopher D. Haley (eds), *The 1702 Chair of Chemistry at Cambridge: Tranformation and Change*, Cambridge University Press, Cambridge, 2005, pp. 31–56; p. 35.

160. Phil Withington, 'Views from the Bridge: Revolution and Restoration in Seventeenth-Century York', *Past and Present* 170, 2001, pp. 121–51; pp. 126, 128.

161. P.M. Tillot, ed., 'The Seventeenth Century: Topography and Population', in *A History of the County of York: The City of York*, Victoria County History, London, 1961, pp. 160–65.

162. 'Articuli supradicti, quibus affiguntur nomina sequentium medicorum; scilicet, Stephani Tayleri, M.D., R. Wittye, M.D.; Pet. Vavasor, M.D., Gulielmi Ayscough, M.B, Martini Lister, A.M. , Hen. Corbett, M.D., N. Johnstoni, M.D.', London, British Library, MS. Sloane 1393, f. 17. There are also letters in MS. Sloane 1393, ff. 13–16, discussing the writing and contents of the collectively written articles.

163. Andrew Wear, 'The Popularization of Medicine in Early Modern England', in Roy Porter (ed.), *The Popularization of Medicine 1650–1850*, Routledge, London, 1992, pp. 17–41; p. 17.

164. P. Hunting, 'The Worshipful Society of Apothecaries of London', *Postgraduate Medical Journal* 80, 2004, pp. 41–4; p. 42.

165. London, British Library, MS. Sloane 1393, f. 17.

166. The description of this case is adapted from that of Stuart Anderson, *Making Medicines: A Brief History of Pharmacy and Pharmaceuticals*, Pharmaceutical Press, London, 2005, p. 66. See also Harold J. Cook, 'The Rose Case Reconsidered: Physicians, Apothecaries and the Law in Augustan England', *Journal of the History of Medicine and Allied Sciences* 45, 1990, pp. 527–55.

167. Oxford, Bodleian Library, MS. Lister 32*. Carr has also noted the fee amounts in the casebooks, and has done a good empirical analysis of them, from which my

discussion is taken. See Carr, 'The Biological Work of Martin Lister', p. 22. The equivalence in today's currency is taken from Lawrence H. Officer and Samuel H. Williamson, 'Purchasing Power of British Pounds from 1270 to Present', 2017, www.measuringworth.com.

168. Oxford, Bodleian Library, MS. Lister 32*, f. 20r. Mrs Katherine Lyster and Charles Lyster were treated on 16 January 1676 without charge.

169. Oxford, Bodleian Library, MS. Lister 32*, f. 51r.

170. Anton Sebastian (ed.), *A Dictionary of the History of Medicine*, Informa Health Care, New York, 1999, s.v. 'Fees' for Mead's fees.

171. Officer and Williamson, 'Five Ways to Compute the Relative Value of a UK Pound Amount, 1270 to Present', www.measuringworth.com.

172. Carr, 'The Biological Work of Martin Lister', p. 22.

173. A.G. Chevalier, 'The "Antimony War" – A Dispute Between Montpellier and Paris', *Ciba Symposium* 2, 1940, pp. 418–23.

174. Martin Lister, 'An Observation of Two Boys Bit by a Mad Dog', *Philosophical Transactions* 20 (242), 1698, pp. 246–8; p. 248.

175. Oxford, Bodleian Library, MS. Lister 32, ff. 31v–32v.

176. Tillot (ed.), 'The Seventeenth Century: Topography and Population', pp. 160–65.

177. London, Natural History Museum, MS. Ray 1, f. 11; Roos, *The Correspondence of Dr. Martin Lister*, vol. 1, pp. 242–7; p. 243.

178. *Johannes Goedartius, Of Insects: Done into English and Methodized, with the Addition of Notes*, John White for Martin Lister, York, 1682.

179. Lister, 'To the Reader', in ibid., p. 3.

180. Leeds, Yorkshire Archaeological Society, MS. 30, Thoresby Collection. These sketches were not the work of Lister's daughters, as the manuscript dates from the early 1670s.

181. London, British Library, MS. Stowe 745, f. 1r. This statement is also quoted by Sloan, 'A Noble Art', p. 39.

182. R.W. Unwin, 'A Provincial Man of Science at Work: Martin Lister, F.R.S., and His Illustrators, 1670–1683', *Notes and Records of the Royal Society of London* 49, 1995, pp. 209–30; p. 291.

183. Antony Griffiths, 'Lodge, William (1649–1689)', *Oxford Dictionary of National Biography*, Oxford University Press, Oxford, 2004.

184. Roos, *The Correspondence of Dr. Martin Lister*, vol. 1, p. 648. Lister related what Ray had written to the Royal Society secretary Henry Oldenburg on 7 January 1673/4.

185. Peter Anstey. 'Two Forms of Natural History', 17 January 2011, *Early Modern Experimental Philosophy*, University of Otago, https://blogs.otago.ac.nz/ emxphi/2011/01/two-forms-of-natural-history.

186. Bettina Dietz, 'Mobile Objects: The Space of Shells in Eighteenth-century France', *British Journal for the History of Science*, vol. 39, no. 3, 2006, pp. 363–82; pp. 367, 365.

187. Martin Lister, *Historiæ Animalium Angliæ Tres Tractatus*, John Martyn, London, 1678, frontispiece to fourth book ['Cochlitarum Angliæ Sive Lapidem ad Cochlearum quandam imaginem figuratorum'].

188. Lister, Preface to *Historiæ Animalium*, p. 2: 'Summam sanè diligentiam adhibui, ut veras species distinguendo, non multiplicando citra necessitatem, singulas, minutissimis licèt, fidissimis tamen Observationibus, quæ ad animalium mores vitámque; spectarent, exornarem' (I have taken particular care to distinguish genuine species and not to multiply them beyond necessity: in this way I have set out individual species by extremely minute but extremely faithful observations pertaining to the habits and life of these animals).

189. Unwin has noted the protracted delays in Lister receiving his illustrations from Lodge; see his article "A Provincial Man of Science at Work', p. 216.

190. Oxford, Bodleian Library, MS. Lister 34, f. 153; Roos, *The Correspondence of Dr. Martin Lister*, vol. 1, pp. 703–4.

191. 'Book of the Month: December 2007,' www.royalsociety.org.

192. D. Ferussac and G.P. Deshayes, *Histoire naturelle générale et particulière des mollusques terrestres et fluviatiles...*, 4 vols, J.B. Baillière, Paris, 1820–51, vol. 2, pt 1, pp. 135ff.

193. Guy L. Wilkins, *A Catalogue and Historical Account of the Sloane Shell Collections*, British Museum, London, 1953, p. 15.

194. Lister, *Historiæ Animalium*, 'Titulus IX', p. 123. Lister describes *Euconulus fulvus* as living 'in musco ad grandium arborum radices in sylvis Burwellensibus agri Lincolniensis'. Its small size made it quite difficult to find and it was rare, as Lister indicated: 'est tamen admodum rara bestiola'. W.D. Averell in his editorial preface to the *Conchologist's Exchange* also observes: 'a notable instance of unchanged habitat is furnished in the case of *Cyclostomas elegans*. This pretty shell is found to-day in Burwell Wood, Lincolnshire, England in the same locality in which it was found in 1678 by Dr. Martin Lister an enthusiastic conchologist who records the fact in his quaint work entitled "Historiæ Animalium Angliæ".' See William D. Averell, *The Conchologists' Exchange*, vol. 1, no. 8, February 1887, p. 1. Averell, however, notes that *Euconulus fulvus* has been considered extinct in this locality, contrary to my own observations.

195. *Clausiliidæ* were called by Lister 'Buccinum plullum, opacum, ore compresso, circiter denis spiris fastigiatum', or blackish, dark, with a constricted mouth, and ten high coils. The shells are extremely high-spired, with numerous whorls. See Lister, *Historiæ Animalium*, 'Titulus X', p. 123. For his descriptions of *Helix*, see *Historiæ Animalium*, 'Titulus I', p. 111, for *Helix pomatia*; and 'Titulus II', p. 113, for *Helix aspersa*. Carr, 'The Biological Work of Martin Lister', pp. 207–8, includes a species list of the molluscs in *Historiæ Animalium*.

196. Ken Arnold, *Cabinets for the Curious: Looking Back at Early English Museums*, Ashgate, Farnham, 2006, p. 213.

197. Carr, 'The Biological Work of Martin Lister', p. 281.

198. Birch, *History of the Royal Society*, vol. 4, pp. 237–8, as quoted in Jeff Carr, 'The Fossil Controversy in Seventeenth-century England', unpublished paper, p. 21. My thanks to Dr Carr for giving me access to his work.

199. Martin Lister, Preface to section 4 of *Historiæ Animalium Angliæ Tres Tractatus*, John Martyn, London, 1678, p. 1: 'Non autem ignoro, hac rerum viventium imagines multorum ingenia fatigâsse. At eorum sententiæ non utique; examinandas putavi...'

200. Ibid. 'Sed ipsas res coram Lectoribus sisto; ipsæ loquantur. Si tamen eorum
 sententiæ qui hos lapides terrigenos esse judicârunt, favere videar, non temerè
 id facio'.
201. Carr, 'The Fossil Controversy in Seventeenth-century England', p. 27.
202. Charles Lyell, *Principles of Geology, being an attempt to explain the former changes of the
 Earth's surface, by reference to causes now in operation,* John Murray, London, 1830, vol.
 1, p. 31.
203. Alan Cutler, *The Seashell on the Mountaintop: A Story of Science, Sainthood and the
 Humble Genius Who Discovered a New History of the Earth,* Cambridge University
 Press, Cambridge, 2003, p. 136.
204. *The Correspondence of Henry Oldenburg,* vol. 10, pp. 324–34; p. 334. The original
 letter was reprinted in *Philosophical Transactions* 8 (100), 1674, pp. 6181–91; London,
 Royal Society Library, MS./L5/61. Unwin, 'Lister and his Illustrators,' pp.
 209–30.

TWO

1. Rebecca Bushnell, *Green Desire: Imagining Early Modern English Gardens,* Cornell
 University Press, Ithaca NY, 2003, p. 133.
2. Oxford, Bodleian Library, MS. Lister 5, ff. 103r, 103v.
3. See Leopoldine van Hogendorp Prosperetti, 'Conchas Legere': Shells as
 Trophies of Repose in Northern European Humanism', *Art History,* vol. 29, no. 3,
 2006, pp. 387–413; p. 395.
4. F.A. Stoett,'In zyn schulp kruipen', *Nederlandsche spreekwoorden, spreekwijzen,
 uitdrukkingen en gezegden,* W.J. Thieme & Cie, Zutphen, 1923–25, note 2041, as
 quoted in Prosperetti, 'Conchas Legere', p. 392.
5. Prosperetti, 'Conchas Legere', pp. 387, 400.
6. John R. Parker and Basil Harley (eds), *Martin Lister's English Spiders 1678,* Harley
 Books, Colchester, 1992.
7. *'Viri Clarissimi Martinus Lister M.D. Conchæ et fossillia Quæ in Historiæ Animalium
 Anglicarum Describuntur* [Shells and Fossils which are described in the *Historiæ
 Animalium Angliæ* of that distinguished man, Martin Lister, MD]', Oxford,
 Ashmolean Museum, AMS 19. The catalogue is reprinted in Arthur MacGregor,
 Melanie Mendonça and Julie White (eds), *Manuscript Catalogues of the Early
 Museum Collections, 1683–1886, Part I,* Ashmolean Museum, Oxford, 2000, pp. 153–8.
8. Oxford, Ashmolean Museum, AMS 19. A copy of Lister's letter to Plot is
 appended to the beginning of the catalogue.
9. Oxford, Bodleian Library, MS. Ashmole 1816, f. 172.
10. See Anne Goldgar, *Impolite Learning: Conduct and Community in the Republic of
 Letters, 1680–1750,* Yale University Press, New Haven CT, 1995.
11. William G. Maton and Reverend Thomas Rackett, 'An Historical Account of
 Testaceological Writers', *Transactions of the Linnean Society* 7, 1803, pp. 119–224;
 p. 140.
12. Letter of Emanuel Mendes da Costa, 13 December 1757, London, Royal Society,
 Miscellaneous Manuscripts, vol. 14, item 141. See also Lister's letter to Hans
 Sloane of 12 September 1707 in which he asks for £150 for the copperplates and

shells in his collection. Sloane refused. London, British Museum, MS. Sloane 4041, ff. 23–24.

13. London, Royal Society, RS EL/L5/37 and RS Letter Book, vol. 4, pp. 358–63; printed in *The Correspondence of Henry Oldenburg*, vol. 8, pp. 212–16, letter 1778.

14. Oxford, Bodleian Library, MS. Lister 34, f. 151; Roos, *The Correspondence of Dr. Martin Lister*, vol. 1, pp. 760–64; p. 761.

15. Oxford, Bodleian Library, MS. Lister 34, f. 151; Roos, *The Correspondence of Dr. Martin Lister*, vol. 1, pp. 760–64; p. 760.

16. Oxford, Bodleian Library, MS. Lister 24, f. 149; Roos, *The Correspondence of Dr. Martin Lister*, vol. 1, pp. 751–3. This letter from Lodge to Lister is dated 5 January 1674/5.

17. Corporation of London Record Office, Ward Presentments, 242B, Farringdon Extra (1685), as quoted in Brian Cowan, *The Social Life of Coffee: The Emergence of the British Coffeehouse*, Yale University Press, New Haven CT, 2008, p. 126.

18. George Edwards, *A Natural History of Uncommon Birds*, College of Physicians, London, 1751, vol. 2, pp. 160, 209. See also Arthur MacGregor, 'Patrons and Collectors: Contributors of Zoological Subjects to the Works of George Edwards (1694–1773)', *Journal of the History of Collections*, vol. 26, no. 1, 2014, pp. 35–44.

19. Joseph Ewan and Nesta Ewan, *John Banister and His Natural History of Virginia 1678–1692*, University of Illinois Press, Urbana, 1970, p. 93.

20. S. Mitchill, 'A Discourse … Embracing a Concise and Comprehensive Account of the Writings which Illustrate the Botanical History of North and South America', *New York Historical Society Collections* 2, 1814, pp. 151–215; p. 172.

21. See London, British Library, MS. Sloane 4002, for Banister's papers. This manuscript infers Lister received the papers from the bishop at some point.

22. Michael Hunter, *Science and the Shape of Orthodoxy: Intellectual Change in Late Seventeenth-Century Britain*, Boydell & Brewer, Woodbridge, 1995, p. 210; Ewan and Ewan, *John Banister*, p. 274.

23. Ewan and Ewan, *John Banister*, p. 309. The Banister manuscripts are in London, Royal Society, RS Cl.P/15i/43.

24. Ewan and Ewan, *John Banister*, p. 317.

25. Ibid., p. 309.

26. Ray, *Further Correspondence of John Ray*, vol. 1, p. 136.

27. Ewan and Ewan, *John Banister*, p. 309.

28. Clayton E. Ray, 'Foreword', *Geology and Paleontology of the Lee Creek Mine, North Carolina*, vol. II, Smithsonian Institution Press, Washington DC, 1987, pp. 1–2.

29. London, British Library, MS. Sloane 4002, f. 31.

30. Martin Lister, *Conchyliorum Bivalvium Utirusque Aquæ Exercitatio Anatomica Tertia: Huic Accedit Dissertatio Medicinalis De Calculo Humano*, printed by the author, London, 1696, pp. 128–34.

31. Martin Lister, *Historiæ Animalium Angliæ Tres Tractatus*, John Martyn, London, 1678, p. 201.

32. London, British Library, East India Company and India Office General Ledgers, Ledger H, IOR/L/AG/1/1/9/f. 402(3). Van Mildert was also related by marriage to other merchant traders and artisans, including John Philip Elers (1664–1738), a

Dutch potter who made red ware, usually teapots, imitating oriental red potters, which the East India companies imported into England ('Elers, John Philip', *Dictionary of National Biography*, Oxford University Press, Oxford).

33. Monticello Archaeology Department, Monticello Research Report, August 2003, www.monticello.org/site/research-and-collections/cowrie-shell.

34. Jan Hogendorn and Marion Johnson, *The Shell Money of the Slave Trade*, Cambridge University Press, Cambridge, 2003, p. 46.

35. '21 January 1695', in *Journal of the House of Commons, 1693–1697*, vol. 11, reprint 1803, House of Commons, London, p. 404; Marguerite Eyer Wilbur, *The East India Company and the British Empire in the Far East*, Stanford University Press, Stanford CA, 1945, p. 138.

36. London, British Library, MS. Sloane 4050, f. 261, Daniel van Mildert, of Homerton, in Hackney: Letter to Sir H. Sloane: 1729/30.

37. James Delbourgo, 'Slavery in the Cabinet of Curiosities: Hans Sloane's Atlantic World', p. 6, www.britishmuseum.org/pdf/delbourgo%20essay.pdf. For the connection between Sloane and slavery, see also James Delbourgo's recent publication *Collecting the World: The Life and Curiosity of Hans Sloane*, Penguin, New York, 2017.

38. 'Publisher's Note', The Papers of Sir Hans Sloane, 1660–1753, Adams Matthew Publications, Marlborough, www.ampltd.co.uk/digital_guides/history_of_science_series_one_part_6/Publishers-Note.aspx.

39. Accounts of Sir Hans Sloane January 1723/4, Lincolnshire Archives, ANC 1X/D/5d. See also *Archivists' Report, Lincolnshire Archives Committee*, 13 March 1951–27 March 1952, pp. 40–41. These accounts were also pointed out by Delbourgo, in *Collecting the World*, fig. 17.

40. Evelyn D. Heathcote, *An Account of Some of the Families Bearing the Name of Heathcote*, Warren & Son, Winchester, 1899, p. 82. Sloane: Heathcote, Lincolnshire Archives, Reference 1–ANC/4/6.

41. Minutes of a meeting of the Council of the Royal Society, 30 June 1720. London, Royal Society Library, RS CMO/2/292. George Heathcote was made an FRS when Sloane was president on 9 January 1728/9, but it is unclear if he was a relation. Kaempfer's manuscripts are now London, British Library, MSS. Sloane 3060–3062.

42. Thomas Birch, *The History of the Royal Society*, vol. 4, A. Millar, London, 1756–57, pp. 327–8.

43. Carol Gibson-Wood, 'Classification and Value in a Seventeenth-Century Museum', *Journal of the History of Collections*, vol. 9, no. 1, 1997, pp. 61–77; pp. 61, 62.

44. Ibid., p. 62.

45. John Evelyn, *The Diary of John Evelyn*, ed. Austin Dobson, Cambridge University Press, Cambridge, 2015, vol. 3, pp. 212–13.

46. Oxford, Bodleian Library, MS. Ashmole 1816, f. 172.

47. London, London Metropolitan Archives, Diary of James Petiver, LMA/4521/C/02/002, f. 7v. The diary is transcribed and online as an appendix to Anna Marie Roos, '"Only meer Love to Learning": A Rediscovered Travel Diary of Naturalist and Collector James Petiver (c.1665–1718)', *Journal of the History of Collections*, 2016, doi:10/1093/jhc/fhw041.

48. London, British Library, MS. Sloane 3962, f. 85r. My thanks to Sachiko Kusukawa for alerting me to this source.

49. London, British Museum, MSS. SL 5279, Drawings of Naturalia by Guillaume Toulouze. My thanks to Sachiko Kusukawa for alerting me to this source. Elizabeth Hyde, *Cultivated Power: Flowers, Culture, and Politics in the Reign of Louis XIV*, University of Pennsylvania Press, Philadelphia, 2005, p. 128.

50. London, British Museum, MSS. SL 5277, Drawings by Nicolas Robert; Hyde, *Cultivated Power*, p. 128.

51. Alain Renaux, *Louis XIV's Botanical Engravings*, Lund Humphries, Aldershot, 2008, p. 10.

52. Gibson-Wood, 'Classification and Value', p. 64.

53. 'Notes and Observations', in Martin Lister, *Historiæ Sive Synopsis Conchyliorum Methodicæ, Editio Altera*, ed. William Huddesford, Clarendon Press, Oxford, 1770, p. 5.

54. Oxford, Bodleian Library, MS. Lister 29, f. 43r. Lister indicated he should note this reference well, showing his interest in the shell drawings.

55. According to Pennington, five of Hollar's shells were copied in the 1685 edition of the *Historiæ Conchyliorum*, including in book 4, nos 10 and 24 in section VIII; no. 39 in section X; and nos 4 and 18 in section XI. See Richard Pennington, *A Descriptive Catalogue of the Etched Works of Wenceslaus Hollar 1607–77*, Cambridge University Press, Cambridge, 2002, p. 337.

56. London, British Library, Additional MS. 21111, f. 15r. The letter was from Francis Place to George Vertue, a biographer of Hollar.

57. Richard Tyler, *Francis Place 1647–1728*, exhibition catalogue, York City Art Gallery, York, 1971, p. 8. In 1665 and 1666 Hollar etched fourteen such heads from Place's drawings; eight are extant in the Department of Prints and Drawings at the British Museum, London. See Pennington, *A Descriptive Catalogue of the Etched Works of Wenceslaus Hollar 1607–77*, nos 1630, 1633, 1634, 1635, 1636, 1637, 1638, 1639.

58. Tyler, *Francis Place*, p. 8. Sloan has noted that, although Place never apprenticed with Hollar, he did work with him 'copying plates for illustrated books'. So he was clearly influenced by Hollar's style and aesthetic interests. See Kim Sloan, '*A Noble Art*': *Amateur Artists and Drawing Masters, c.1600–1800*, British Museum Press, London, 2000, p. 33.

59. George Vertue, *A Description of the Works of the Ingenious Delineator and Engraver Wenceslaus Hollar*, William Bathoe, London, 1759, pp. 113–14. In addition to the engravings of insects that he made for Lister, Place produced a series of engravings of birds after Barlow's designs, as well as a series of copies of Hollar's engravings of raptors and water birds. See H.M. Hake, 'Some Contemporary Records Relating to Francis Place, Engraver and Draughtsman, with a Catalogue of His Engraved Work', *Walpole Society* 10, 1921–2, pp. 39–69; pp. 52–6.

60. *Amazing Rare Things: Natural History in the Age of Discovery*, The Queen's Gallery, Buckingham Palace, London, 14 March–28 September 2008, www.royalcollection.org.uk/microsites/amazingrarethings.

61. Vertue, *A Description of the Works of the Ingenious Delineator and Engraver Wenceslaus Hollar*, Class X, pp. 113–14, as quoted in Pennington, *A Descriptive Catalogue of the Etched Works of Wenceslaus Hollar 1607–77*, p. 337.

62. Tyler, *Francis Place*, p. 10.

63. London, British Library, MS. Sloane 3962, f. 188r, Papers of William Courten.

64. Raymond Stearns, 'James Petiver: Promoter of Natural Science, *c.*1663–1718', *Proceedings of the American Antiquarian Society* 62, October 1952, pp. 243–65; p. 391.

65. London, British Library, MS. Sloane 3962, f. 192r, Papers of William Courten.

66. Stearns, 'James Petiver: Promoter of Natural Science', p. 391.

67. London, British Library, MS. Sloane 3962, ff. 188r, 188v, Papers of William Courten; Stearns, 'James Petiver: Promoter of Natural Science', p. 391.

68. Oxford, Bodleian Library, MS. Ashmole 1816, f. 86. Sachiko Kusukawa has also recently noted Lister's censure: see 'William Courten's Lists of "Things Bought" from the Late Seventeenth Century', *Journal of the History of Collections*, vol. 29, no. 1, 2017, Appendix, n196.

69. London, British Library, MS. Sloane 3942, f. 188v.

70. Aberystwyth, National Library of Wales, Peniarth MS. 427, f. 86.

71. Stearns, 'James Petiver: Promoter of Natural Science', p. 392.

72. Oxford, Bodleian Library, MS. Ashmole 1816, ff. 107–108.

73. Stearns, 'James Petiver: Promoter of Natural Science', p. 392.

74. Oxford, Bodleian Library, MS. Ashmole 1829, ff. 10–11.

75. Jones did not return to England until 1758, when he was 83 years of age, having served in the interim as a chaplain to the East India Company in Fort St George (Madras). Even in India he indicated to the naturalist Richard Richardson Jr that he was busy collecting, and brought back six books of dried plants or *horti sicci*, insects, fishes, shells and antiquities; see Bodleian Library, MS. Radcliffe Trust c. 12, ff. 32, 33. Jones donated these to Richardson Jr at North Bierley Hall in Yorkshire. As MS. Radcliffe Trust c. 12, ff. 34 and 35 demonstrate, Richardson and his father were keen botanists with hothouses full of specimens; although the Hall was demolished in the 1960s, the extensive gardens have survived.

76. London, Royal Society Library, Repository Holdings, MS. Catalogue D, MS. 413, f. 123.

77. Oxford, Bodleian Library, MS. Lister 34, f. 118r.

78. The incomplete engravings may be seen in Martin Lister, 'An Extract of a Letter of Mr. Martin Lister Concerning the First Part of His Tables of Snails, Together with Some Quære's Relating to Those Insects, and the Tables Themselves Sent to the Publisher from York, March 12. 1673', *Philosophical Transactions*, 9 (105), 1674, pp. 96–9.

79. Oxford, Bodleian Library, MS. Lister 34, f. 163; *The Correspondence of Henry Oldenburg*, ed. A. Rupert Hall and Marie Boas Hall, 13 vols, University of Wisconsin Press, Madison, vol. 11, p. 5, as quoted in R.W. Unwin, 'A Provincial Man of Science at Work: Martin Lister, F.R.S., and His Illustrators, 1670–1683', *Notes and Records of the Royal Society of London* 49, 1995, pp. 209–30; p. 216.

80. Lister, 'An Extract of a Letter of Mr. Martin Lister Concerning the First Part of His Tables of Snails', p. 96.

81. Sloan, *'A Noble Art'*, p. 39.

82. Tyler, *Francis Place*, p. 10.

83. Julia Nurse, 'Place, Francis (1647–1728)', *Oxford Dictionary of National Biography* Oxford University Press, Oxford, 2004.

84. The notebook with Lister's sketches is *'The Natural Histories of Insects'* by Johannes Godartius translated into English by Martin Lister 1672, Leeds, Thoresby Manuscripts, John Bargrave Collection, Yorkshire Archaeological Society, MS. 30. In 2015 the Collection was transferred to Special Collections, University of Leeds. The author first gave notice of the discovery of this manuscript in Kirsty McHugh (ed.), *The Yorkshire Archaeological Society: A Celebration of 150 Years of Collecting*, Yorkshire Archaeological Society, Leeds, 2013, pp. 56–7.

85. Brian Ogilvie, 'Nature's Bible: Insects in Seventeenth-Century European Art and Science', *Tidsskrift for kulturforskning*, vol. 7, no. 3, 2008, pp. 5–21; p. 11.

86. Leeds, Special Collections, University of Leeds Library, Yorkshire Archaeological and Historical Society, Ralph Thoresby Manuscript Collection: Manuscript "Of Insects" by Martin Lister, YAS/MS30. We can be certain that these were not the work of Lister's daughters, because the date of the manuscript is from the early 1670s.

87. Martin Lister, 'Preface' to *Johannes Godartius, Of Insects: Done into English, and Methodized, with the Addition of Notes. The Figures Etched upon Copper, by Mr. F[rancis] P[lace]*, John White, York, 1682, f. A4v.

88. Clare Jackson, 'Kirke, Thomas (1650–1706)', *Oxford Dictionary of National Biography*, Oxford University Press, Oxford, 2004.

89. Godfrey Copley, letter to Thomas Kirke, 20 November 1697, London, Royal Society, Miscellaneous Manuscripts, vol. 14, 132.

90. London, British Library, MS. Sloane 4036, ff. 197–198.

91. Sachiko Kusukawa, 'Thomas Kirke's Copy of *Philosophical Transactions*', *Spontaneous Generations*, vol. 6, no. 1, 2012, pp. 8–14; p. 11.

92. Birch, *History of the Royal Society*, vol. 4, p. 94.

93. For a discussion of Malphigi's and Swammerdam's pioneering works, see Matthew Cobb, 'Malphigi, Swammerdam and the Colourful Silkworm: Replication and Visual Representation in Early Modern Science', *Annals of Science 59*, 2002, pp. 111–47.

94. Jeff Carr, 'The Biological Work of Martin Lister (1638–1712)', Ph.D. thesis, University of Leeds, 1974, p. 169.

95. Thomas Moufet, *Insectorum sive minorum animalium theatrum*, London, 1634, pp. 1124, 1040, as quoted in ibid., p. 169.

96. Lister, *Johannes Godartius, Of Insects*, p. 11.

97. Lister, 'Preface', ibid., p. 3.

98. For Malpighi, see Cobb, 'Malpighi, Swammerdam, and the Colourful Silkworm', p. 144.

99. Lister, *Johannes Godartius, Of Insects*, p. 7.

100. Ibid., p. 41.

101. Plate [8] of 14 illustrating Lister's translation of *Johannes Godartius, Of Insects, Done into English and Methodized, with the Addition of Notes*. The figures etched upon copper by 'Mr F. Pl. York' (1682) depict nine flies and moths, alongside their pupal and larval forms, against a blank background etching. London, British Museum, Prints and Drawings Department, Registration number Ee,2.69, Bibliographic Reference Hake 71. Location: British XVIIc Mounted Roy.

102. Lister, *Johannes Godartius, Of Insects*, p. 8.

103. Thomas Shadwell, *The Virtuoso. A Comedy, Acted at the Duke's Theatre*, T.N. for Henry Herringman, London, 1676, p. 12.

104. Martin Lister, 'Preface', *Exercitatio anatomica in qua de Cochleis, Maximè Terrestribus & Limacibus, agitur*, London, Samuel Smith & Benjamin Walford, London, 1694, p. 2. Shadwell, *The Virtuoso*, pp. 47–8. Shadwell wrote, 'I think I have found out more Phœnomena's or Appearances of Nature in Spiders, than any man breathing: Wou'd you think it? there are in England six and thirty several sorts of Spiders; there's your Hound, Grey-hound, Lurcher, Spaniel Spider.' This is a pointed reference to Lister's table of thirty-seven spiders in his *Historiæ Animalium*, John Martyn, London, 1678.

105. Oxford, Bodleian Library, MS. Ashmole 1816, f. 176r. He also expresses much the same sentiment in MS. Ashmole 1816, f. 116r.

106. 'Place to Kirke, 2 December 1693, Yorkshire Archaeological Society, Leeds', quoted in J.T. Brighton, 'Henry Gyles Virtuoso and Glasspainter of York', *York Historian* 4, 1984, p. 9.

107. For more on Hollar, see Craig Ashley Hanson, *The English Virtuoso: Art, Medicine, and Antiquarianism in the Age of Empiricism*, University of Chicago Press, Chicago, 2009, pp. 31–3; Karin Leonhard and Maria-Theresia Leuker, 'Who Commissioned Hollar's Shells?', *Simolus: Netherlands Quarterly for the History of Art*, vol. 37, no. 3/4, 2013–14, pp. 227–39; Place's ink drawing on paper 'Gateway, Bamburgh Castle 1678' is in the Tyne and Wear Museum, Newcastle-upon-Tyne, accession number TWCMS: B8033.

108. Sloane, '*A Noble Art,*' p. 33.

109. Adrian Johns, *Nature of the Book: Print and Knowledge in the Making*, University of Chicago Press, Chicago, 1998, p. 447.

110. Oxford, Bodleian Library, MS. Lister 35, f. 50r.

111. Oxford, Bodleian Library, MS. Lister 35, f. 49r.

112. 'Preface', *Johannes Godartius, Of Insects*. For information about White, see Geoffrey Keynes, *Dr Martin Lister: A Bibliography*, St Paul's Bibliographies, Bury St Edmunds, 1981, p. 2.

113. Some of the material in this section previously appeared in my article 'The Art of Science: A "Rediscovery" of the Lister Copperplates', *Notes and Records: The Royal Society Journal of the History of Science*, vol. 66, no. 1, March 2012, pp. 19–40.

114. Donald Optiz, Staffan Bergwik and Brigitte Van Tiggelen, 'Introduction: Domesticity and the Historiography of Science', in D. Optiz, S. Bergwik and B. Van Tiggelen (eds), *Domesticity and the Making of Modern Science*, Palgrave Macmillan, Basingstoke, 2016, pp. 1–18; p. 3.

115. Anita Guerrini, 'The Ghastly Kitchen,' *History of Science*, vol. 54, no. 1, March 2016, pp. 71–97.

116. See Lynette Hunter and Sarah Hutton (eds), *Women, Science and Medicine 1500–1700: Mothers and Sisters of the Royal Society*, Sutton Publishing, Stroud, 1997.

117. Optiz, Bergwik and Van Tigglen, 'Introduction: Domesticity and the Historiography of Science', p. 5.

118. Richard Mabey, 'Exploring the Theatrical Space of a Garden', *New Statesman*, 7 August 2015, www.newstatesman.com/2015/07/putting-down-roots.

119. Mary Terrall, *Catching Nature in the Act: Réaumur and the Practice of Natural History in the Eighteenth Century*, University of Chicago Press, Chicago, 2014.

120. Isabelle Lémonon, 'Gender and Space in Enlightenment Science', in Optiz, Bergwik and Van Tiggelen (eds), *Domesticity and the Making of Modern Science*, p. 42. See Robert A. Selig, 'Conversions between Eighteenth Century Currencies', www.w3r-us.org/history/library/seligreptde6.pdf. £1 was worth approximately 23 livres, 3 sous, 6 deniers.

121. Anna Marie Roos, 'Franz Michael Regenfuss, *Auserlesene Schnecken, Muschelen und andre Schaalthiere*', in Christopher Pressler and Karen Attar (eds), *Senate House Library, University of London*, Scala, London, 2012, essay 26, n.pag.

122. Martin Lister, *De Cochleis tam terrestribus*, published by the author, London, 1685, Oxford, Bodleian Library, Lister L 95. Although this work is listed as a printed book, it is a draft printing interspersed with sketches.

123. The bird is indeed portrayed in John Ray and Francis Willughby, *The Ornithology of Francis Willughby...*, John Martyn, London, 1678, p. 266.

124. Martin Lister, 'A Description of Certain Stones Figured Like Plants, and by Some Observing Men Esteemed to be Plants Petrified', *Philosophical Transactions* 8 (100), 1673, pp. 6181–91. These drawings are unnumbered. Numbered drawings appear in the Royal Society Letter Book, vol. 6, p. 371. Lodge indicates he drew these for Lister in his letter of 23 October 1673, Oxford, Bodleian Library, MS. Lister 34, f. 114.

125. Advertisement, *Philosophical Transactions* 13 (145), 1683, p. 112.

126. Oxford, Bodleian Library, MS. Lister 35, f. 73r.

127. Paul Bidwell, 'The Roman Names of the Fort at South Shields and an Altar to the Di Conservatores', in Rob Collins and Frances McIntosh (eds), *Life in the Limes: Studies of the People and Objects of the Roman Frontiers*, Oxbow Books, Oxford, 2014, pp. 49–58.

128. Daniel Woolf, *The Social Circulation of the Past: English Historical Culture, 1500–1730*, Oxford University Press, Oxford, 2003, pp. 142–50.

129. Martin J.S. Rudwick, *Earth's Deep History: How It Was Discovered and Why It Matters*, University of Chicago Press, Chicago, 2014, p. 48.

130. Robert Hooke, *The Posthumous Works of Robert Hooke; containing his Cutlerian Lectures, and other Discourses read at the Meetings of the Illustrious Royal Society... published by R. Waller*, Samuel Smith and Benjamin Walford, London, 1705, p. 321.

131. Martin Lister, 'An Account of a Roman Monument found in the Bishoprick of Durham, and of some Roman Antiquities at York, sent in a Letter from Martin Lister Esq.', *Philosophical Transactions* 13 (145), 1683, pp. 70–74; p. 70.

132. Barbara Stafford, *Artful Science: Enlightenment Entertainment and the Eclipse of Visual Education*, MIT Press, Cambridge, 1996, p. 157.

133. E.C. Spary, 'Scientific Symmetries', *History of Science* 42, 2004, pp. 1–46; p. 1.

134. Lister, 'Preface', *Historiæ Animalium Angliæ Tres Tractatus*, John Martyn, London, 1678, pp. 2, 3. 'Rursus omnium ferè Animalium figuras coram me delineandas curavi; ut optimus artifex, non suum tantùm conceptum, ut fieri solet, exprimeret; sed, quò faciliùs acciperet, quæ uniuscuiusque; speciei maximè depingendæ essent Notæ, eas primum digito indicavi.'

135. Wroughton, Science Museum Archives, MS. 685, Original Drawings for Lister's Conchology, c.1690.
136. Sachiko Kusukawa, 'Drawings of Fossils by Robert Hooke and Richard Waller', *Notes and Records: The Royal Society Journal of the History of Science*, vol. 67, no. 2, June 2013. Hooke's original drawings are in London, British Library, MS. Additional 5262, no. 152. Lister's drawings of ammonites are engraved in his *Historiæ Conchyliorum*, plate 1043.
137. Lorraine Daston, 'On Scientific Observation', *Isis* 99, 2008, pp. 97–110; p. 107.
138. Ibid.
139. Guy L. Wilkins, *A Catalogue and Historical Account of the Sloane Shell Collection*, British Museum, London, 1953, p. 39.
140. Sachiko Kusukawa, 'William Courten's Lists of "Things Bought" from the Late Seventeenth Century', *Journal of the History of Collections*, vol. 29, no. 1, 2017, pp. 1–17.
141. London, British Library, MS. Sloane 4044, f. 63r, letter of Charles Seward to Sir Hans Sloane, 31 December 1714.
142. London, British Museum, Am, SLMisc, CUPBD2/SH.3, Sloane Manuscript Catalogue of Miscellanies, item 238/0020. My thanks to Kim Sloan for this information.
143. London, British Library, MS. Sloane 3961. My thanks to Sachiko Kusukawa for alerting me to this source. See also her recent article 'William Courten's Lists of "Things Bought"'.
144. Lewis B. Brown, 'Notes on the Land and Freshwater Snails of Barbados', *Journal of Conchology*, vol. 10, no. 9, 1902, pp. 266–73; p. 268.
145. London, British Library, MS. Sloane 3961, f. 27v.
146. Brown, 'Notes on the Land and Freshwater Snails of Barbados', p. 268.
147. Oxford, Bodleian Library, MS. Ashmole 1816, f. 79r.
148. The location of the original manuscript for the Lhwyd letter is unknown, but there are printed versions in: William Derham, ed. *Philosophical Letters between the Late John Ray and Several of His Correspondents, Natives and Foreigners. To which are Added Those of Francis Willughby*, Jenys, London, 1718, p. 224; *The Correspondence of John Ray*, ed. Edwin Lankester, The Ray Society, London, 1848, pp. 212–13; R.T. Gunther (ed.), *Early Science in Oxford*, 14 vols, Volume 14: *Life and Letters of Edward Lhwyd*, Clarendon Press, Oxford, 1945, pp. 99–100.
149. John Ray, letter to Edward Lhwyd, 7 May 1690, Oxford, Bodleian Library, MS. Eng. hist. c. 11, f. 45; published in *Further Correspondence of John Ray*, ed. R.T. Gunther, pp. 206–7.
150. London, Natural History Museum, Sloane Inventories, 50.L.6, f. 275r. .
151. Wilkins, *A Catalogue and Historical Account*, p. 22.
152. London, British Library, MS. Sloane 3961, f. 40v.
153. London, Natural History Museum, Sloane Inventories, 50.L.6, f. 116r.
154. London, British Library, MS. Additional 421, f. 2r. '[Sloane] came into England, and liv'd in a House adjoining to the Laboratory of Apothecaries Hall with Mr Staphorst, the Chemist, who had learn'd that art under Mr. Stahl his Kinsman.' William Poole, 'A Fragment of the Library of Theodore Haak (1605–1690)', *Electronic British Library Journal*, 2007, p. 12, www.bl.uk/eblj/2007articles/pdf/ebljarticle62007.pdf (accessed 12 October 2013).

155. London, British Library, MS. Sloane 4038, ff. 193–194, 296–97, letters from Peter Hotton to Sir Hans Sloane, 22 July 1701 and 30 January 1702.

156. H.H. Dijkstra, 'A Contribution to the Knowledge of the Pectinacean Mollusca (*Bivalvia: Propeamussiidæ, Entoliidæ, Pectinidæ*) from the Indonesian Archipelago', *Zoologische Verhandelingen Leiden*, vol. 271, no. 24, 1991, p. 32.

157. Wilkins, *A Catalogue and Historical Account*, p. 15.

158. Oxford, Bodleian Library, MS. Ashmole 1822, f. 231r.

159. Robert Hooke, 'Preface', *Micrographia*, John Martyn, London, 1665, p. 4.

160. Mark Michael Smith, *Sensing the Past: Seeing, Hearing, Smelling, Tasting, and Touching in History*, University of California Press, Berkeley, 2008, p. 99.

161. Bettina Mathes, 'As Long as a Swan's Neck? The Significance of the Enlarged Clitoris in Early Modern Anatomy', in Elizabeth D. Harvey (ed.), *Sensible Flesh: On Touch in Early Modern Culture*, Pennsylvania State Press, Philadelphia, 2003, p. 117. See also Joe Moshenka, *Feeling Pleasures: The Sense of Touch in Renaissance England*, Oxford University Press, Oxford, 2014.

162. Jeremy Woodley, 'Anne Lister, Illustrator of Martin Lister's *Historiæ Conchyliorum* (1685–1692)', *Archives of Natural History*, vol. 21, no. 2, 1994, pp. 225–9; p. 226.

163. Oxford, Bodleian Library, MS. Ashmole 1816, ff. 92, 101–102, letters of Lister to Edward Lhwyd, 20 October 1692, 18 October 1693.

164. Meghan Doherty, 'Creating Standards of Accuracy: Faithorne's *The Art of Graving* and the Royal Society', in Rima D. Apple, Gregory J. Downey and Stephen L. Vaughn (eds), *Science in Print: Essays on the History of Science and the Culture of Print*, University of Wisconsin Press, Madison, 2012, pp. 15–36; p. 31.

165. John Evelyn, *Sculptura: or the History, and Art of Chalcography and Engraving in Copper*, J.C., London, 1662, pp. 149–50.

166. Doherty, 'Creating Standards of Accuracy', p. 31.

167. George Edwards, *A Natural History of Uncommon Birds*, 4 vols, Royal College of Physicians, London, 1751, vol. 4, p. 230.

168. William Faithorne, *The Art of Graveing and Etching*, William Faithorne, London, 1662, p. 4.

169. A portable X-ray fluorescence device (Bruker Tracer III-V) was used by Dr Peter Bray to examine two dozen of the Lister copperplates, selected by random sampling, in the Bodleian Library on 8 April 2011. The X-ray spectrum is recorded as characteristic peaks whose intensity corresponds to the percentage of each element in the alloy. Present were: Dr Peter Bray and Professor Mark Pollard (University of Oxford), Clive Hurst (Head of Rare Books, Bodleian Library), Dr Alexandra Franklin (Bodleian Library) and the author.

170. My thanks go to Professor Mark Pollard for this information.

171. Martin Lister, *De Cochleis tam terrestribus*, published by the author, London, 1685; Oxford, Bodleian Library, Lister L 95.

172. George Vertue, *Notebooks*, 6 vols, Walpole Society, Oxford, 1934–55), vol. 6, p. 184; Ronald Paulson, *Hogarth*, Volume 1: *The 'Modern Moral Subject' 1697–1732*, Lutterworth Press, Cambridge, 1991, p. 59.

173. Keynes, *Dr Martin Lister: A Bibliography*, p. 28.

174. Edwards, *A Natural History of Uncommon Birds*, p. 231.

175. William Salmon, *Polygraphice*, Thomas Passenger and Thomas Sawbridge, London, 1677, p. 76.

176. Edwards, *A Natural History of Uncommon Birds*, pp. 232–3.

177. Keynes, *Dr Martin Lister: A Bibliography*, p. 28; Oxford, Bodleian Library, MS. Lister 4, f. 77, as discussed by Woodley, 'Anne Lister', p. 227; London, British Library, MSS. Stowe 746, f. 97r.

178. Faithorne, *The Art of Graveing and Etching*, p. 7.

179. Edwards, *A Natural History of Uncommon Birds*, p. 233.

180. Ibid., p. 234.

181. Anna Marie Roos, 'A Speculum of Chymical Practice: Isaac Newton, Martin Lister (1639–1712), and the Making of Telescopic Mirrors', *Notes and Records of the Royal Society*, vol. 64, no. 2, 20 June 2010, pp. 105–20; p. 109. Lister's chymistry is also discussed in Anna Marie Roos, *Salt of the Earth: Natural Philosophy, Medicine and Chymistry in England, 1650–1750*, Brill, Leiden, 2007, ch. 3 *passim*.

182. Michael Hunter and Jim Bennett, *The Image of Restoration Science: The Frontispiece to Thomas Sprat's History of the Royal Society (1667)*, Routledge, London and New York, 2017, pp. 134–6.

183. Paulson, *Hogarth*, vol. 1, p. 59; Faithorne, *The Art of Graveing and Etching*, opp. p. 22.

184. Shelfmark 222, Bodleian Library. As the draft notebook (Lister L95) also contains an original drawing for one of Lister's articles for *Philosophical Transactions* about a Roman altar dating from 1683, the date for the book and thus for Susanna's drawings may be earlier than 1685.

185. Keynes, *Dr Martin Lister: A Bibliography*, p. 32; Jeremy Woodley, 'Susanna Lister (1670–1738) and Anna Lister (1671–1695x1704)', *Oxford Dictionary of National Biography*, Oxford University Press, Oxford, 2004.

186. Keynes, *Dr Martin Lister: A Bibliography*, p. 32; Woodley, 'Anne Lister', p. 227. Keynes is referring to illustrations following the article 'A Letter from William Molyneux Esq; Secretary to the Dublin Society; to One of the S. of the R.S. concerning a New Hygroscope, Invented by Him', *Philosophical Transactions* 15 (172), 1685, pp. 1032–5. There is also the possibility that the engraver could be John Savage; however, in my article 'The Art of Science' I consider the evidence and show that this is probably not the case.

187. *Women's Work: Portraits of 12 Scientific Illustrators from the 17th to the 21st Century*, http://womenswork.lindahall.org. There is also a printed catalogue for the exhibition, which was curated by Nancy Green of the Linda Hall Library with contributions from Douglas Holland of Missouri Botanical Garden Library as well the history of science department of the Linda Hall Library. The articles are: A. von Leeuwenhoek, 'An Abstract of a Letter from Mr. Anthony Leewenhoeck of Delft to Mr. R.H. concerning the appearances of several woods and their Vessels as observed in a Microscope', *Philosophical Transactions* 13 (148), 1683, pp. 197–208; Antoine von Leeuwenhoek, 'An Extract of a Letter from Mr. Anthony Leewenhoeck F. of the R.S. to a S. of the R. Society', *Philosophical Transactions* 15 (170), 1685, pp. 963–79.

188. Lister remarked to John Ray in March 1670 that he 'must carry my wife to ly in at her mothers in Craven, where I shall be most part of this Summer'. London, Natural History Museum, MS. Ray 1, f. 9, letter 25b. Susanna was born at

Carleton Hall in Carleton-in-Craven, Yorkshire, and baptized on 9 June 1670. See Parish Register (P 18/3) of Carleton-in-Craven, West Yorkshire Archive Service, Leeds.

189. Woodley, 'Anne Lister', *passim*.

190. Keynes, *Dr Martin Lister: A Bibliography*, p. 32.

191. Martin Lister, 'The Anatomy of a Scallop', *Philosophical Transactions* 19 (229), 1695–97, pp. 567–70. The illustration appears before the article, on p. 560. *Women's Work* also notes this illustration, but here it is attributed to Susanna Lister; it is more likely the work was by Anna as she signed the other works in the series, as well as signing anatomical drawings in her sketchbook (Oxford, Bodleian Library, MS. Lister 9).

192. Oxford, Bodleian Library, MS. Lister 9.

193. Martin Lister, 'An Account of the Nature and Differences of the Juices, More Particularly, of Our English Vegetables', *Philosophical Transactions* 19 (224), 1695–97, pp. 362–4. Lister remarks, 'These were some Papers, which belong'd to a Treatise of Vegetation; they were most of them made about Thirty Years ago; but as I cannot now attend the finishing of them, so I would not lose them; and therefore recommend them to your Care, such as they are.'

194. Mei-Ying Sung, *William Blake and the Art of Engraving*, Pickering & Chatto, London, 2009.

195. Wilkins, 'Notes on the *Historiæ Conchyliorum*', p. 197.

196. See Roos, *Web of Nature*, pp. 300–301.

197. *Et cùm jam primùm microscopio, ex visûs defectu uti cogar, eisdem ope me rursus iisdem studiis frui, quae diu nudis oculis denegata sunt, magnopere gaudio.* Martin Lister, 'Preface', *Exercitatio anatomica in qua de Cochleis, Maximè Terrestribus & Limacibus, agitur*, London, Samuel Smith & Benjamin Walford, London, 1694, p. 2.

198. Edward G. Ruestow, *The Microscope in the Dutch Republic: The Shaping of Discovery*, Cambridge University Press, Cambridge, 1996, p. 15. See also Brian Bracegirdle, 'The Performance of Seventeenth and Eighteenth Century Microscopes', *Medical History* 22, 1978, pp. 187–95; Marian Fournier, *The Fabric of Life: Microscopy in the Seventeenth Century*, Johns Hopkins University Press, Baltimore MD, 1996; Catherine Wilson, *The Invisible World: Early Modern Philosophy and the Invention of the Microscope*, Princeton University Press, Princeton NJ, 1995.

199. Ruestow, *The Microscope in the Dutch Republic*, p. 16.

200. Amami Kato, 'Distorted Depth Perception under the Microscope: Compensation by Surgical Navigator and Image Projection', *Acta Medica Kinki University*, vol. 33, no. 1–2, 2008, pp. 1–8; M. Carrozzo, 'A Hybrid Frame of Reference for Visual Manual Coordination', *Neuroreport* 5, 1994, pp. 453–6; I. Faillenot, H. Sakata and N. Costes, 'Visual Working Memory for Shape and 3-D Orientation: A PET Study', *Neuroreport* 8, 1997, pp. 859–62.

201. Wilson, *The Invisible World*, p. 102.

202. Oxford, Bodleian Library, MS. Lister 9, f. 9r. Brachiopods are a phylum of marine animals with hard shells on the upper and lower surfaces. They differ from bivalve molluscs (like scallops or clams), which have shells on the left and right.

203. Maria Sibylla Merian (1647–1717) is said to have been the first woman to use

a microscope, although Natalie Zemon Davis has indicated that Merian was only using a magnifying glass to do her works with insects. See Natalie Zemon Davis, *Women on the Margins: Three Seventeenth-Century Lives*, Harvard University Press, Cambridge MA, 1995, p. 151.

204. This point is made by Warren D. Allmon, 'The Evolution of Accuracy in Natural History Illustration: Reversal of Printed Illustrations of Snails and Crabs in Pre-Linnaean Works Suggests Indifference to Morphological Detail', *Archives of Natural History*, vol. 34, no. 1, 2007, pp. 174–91.

205. Rembrandt van Rijn, *The Shell* (*Conus marmoreus*), 1650, etching, drypoint and burin, state II (3), 97 × 132 mm, Museum Het Rembrandthuis, Amsterdam.

206. K. Leonhard, 'Shell Collecting: On 17th-Century Conchology, Curiosity Cabinets, and Still Life Painting', in Karl A.E. Enenkel and Paul Smith (eds), *Early Modern Zoology: The Construction of Animals in Science, Literature and the Visual Arts*, Brill, Leiden, 2007, pp. 177–216, esp. pp. 196–202.

207. Ibid., p. 198. Anna's drawing after Rembrandt may be seen in Oxford, Bodleian Library, MS. Lister 9, f. 47r. Her correct orientation of the shell is in Martin Lister, *Historiæ Sive Synopsis Methodicæ Conchyliorum*, published by the author, London, 1685, fig. 787 and fig. 32.

208. Allmon, 'The Evolution of Accuracy in Natural History Illustration', pp. 175, 178.

209. Bettina Dietz, 'Mobile Objects: The Space of Shells in Eighteenth-century France', *British Journal for the History of Science*, vol. 39, no. 3, 2006, pp. 363–82; p. 367; Carr, 'The Biological Work of Martin Lister', p. 212.

210. Hugh Watson, 'The Names of the Two Common Species of Viviparus', *Proceedings of the Malacological Society* 31, June 1955, pp. 163–74; pp. 164–5; Lister, *Exercitatio anatomica altera, in qua maxime Agitur de buccinis fluviatilibus de marinis*, pp. 17–48, 263–5 pl. 2.

211. Watson, 'The Names of the Two Common Species of Viviparus', p. 165. In Lister's *Historiæ Sive Synopsis Methodicæ Conchyliorum*, figure 26 on plate 126 portrays the narrower species, and figure 5 on plate 6 shows the more ventricose species – the 'Cochlea altera vivipara', this plate being similar to plate 2 in his *Exercitatio Anatomica*. Linnaeus cites Lister's figure of the narrower species in his own taxonomy.

212. *Women's Work*, Linda Hall Library of Science and Engineering, www.lindahall. org/ events_exhib/exhibit/exhibits/womenswork/lister2.shtml.

213. Dietz, 'Mobile Objects', p. 367.

THREE

1. And, of course, this natural order is distinctly pre-Linnaean.
2. Turbinate: having a broadly conical spire and a convex base.
3. Guy. L. Wilkins, *A Catalogue and Historical Account of the Sloane Shell Collection*, British Museum, London, 1953, p. 13.
4. Diane Bergman, email to Dunja Sharif, 19 March 2012, forwarded to me by Alexandra Franklin on 27 March 2012.
5. This chapter incorporates material from more detailed consideration of the ephemera in my 'Fossilized Remains: The Martin Lister and Edward Lhuyd Ephemera', in Vera Keller, Anna Marie Roos and Elizabeth Yale (eds), *Archival*

Afterlives: Life, Death, and Knowledge-making in Early Modern British Scientific and Medical Archives, Brill, Leiden, 2018.

6. Arthur MacGregor, 'William Huddesford (1732–1772): His Role in Reanimating the Ashmolean Museum, His Collections, Researches and Support Network', *Archives of Natural History* 34, April 2007, pp. 47–68.

7. Bryn Roberts, 'Memoirs of Edward Lhwyd, Antiquary and Nicholas Owen's British Remains', *National Library of Wales Journal*, vol. 19, no. 1, 1975, p. 74.

8. Letter from Huddesford to Emanuel Mendez Da Costa, 30 November 1757, in John Nichols (ed.), *Illustrations of the Literary History of the Eighteenth Century*, vol. 4, Nichols, London, 1822, p. 456.

9. Nichols (ed.), *Illustrations of the Literary History of the Eighteenth Century*, vol. 4, p. 458; MacGregor, 'William Huddesford (1732–1772)', p. 58.

10. Oxford, Bodleian Library, MS. Ashmole 1822, ff. 225r, 226r.

11. MacGregor, 'William Huddesford (1732–1772)', pp. 59, 66. As MacGregor indicates, Fothergill's laments were related in an undated letter from Huddesford to the antiquarian John Loveday, received on 12 April 1769. The letter exists only in typescript in the collection of Robert William Theodore Gunther in Oxford, Museum of the History of Science, MS. Gunther 45/2. It is reproduced in the appendix to B.F. Roberts, 'A Note on the Ashmolean Collection of Letters Addressed to Edward Lhuyd', *Welsh History Review* 7, 1975, pp. 183–5.

12. Nichols, *Illustrations of the Literary History of the Eighteenth Century*, vol. 4, p. 458, as quoted in MacGregor, 'William Huddesford (1732–1772)', p. 59.

13. MacGregor, 'William Huddesford (1732–1772)', p. 59.

14. Oxford, Bodleian Library, MS. Ashmole 1822, f. 225v.

15. MacGregor, 'William Huddesford (1732–1772)', p. 59. These documents comprise Oxford, Bodleian Library, MSS. Lister. See also Roberts, 'Memoirs of Edward Lhwyd', p. 184.

16. It is only recently that items that are not books or manuscripts have appeared in the public catalogue of the Bodleian Library.

17. William Huddesford, *An Address to the Freemen and Other Inhabitants of the City of Oxford*, Abraham Lightholder, Lucern, 1764.

18. Letter from William Huddesford to William Borlase, 31 July 1770; Penzance, Morrab Library, Borlase papers, MOR/BOR/3, f. 62.

19. Letter from James Granger to William Huddesford, 5 July 1770; Oxford, Bodleian Library, MS. Ashmole 1822, f. 323r.

20. Oxford, Bodleian Library, MS. Ashmole 1822, ff. 323–324.

21. Nichols, *Illustrations of the Literary History of the Eighteenth Century*, vol. 4, p. 140.

22. Lister held a fellowship by royal mandate at St John's College, granted in 1660. For Huddesford's letters concerning oral history interviews, see the following in London, British Library, Additional Manuscripts 22596: Edward Gregory to William Huddesford; Magd. Coll. [Cambridge], 27 Feb. 1770, f. 86. T[homas] Martyn [Professor of Botany at Cambridge 1761–1825] to Edward Gregory; Sidney Coll., 22 Dec. 1769, f. 88. Susanna Gregory to her nephew, Edward Gregory; Short Hill, Nottingham, 31 Jan. 1770. With *seal*. Accompanied by a paper of answers to questions about Dr. Lister. ff. 90, 92. Matthew Lister [of

Burwell Park, near Louth] to Edward Gregory; Leadenham [near Sleaford], 22 Feb. 1770, f. 94. Rev. George Ashby [president of St John's College, Cambridge] to William Huddesford; 'S[t] J[ohn's] C[ollege] C[ambridge]', 9 Mar. 1770, f. 95.

23. Oxford, Bodleian Library, MS. Engl. Misc. d91, f. 146.
24. The biography's structure is only extant as an outline in manuscript. See 'Dr Martin Lister: Life of, by Rev. W. Huddesford: 1769–1770 Imperfect', London, British Library, Additional Manuscripts 22596, f. 84. Lister's working copy, in the Linnean Society Library, London (MS. 131, Case 2c) is: *De Cochleis, tam terrestribus, quam fluviatilibus exoticas, item de ijs quae etiam in Anglia inveniantur Libri II. (Conchyliorum Marinorum Liber III ... [&] Buccinorum Marinorum Liber IV); De Cochleis*, published by the author, London, 1685–92.
25. One of Whiteside's coin catalogues is prefaced with the following note: 'We whose Names are under-written do hereby give leave to Mr Whitesid[e] to make Use of Dr Lister's Copper Plates, and to take off a Number of Copies, not exceeding thirty, or his History of Shells.' *Account of the Coins missing before the Year 1715. In Mr Whiteside's Hand*, Oxford, Ashmolean Museum, AMS 21 (formerly Arch. Ash. 80), f. 1r.
26. Oxford, Bodleian Library, MS. Ashmole, 1822, ff. 291–292.
27. Oxford, Bodleian Library, RR. y. 56.
28. London, British Library, MS. Sloane 3691, f. 33r.
29. Loretta Chase and Isabella Bradford, 'Pins and Pinning', *Two Nerdy History Girls*, 2009, http://twonerdyhistorygirls.blogspot.co.uk/2009/11/pins-pinning.html (accessed 12 October 2013).
30. Abigail Shinn, 'Cultures of Mending', in *The Ashgate Research Companion to Popular Culture in Early Modern England*, ed. Andrew Hadfield, Matthew Dimmock and Abigail Shinn, Ashgate, Farnham, 2014, p. 246.
31. The watermark is extant on several pages of the 1685–88 edition of the *Historiæ Conchyliorum*, Oxford, Bodleian Library, Gough Nat. Hist. 57, as well as on several pages of Lister's letters. The watermark's three circles, Griffins, Cross and Crown, Arms of Genoa, are similar to ARMS.099.1 in the Thomas Gravell Watermark Archive, www.gravell.org. The source of the Gravell watermark was a 1666 London imprint from Washington DC, Folger Shakespeare Library, L.F. WM Coll 1.
32. Wilkins, *A Catalogue and Historical Account of the Sloane Shell Collection*, p. 39.
33. Working copy of Martin Lister's *De Cochleis*, London, Linnean Society, MS. 131, Case 2c.
34. Lister, *Historiæ Conchyliorum* Grangerized, Oxford, Bodleian Library, RR. y. 56.
35. Wilkins, *A Catalogue and Historical Account of the Sloane Shell Collection*.
36. My thanks to the anonymous reviewer of the manuscript of this book for this point.
37. This is a point first made by Jeff Carr in 'The Biological Work of Martin Lister (1639–1712)', Ph.D. thesis, University of Leeds, 1974, p. 211. My thanks to Dr Carr for our discussion of this issue.
38. Lister, *Historiæ Animalium*, p. 131, as noted by Carr, 'The Biological Work of Martin Lister (1639–1712)', p. 211.

39. Isabelle Charmantier and Staffen Müller-Wille, 'Carl Linnaeus's Botanical Paper Slips', *Intellectual History Review*, vol. 24, no. 2, 2014, p. 219.

40. Working copy of Martin Lister's *De Cochleis,* London, Linnean Society, MS. 131, Case 2c. Lister's inscription is in the front of the work, on the first endpaper. My thanks to Vera Keller for tracing the source of the quotation.

41. For instance, Lister wrote about depth of colour: 'Huic color interdum fusius, quae altera tantum varietas esse videtur'. He then commented on pattern: 'Rhombus C.P. lineis plurimus rufoscentibus et ex albu maculati distinctis clavicula leviter mericata, rostro purpurascente'. Oxford, Bodleian Library, Lister Ephemera, Box 1, 17.

42. Martin Lister, *Historiæ Animalium Angliæ Tres Tractatus,* John Martyn, London, 1678, table 1, fig. 3. Roberts, 'A Note on the Ashmolean Collection', p. 183.

43. Oxford, Bodleian Library, MS. Ashmole 1822, ff. 278–279.

44. Letter from James Granger to William Huddesford, 17 November 1769, in Nichols, *Illustrations of the Literary History of the Eighteenth Century*, vol. 4, p. 139.

45. Letter from John Lightfoot to William Huddesford, 3 December 1770, Oxford, Bodleian Library, MS. Ashmole 1822, ff. 295–296.

46. Letter from Evenus Hammer to William Huddesford, 20 July 1769, Oxford, Bodleian Library, MS. Ashmole 1822, f. 258r. Not much is known about Hammer. His signature appears in an *album amicorum* of Johann Thomas Ludwig Wehrs (1751–1811) of Göttingen dated 13 October 1770; Hammer was a student of maths. See Göttingen Stadtarchiv, Stabu Nr. 17, 55r, wws 11.6.2013. See also W.W. Schaubel, Repertorium Alborum Amicorum, www.raa.phil.uni-erlangen.de/index.shtml (accessed 25 October 2014).

47. Ian Gadd, 'An International Press', in *The History of Oxford University Press*, Volume I: *Beginnings to 1780*, Oxford University Press, Oxford, 2013, p. 19.

48. Oxford, Bodleian Library, MS. Lister 32, *passim*. This work is Lister's casebook for 1692.

49. Letters testimonial signed by Martin Lister and William Cole for the licensure of Alan Henman alias Taylor, M.A. 5 January 1706, Order no VX IA/10/401, Lambeth Palace Library, London.

50. 'An Account of Books', *Philosophical Transactions* 18, 1694, pp. 65–76; p. 66.

51. Oxford, Bodleian Library, MS. Lister 3, f. 154. The letter is published in Robert T. Gunther (ed.), *Early Science in Oxford*, 14 vols, Volume 14: *Life and Letters of Edward Llwyd*, Clarendon Press, Oxford, 1945, p. 155.

52. John Strype, *A Survey of the Cities of London and Westminster*, 2 vols, A. Churchill, J. Knapton, R. Knaplock et al., London, 1720, ch. 11, appendix 1, p. 79.

53. Brian Bouchard, 'Dr Martin Lister MD FRS', Epsom and Ewell History Explorer (January 2013), www.epsomandewellhistoryexplorer.org.uk/DrLister.html (accessed 15 April 2018).

54. Oxford, Bodleian Library, MS. Lister 4, f. 15r. Their marriage took place on 24 October 1698, in the church of St Stephen, Walbrook, London. See London, England, Baptisms, Marriages and Burials, 1538-1812, London Metropolitan Archives, St Stephen Walbrook, Composite register, 1557–1716, P69/STE2/A/001/MS08319.

55. The parish church of Herne, dedicated to St Martin of Tours, has a black

marble slab memorial to Sir Gilbert, Susanna, and his other two wives Elizabeth Juxon and Honeywood Denne, in the south chantry chapel. The arms of all the families are duly incised. See James Robert Buchanan, *Memorials of Herne, Kent*, 3rd edn, E. Stock, London, 1887, pp. 28–9.

56. Jeremy Woodley, 'Lister , Susanna', in *Oxford Dictionary of National Biography*, Oxford University Press, Oxford, 2004. Reverend Bedford's autograph journal mentions that his wife Susanna died on 3 January 1768 and was buried on 10 January. At the time of writing, the journal was available for sale at Personalia, www.personalia.co.uk.

57. Woodley, 'Lister, Susanna'.

58. IGI Individual Record for Anne Lister, Batch Number M001457, 1658–1757, familysearch.org. IGI Individual Record for Elizabeth Bristow, Batch Number C001455, 1701–1715, familysearch.org. The parish records of St Martin-in-the-Fields also show Elizabeth Bristow's marriage to Matthew Aish in 1740, so it is clear they had ties to the area. My thanks to Jeremy Woodley for this information.

59. Oxford, Bodleian Library, MS. Lister 3, ff. 211–218.

60. F.W. Martini and J.H. Chemnitz, *Neues Systematisches Conchyliencabinet*, 11 vols Raspe, Nürnberg, 1764–95; L.W. Dillwyn (ed.), 'Preface', in *An Index to the Historiæ Conchyliorum of Lister*, Clarendon Press, Oxford, 1823.

61. Elkanah Settle, *Threnodia Apollinaris. A Funeral Poem to the Memory of Dr Martin Lister, Late Physician to her Majesty*, printed for the author, London, 1712, p. 10.

62. Bouchard, 'Dr Martin Lister MD FRS'.

63. R.W. Goulding, 'Martin Lister, M.D., F.R.S.', *Reports and Papers Read at the Meetings of the Architectural Societies of the Counties of Lincoln and Nottingham*, vol. 25, no. 2, 1890, pp. 329–70; p. 365.

Bibliography

EPHEMERA & SPECIMENS

Bodleian Library, Oxford

Lister, Martin. Lister Copper Plates. Lister E71.
Lister, Martin. Lister Ephemera. 4 Boxes.

Natural History Museum, London

Lister, Martin. Shell Specimens.

MANUSCRIPTS

Bodleian Library, Oxford

MS. Ashmole 1816. Correspondence of Martin Lister.
MS. Ashmole 1822. Correspondence of William Huddesford.
MS. Ashmole 1829. Correspondence of Hugh Jones.
MS. Eng. Hist c11. Correspondence of Tancred Robinson.
MS. Engl. Misc. d91. Correspondence of William Huddesford.
MSS. Lister 2–4, 34. Correspondence of Martin Lister.
MS. Lister 5. Adversaria of Martin Lister.
MS. Lister 9. Drawings of shells from which the figures in *Historiæ Conchyliorum* were engraved by Anna and Susanna Lister.
MS. Lister 19. A copy of *Every Man's Companion, Or An useful Pocket-Book*, Francis Cossinet, London, 1661, with notes by Lister about his journey to Paris and Montpellier in 1663–66.
MSS. Lister 27, 29, 30, 31, 32, 32*. Copies of printed almanacks, interleaved, with MS notes by Lister, forming a rough account book, chiefly of fees, for each year, with personal lists and notes.
MS. Radcliffe Trust c. 12. Correspondence of Hugh Jones and Richard Richardson.

British Library, London

East India Company and India Office General Ledgers, Ledger H, IOR/L/
AG/1/1/9/f.402(3).

MS. Additional 21111, f. 15r. Letter from Francis Place to George Vertue.

MS. Additional 22596. Papers, chiefly in the handwriting of the Rev. W. Huddesford,
Keeper of the Ashmolean Museum [1767–1772], relative to the life of Dr Martin
Lister.

MS. Sloane 1393, f. 13. Agreement of the Corporation of Physicians at York.

MS. Sloane 2052. Papers of Thomas Mayerne.

MS. Sloane 3961. Inventory of William Courten.

MS. Sloane 3962, Papers of William Courten.

MS. Sloane 4002. Papers and Draughts of the Reverend Mr Banister in Virginia
sent to Dr Henry Compton Bishop of London, and Dr Lister from Mr Petiver's
Collection.

MS. Sloane 4038. ff. 193–194, 296–97. Letters of Peter Hotton, Letters from Peter
Hotton to Sir Hans Sloane, 22 July 1701 and 30 January 1702.

MS. Sloane 4041, ff. 23–24. Letter of Martin Lister to Hans Sloane, 21 September 1709.

MS. Sloane 4044, f. 63r. Letter of Charles Seward to Sir Hans Sloane, 31 December
1714.

MS. Sloane 4050, f. 261. Letter of Daniel van Mildert, of Homerton in Hackney, to Sir
H. Sloane, 1729/30.

MS. Stowe 145, Letters of Martin Lister and Francis Place.

British Museum

Am, SLMisc, CUPBD2/SH.3. Sloane Manuscript Catalogue of Miscellanies, item
238/0020.

Registration number Ee,2.69, Bibliographic Reference Hake 71. Location: British
XVIIc Mounted Roy, Prints and Drawings Department. Plate [8] of 14 illustrat-
ing Martin Lister's translation of *Johannes Godartius, Of Insects, done into English and
Methodized, with the Addition of Notes. The figures etched upon copper by Mr F. Pl. York*
(1682). Depicts nine flies and moths, alongside their pupal and larval forms, against
a blank background etching.

MSS. SL 5279. Drawings of Naturalia by Guillaume Toulouze.

MSS. SL 5277. Drawings by Nicolas Robert.

Lincolnshire Archives, Lincoln

ANC 1X/D/5d. Accounts of Sir Hans Sloane, January 1723/4.

Linnean Society, London

MS. 131. Case 2c. Working Copy of *De Cochleis* by Martin Lister.

Morrab Library, Penzance

MS. Borlase 3. Correspondence of William Huddesford.

National Archives, Kew

State Papers Domestic, James I, 1611–1618 (5 April 1617).

Will of Sir Matthew Lister, 18 August 1656, PROB 11/261, sig. 9.

National Library of Wales, Aberystwyth
Peniarth MS. 427. Edward Lhwyd Correspondence.

Natural History Museum, London
MSS. 50 L 6. Inventories: Conchology of Sir Hans Sloane.
MSS. Ray. Correspondence.

Royal Society, London
CMO/2/292, Minutes of a meeting of the Council of the Royal Society, 30 June 1720.
Early Letters and Classified Papers.
Miscellaneous Manuscripts Volume 14, letters 132 and 141. Letters of Thomas Kirke
 and Emanuel Mendes da Costa.
MS. Catalogue D, MS 413, Repository Holdings.
Royal Society Letter Book, vol. 6, p. 371. Drawings of Lister's Crinoids by William
 Lodge.

Science Museum Archives, Wroughton, Sussex
MS. 685. Original Drawings for Lister's Conchology, *c.*1690.

University College Library, University of Cambridge
Add. MS. 4024. Treatise in autograph of Henry Gyles, glasspainter, coloring mezzo-
 tinto and transferring them to glass.

Yorkshire Archaeological Society, Leeds
(now University of Leeds Special Collections)
MS. 30 – *'The Natural Histories of Insects'* by Johannes Godartius translated into English
 by Martin Lister 1672. Thoresby Manuscripts, John Bargrave Collection.

PRINTED SOURCES

Aldrovandi, Ulisse. *De reliquis animalibus exanquibus libri quatuor, post mortem euis
 editi: nempe de mollibus, crustaceis, testaceis, et zoophytis.* Bologna: Johannes Baptista
 Ballagambam, 1606.
Allmon, Warren D. 'The Evolution of Accuracy in Natural History Illustration:
 Reversal of Printed Illustrations of Snails and Crabs in pre-Linnaean Works
 Suggests Indifference to Morphological Detail'. *Archives of Natural History*, vol. 34,
 no. 1 (2007), pp. 174–91.
Anderson, Stuart. *Making Medicines: A Brief History of Pharmacy and Pharmaceuticals.*
 Pharmaceutical Press, London, 2005.
Anstey, Peter. 'Boyle on Seminal Principles'. *Studies in the History and Philosophy of
 Biology and Biomedical Sciences* 33 (2002), pp. 597–630.
Arnold, Ken. *Cabinets for the Curious: Looking Back at Early English Museums.* Farnham:
 Ashgate, 2006.
Aston, John. 'The Journal of John Aston 1639'. In *Six North Country Diaries*, ed. John
 Crawford Hodgson, pp. 1–34. Edinburgh: Surtees Society, 1910.

Aubrey, John. *Aubrey's Brief Lives,* ed. Richard W. Barber. Woodbridge: Boydell & Brewer, 1982.

Axtell, James L. 'Education and Status in Stuart England: The London Physician'. *History of Education Quarterly,* vol. 10, no. 2 (Summer 1970), pp. 141–59.

Balzac, Jean-Louis Guez de. *Letters of Monsieur de Balzac. 1. 2. 3. and 4th Parts. Translated out of French into English. by Sr Richard Baker Knight, and Others.* London: John Williams and Francis Eaglesfield, 1654.

Banks, Reverend Michael T.H. *Thorpe Arnold: The Story of its Church and People.* Privately printed, 1980.

Barbour, Reid. *Sir Thomas Browne: A Life.* Oxford University Press, Oxford, 2013.

Bartholin, Thomas. *On Medical Travel,* trans. C.D. O'Malley. Lawrence KS: Kansas University Press, 1961.

Bidwell, Paul. 'The Roman Names of the Fort at South Shields and an Altar to the Di Conservatores'. In Rob Collins and Frances McIntosh (eds), *Life in the Limes: Studies of the People and Objects of the Roman Frontiers,* pp. 49–58. Oxford: Oxbow Books, 2014.

Birch, Thomas. *The History of the Royal Society.* London: A. Millar, 1756–7.

Birkhead, Tim, ed. *Virtuoso by Nature: The Scientific Worlds of Francis Willughby FRS (1635–1672).* Brill, Leiden, 2016.

Bracegirdle, Brian. 'The Performance of Seventeenth and Eighteenth Century Microscopes'. *Medical History* 22 (1978), pp. 187–95.

Brighton, J.T. 'Henry Gyles: Virtuoso and Glasspainter of York, 1645–1709'. *York Historian* 4 (1984), pp. 1–59.

Brown, Lewis B. 'Notes on the Land and Freshwater Snails of Barbados'. *Journal of Conchology,* vol. 10, no. 9 (1902), pp. 266–73.

Bushnell, Rebecca. *Green Desire: Imagining Early Modern English Gardens.* Ithaca NY: Cornell University Press, 2003.

Carr, Jeff. 'The Biological Work of Martin Lister (1639–1712)'. Ph.D. thesis, University of Leeds, 1974.

Carr, Jeff. 'The Fossil Controversy in Seventeenth-century England', unpublished paper.

Carrozzo, M. 'A Hybrid Frame of Reference for Visual Manual Coordination'. *Neuroreport* 5 (1994), pp. 453–6.

Chamberlain, Eric. *Catalogue of the Pepys Library at Magdalene College, Cambridge: Prints and Drawings, Portraits.* London: Boydell & Brewer, 1993.

Charleton, Walter. *The Immortality of the Human Soul.* London: William Wilson, 1657.

Charmantier, Isabella, and Staffan Müller-Wille. 'Carl Linnaeus's Botanical Paper Slips'. *Intellectual History Review,* vol. 24, no. 2 (2014), pp. 215–38.

Chevalier, A.G. 'The "Antimony War" – A Dispute Between Montpellier and Paris'. *Ciba Symposium* 2 (1940), pp. 418–23.

Cobb, Matthew. 'Malphigi, Swammerdam and the Colourful Silkworm: Replication and Visual Representation in Early Modern Science'. *Annals of Science* 59 (2002), pp. 111–47.

Coleman, H. Benedict. 'The Romans in Southern Gaul'. *American Journal of Philology,* vol. 63, no. 1 (1942), pp. 47–8.

Cook, Harold J. 'Policing the Health of London: The College of Physicians and the Early Stuart Monarchy'. *Social History of Medicine,* vol. 2, no. 1 (1989), pp. 1–33.

Cook, Harold J. 'The Rose Case Reconsidered: Physicians, Apothecaries and the Law in Augustan England'. *Journal of the History of Medicine and Allied Sciences* 45, 1990, pp. 527–55.

Cook, Harold J. 'The Cutting Edge of a Revolution? Medicine and Natural History near the Shores of the North Sea'. In J.V. Field and Frank A.J.L. James (eds), *Renaissance and Revolution: Humanists, Scholars, Craftsmen and Natural Philosophers in Early modern Europe*, pp. 45–61. Cambridge: Cambridge University Press, 1993.

Cook, Harold J. 'Physicians and Natural History'. In Nicolas Jardine, James Secord and Emma Spary (eds), *Cultures of Natural History*, pp. 91–105. Cambridge: Cambridge University Press, 1996.

Cowan, Brian. *The Social Life of Coffee: The Emergence of the British Coffeehouse.* New Haven CT: Yale University Press, 2008.

Cram, David, Jeffrey L. Forgeng and Dorothy Johnston, *Francis Willughby's Book of Games.* Farnham: Ashgate, 2003.

Cunningham, Andrew, 'The Bartholins, the Platters, and Laurentius Gryllus: The Peregrinatio Medica in the Sixteenth and Seventeenth Centuries'. In Ole Peter Grell, Andrew Cunningham and Jon Arrizabalaga (eds), *Centres of Medical Excellence? Medical Travel and Education in Europe, 1500–1789*, pp. 3–16. Farnham: Ashgate, 2010.

Cutler, Alan. *The Seashell on the Mountaintop: A Story of Science, Sainthood and the Humble Genius who Discovered a New History of the Earth.* Cambridge: Cambridge University Press, 2003.

Daston, Lorraine. 'On Scientific Observation'. *Isis* 99 (2008), pp. 97–110.

Davis, Natalie Zemon. *Women on the Margins: Three Seventeenth-Century Lives.* Cambridge MA: Harvard University Press, 1995.

Delbourgo, James. *Collecting the World: The Life and Curiosity of Hans Sloane.* New York: Penguin, 2017.

Derham, William. *Select Remains of the Learned John Ray with His Life.* George Scott, London, 1760.

Dietz, Bettina. 'Mobile Objects: The Space of Shells in Eighteenth-century France'. *British Journal for the History of Science*, vol. 39, no. 3 (2006), pp. 363–82.

Dijkstra, H.H. 'A Contribution to the Knowledge of the Pectinacean Mollusca (*Bivalvia: Propeamussiidae, Entoliidae, Pectinidae*) from the Indonesian Archipelago'. *Zoologische Verhandelingen Leiden*, vol. 271, no. 24 (1991), pp. 1–57.

Dillwyn, L.W. *An Index to the Historiæ Conchyliorum of Lister.* Oxford: Clarendon Press, 1823.

Doherty, Meghan. 'Creating Standards of Accuracy: Faithorne's *The Art of Graving* and the Royal Society'. In Rima D. Apple, Gregory J. Downey and Stephen L. Vaughn (eds), *Science in Print: Essays on the History of Science and the Culture of Print*, pp. 15–26. Madison: University of Wisconsin Press, 2012.

Edwards, George. *A Natural History of Uncommon Birds*, 4 vols. London: College of Physicians, 1751.

Egmond, Florike. *Eye for Detail: Images of Plants and Animals in Art and Science, 1500–1630.* London: Reaktion Press, 2017.

Erickson, Peter. 'Review of David Jaffe, The Earl and Countess of Arundel:

Renaissance Collectors (Los Angeles: J. Paul Getty Museum, 1995)'. *Renaissance Quarterly*, vol. 50, no. 3 (September 1997), pp. 942–3.

Evelyn, John. *Sculptura: or the History, and Art of Chalcography and Engraving in Copper*. London: J.C., 1662.

Evelyn, John. *The Diary of John Evelyn*, ed. Austin Dobson. Cambridge: Cambridge University Press, 2015.

Ewan, Joseph, and Nesta Ewan, *John Banister and His Natural History of Virginia 1678–1692*. Urbana and Chicago: University of Illinois Press, 1970.

Faillenot, I., H. Sakata and N. Costes, 'Visual Working Memory for Shape and 3-D Orientation: A PET study'. *Neuroreport* 8 (1997), pp. 859–62.

Faithorne, William. *The Art of Graveing and Etching*. London: William Faithorne, 1662.

Fargeon, Jean. *Catalogue des Marchandises Rares, Curieses, et Particulieres, qui se sont et debitent à Montpelier*. Avignon: P. Offray, 1665.

Ferussac, D., and G.P. Deshayes, *Histoire naturelle générale et particulière des mollusques terrestres et fluviatiles...*, 4 vols. Paris: J.B. Baillière, 1820–51.

Feydeau, Elizabeth de. *A Scented Palace: The Secret History of Marie Antoinette's Perfumer*. London and New York: I.B. Tauris, 2006.

Findlay, Alison. *Playing Spaces in Early Women's Drama*. Cambridge: Cambridge University Press, 2006.

Fournier, Marian. *The Fabric of Life: Microscopy in the Seventeenth Century*. Baltimore MD: Johns Hopkins University Press, 1996.

Foust, C.M. *Rhubarb: The Wondrous Drug*. Princeton NJ: Princeton University Press, 1992.

Frank, Robert G., Jr. 'Science, Medicine, and the Universities of Early Modern England: Background and Sources, Part I'. *History of Science*, vol. 11, no. 3 (1973), pp. 194–216.

Galley, Chris. 'A Never-ending Succession of Epidemics? Mortality in Early-Modern York'. *Social History of Medicine*, vol. 7, no. 1 (1994), pp. 29–57.

Gibson-Wood, Carol. 'Classification and Value in a Seventeenth-Century Museum'. *Journal of the History of Collections*, vol. 9, no. 1 (1997), pp. 61–77.

Gleick, James. *Isaac Newton*. New York: Harper Perennial, 2004.

Goldgar, Anne. *Impolite Learning: Conduct and Community in the Republic of Letters, 1680–1750*. Yale University Press, New Haven CT, 1995.

Gould, Stephen Jay. 'The Jew and the Jew Stone'. *Natural History Magazine*, vol. 109, no. 5 (2000), pp. 26–9.

Green, Mary Anne Everett (ed.). *Letters of Queen Henrietta Maria*. London: Richard Bentley, 1857.

Greenfield, Amy Butler. *A Perfect Red: Empire, Espionage and the Quest for the Color of Desire*. New York: Harper Perennial, 2006.

Griffiths, Antony. *Prints and Printmaking: An Introduction to the History and Techniques*. London: British Museum Press, 1996.

Griffiths, Antony. *The Print in Stuart Britain, 1603–1689*. London: British Museum Press, 1998.

Grovii, Robert [Robert Grove]. *Carmen de Sanguinis Circuitu, A Gulielmo Harvæo Anglo, Primum Invento. Adjecta sunt, Miscellanea Quædam*. London: Walter Kettilby, 1685.

Guerrini, Anita. 'The Ghastly Kitchen'. *History of Science*, vol. 54, no. 1 (2016), pp. 71–97.

Gunther, Robert T. (ed.). *Early Science in Oxford*, 14 vols. Oxford: Clarendon Press, 1923–45.

Gunther, Robert T. (ed.). *Further Correspondence of John Ray*. London: The Ray Society, 1928.

Hake, H.M. 'Some Contemporary Records Relating to Francis Place, Engraver and Draughtsman, with a Catalogue of his Engraved Work'. *Walpole Society* 10 (1921–2), pp. 39–69.

Hall, Marie Boas. *Henry Oldenburg: Shaping the Royal Society*. Oxford: Oxford University Press, 2002.

Hamilton, E. *Henrietta Maria*. New York: Coward, McCann & Geoghegan, 1976.

Hannay, Margaret P. 'The Countess of Pembroke and Elizabethan Science'. In Lynette Hunter and Sarah Hutton (eds), *Women, Science and Medicine, 1500–1700*, pp. 108–21. Stroud: Sutton Publishing, 1997.

Hannay, Margaret P. *Mary Sidney, Lady Wroth*. Farnham: Ashgate, 2013.

Hanson, Craig Ashley. *The English Virtuoso: Art, Medicine, and Antiquarianism in the Age of Empiricism*. Chicago: University of Chicago Press, 2009.

Harley, R.D. *Artists' Pigments c.1600–1835: A Study in English Documentary Sources*. London: Archetype Publications, 2001.

Haslett, Simon. *Coastal Systems*. Abingdon: Routledge, 2008.

Hearn, Karen. *Cornelius Johnson*. London: Paul Holberton Publishing, 2015.

Heathcote, Evelyn D. *An Account of Some of the Families Bearing the Name of Heathcote*. Winchester: Warren & Son, 1899.

Hirai, Hiro. 'Kircher's Chymical Interpretation of the Creation and Spontaneous Generation'. In Lawrence M. Principe (eds), *Chymists and Chymistry: Studies in the History of Alchemy and Early Modern Chemistry*, pp. 77–87. Sagamore Beach, MA: Chemical Heritage Foundation and Science History Publications, 2007.

Hogendorn, Jan, and Marion Johnson. *The Shell Money of the Slave Trade*. Cambridge: Cambridge University Press, 2003.

Hooke, Robert. *Micrographia*. London: John Martyn, 1665.

Hooke, Robert. *The Posthumous Works of Robert Hooke; containing his Cutlerian Lectures, and other Discourses read at the Meetings of the Illustrious Royal Society... published by R. Waller*. London: Samuel Smith & Benjamin Walford, 1705.

Huddesford, William. *An Address to the Freemen and Other Inhabitants of the City of Oxford*. Lucern: Abraham Lightholder, 1764.

Hunter, Michael. *Science and the Shape of Orthodoxy: Intellectual Change in Late Seventeenth-Century Britain*. Boydell & Brewer, Woodbridge, 1995.

Hunter, Michael. *Printed Images in Early Modern Britian: Essays in Interpretation*. New York: Routledge, 2010.

Hunter, Michael, and Jim Bennett. *The Image of Restoration Science: The Frontispiece to Thomas Sprat's History of the Royal Society (1667)*. London and New York: Routledge, 2017.

Hunting, P. 'The Worshipful Society of Apothecaries of London'. *Postgraduate Medical Journal* 80 (2004), pp. 41–4.

Hyde, Elizabeth. *Cultivated Power: Flowers, Culture, and Politics in the Reign of Louis XIV*. Philadelphia: University of Pennsylvania Press, 2005.

Iliffe, Robert. 'Foreign Bodies: Travel, Empire and the Early Royal Society of London'. *Canadian Journal of History* 33 (1998), pp. 358–85.

Jardine, Lisa. *Ingenious Pursuits: Building the Scientific Revolution*. London: Little, Brown, 1999.

Johns, Adrian. *The Nature of the Book: Print and Knowledge in the Making*. Chicago: University of Chicago Press, 1998.

Kato, Amami. 'Distorted Depth Perception under the Microscope: Compensation by Surgical Navigator and Image Projection'. *Acta Medica Kinki University*, vol. 33, no. 1–2 (2008), pp. 1–8.

Kennedy, George A. 'The Contributions of Rhetoric to Literary Criticism'. *The Cambridge History of Literary Criticism*, Volume 4: *The Eighteenth Century*. Cambridge: Cambridge University Press, 1997.

Keynes, Geoffrey. *Dr Martin Lister: A Bibliography*. Bury St Edmunds: St Paul's Biographies, 1981.

Kircher, Athanasius. *Athanassi Kircheri Mundus subterraneus in XII libros digestus*. Amsterdam: Janssonio-Waesbergiana, 1678.

Kusukawa, Sachiko. 'Thomas Kirke's Copy of Philosophical Transactions'. *Spontaneous Generations*, vol. 6, no. 1 (2012), pp. 8–14.

Kusukawa, Sachiko. 'Drawings of Fossils by Robert Hooke and Richard Waller'. *Notes and Records: The Royal Society Journal of the History of Science*, vol. 67, no. 2 (2013).

Kusukawa, Sachiko. 'William Courten's Lists of "Things Bought" from the Late Seventeenth Century'. *Journal of the History of Collections*, vol. 29, no. 1 (2017), pp. 1–17.

Leedham-Green, Elizabeth. *A Short History of the University of Cambridge*. Cambridge: Cambridge University Press, 1996.

Leonhard, K. 'Shell Collecting: On 17th-Century Conchology, Curiosity Cabinets, and Still Life Painting'. In Karl A.E. Enenkel and Paul Smith (eds), *Early Modern Zoology: The Construction of Animals in Science, Literature and the Visual Arts*, pp. 177–214. Leiden: Brill, 2007.

Leonhard, K., and Maria-Theresia Leuker, 'Who Commissioned Hollar's Shells?'. *Simiolus: Netherlands Quarterly for the History of Art*, vol. 37, no. 3–4 (2013–14), pp. 227–39.

Lewis, Gillian. 'The Debt of John Ray and Martin Lister to Guillaume Rondelet of Montpellier'. *Notes and Records of the Royal Society*, vol. 66, no. 4 (2012), pp. 323–39.

Lincolnshire Archives Committee, *Archivists' Report*, 13 March 1951–27 March 1952.

Lister, Martin. 'Some Observations Concerning the Odd Turn of Some Shell-Snailes, and the Darting of Spiders...' *Philosophical Transactions* 4 (1669), pp. 1011–16.

Lister, Martin. *Historiæ Sive Synopsis Methodicae Conchyliorum Editio Altera*, ed. William Huddesford. Oxford: Clarendon Press, 1770.

Lister, Martin. 'A Description of Certain Stones Figured Like Plants, and by Some Observing Men Esteemed to be Plants Petrified'. *Philosophical Transactions* 8 (1673), pp. 6181–91.

Lister, Martin. *Historiæ Animalium Angliae Tres Tractatus*. London: John Martyn, 1678.

Lister, Martin. *Johannes Goedartius, Of Insects: done into English and Methodized, with the Addition of Notes. The Figures Etched upon Copper, by Mr F[rancis] P[lace]*. York: John White for Martin Lister, 1682.

Lister, Martin. *Letters & divers other Mixt Discourses in Natural Philosophy*. York: Published by the author, 1683.

Lister, Martin. 'An Account of a Roman Monument found in the Bishoprick of Durham, and of some Roman Antiquities at York, sent in a Letter from Martin Lister Esq.' *Philosophical Transactions* 13 (1683), pp. 70–74.

Lister, Martin. 'An Extract of a Letter, Relating an Experiment Made for Altering the Colour of the Chyle in the Lacteal Veins', *Philosophical Transactions* 13, 1683, pp. 6–9.

Lister, Martin. *De Cochleis tam terrestribus*. London: Published by the author, 1685.

Lister, Martin. *Historiæ Sive Synopsis Methodicae Conchyliorum*. London: Published by the author, 1685–92.

Lister, Martin. 'Preface', *Exercitatio anatomica in qua de Cochleis, Maximè Terrestribus & Limacibus, agitur*. London: Samuel Smith & Benjamin Walford, London, 1694.

Lister, Martin. 'An Account of the Nature and Differences of the Juices, More Particularly, of Our English Vegetables'. *Philosophical Transactions* 19 (1695–97), pp. 362–4.

Lister, Martin. 'The Anatomy of a Scallop'. *Philosophical Transactions* 19, 229 (1695–97), pp. 567–70.

Lister, Martin. *Conchyliorum Bivalvium Utirusque Aquae Exercitatio Anatomica Tertia: Huic Accedit Dissertatio Medicinalis De Calculo Humano*. London: Published by the author, 1696.

Lister, Martin. 'An Observation of Two Boys Bit by a Mad Dog'. *Philosophical Transactions* 20 (1698), pp. 246–8.

Lister, Martin. *A Journey to Paris in the Year 1698*. London: Jacob Tonson, 1699. Ed. Raymond Phineus Stearns. Urbana: University of Illinois Press, 1967.

Lyell, Charles. *Principles of Geology, being an attempt to explain the former changes of the Earth's surface, by reference to causes now in operation*. London: John Murray, 1830.

MacGregor, Arthur. 'William Huddesford (1732–1772): His Role in Reanimating the Ashmolean Museum, His Collections, Researches and Support Network'. *Archives of Natural History* 34 (2007), pp. 47–68.

MacGregor, Arthur. 'Patrons and Collectors: Contributors of Zoological Subjects to the Works of George Edwards (1694–1773)'. *Journal of the History of Collections*, vol. 26, no. 1 (2014), pp. 35–44.

MacGregor, Arthur, Melanie Mendonça and Julie White (eds). *Manuscript Catalogues of the Early Museum Collections, 1683–1886*, Part I. Ashmolean Museum, Oxford, 2000.

Maclean, Ian. *Logic, Signs and Nature in the Renaissance: The Case of Learned Medicine*. Cambridge: Cambridge University Press, 2002.

Magnol, Pierre. *Hortus Regius Monspeliensis sive Catalogus plantarum quae in Horto Regio Monspeliense demonstratur*. Montpellier, 1697.

Mathes, Bettina. 'As Long as a Swan's Neck? The Significance of the Enlarged Clitoris in Early Modern Anatomy'. In Elizabeth D. Harvey (ed.), *Sensible Flesh: On Touch in Early Modern Culture*, pp. 103–24. Philadelphia: Pennsylvania State Press, 2003.

Maton, William G., and Reverend Thomas Rackett, 'An Historical Account of Testaceological Writers'. *Transactions of the Linnean Society* 7 (1803), pp. 119–224.

McHugh, Kirsty (ed.). *The Yorkshire Archaeological Society: A celebration of 150 years of collecting*. Leeds: Yorkshire Archaeological Society, 2013.

McHugh, Tim. *Hospital Politics in Seventeenth Century France: The Crown, Urban Elites and the Poor*. Farnham: Ashgate, 2007.

Mellick, S.A. 'Thomas Browne: Physician 1605–1682 and the *Religio Medici*'. *Australian and New Zealand Journal of Surgery*, vol. 73, no. 6 (2003), pp. 431–7.

Mitchell Weir, Silas. *Some Recently Discovered Letters of William Harvey with Other Miscellanea*. Philadelphia: College of Physicians, 1912.

Mitchill, S. 'A Discourse ... Embracing a Concise and Comprehensive Account of the Writings which Illustrate the Botanical History of North and South America'. *New York Historical Society Collections* 2 (1814), pp. 151–215.

Moufet, Thomas. *Insectorum sive minorum animalium theatrum*. London: Thomas Cotes, 1634.

Musgrave, William. 'A Letter ... to the Learned Dr. Martin Lister wherein He Endeavors to Prove That the Lacteals Frequently Convey Liquors That are Not White'. *Philosophical Transactions* 14, 1684, pp. 812–19.

Nance, Brian. *Turquet de Mayerne as Baroque Physician: The Art of Medical Portraiture*. London: Wellcome Series, 2001.

Nichols, John. *Illustrations of the Literary History of the Eighteenth Century*. London: Nichols, 1822.

Norgate, Edward. *Miniatura, or the Art of Limning* (1627–8), ed. J.M. Muller and J. Murrell. New Haven and London: Paul Mellon Centre for British Art, 1997.

Ogilvie, Brian. 'Nature's Bible: Insects in Seventeenth-Century European Art and Science'. *Tidsskrift for kulturforskning*, vol. 7, no. 3 (2008), pp. 5–21.

Oldenburg, Henry. *The Correspondence of Henry Oldenburg*, ed. A. Rupert Hall and Marie Boas Hall, 13 vols. Madison: University of Wisconsin Press, 1965–86.

Optiz, Donald, Staffan Bergwik and Brigitte Van Tiggelen, 'Introduction: Domesticity and the Historiography of Science'. In D. Optiz, S. Bergwik and B. Van Tiggelen (eds), *Domesticity and the Making of Modern Science*. pp. 1–18. London: Palgrave Macmillan, 2016.

Packham, John R., and Arthur J. Willis, *Ecology of Dunes, Salt Marsh and Shingle*. London: Chapman & Hall, 1997.

Parker, John R., and Basil Harley (eds). *Martin Lister's English Spiders 1678*. Colchester: Harley Books, 1992.

Parkinson, Anna. *Nature's Alchemist: John Parkinson, Herbalist to Charles I*. London: Frances Lincoln, 2007.

Parkinson, Anna. 'John Parkinson: An Ancient Alchemist's Wisdom'. *Daily Telegraph*, 16 November 2007.

Paulson, Ronald. *Hogarth*, Volume 1: *The 'Modern Moral Subject' 1697–1732*. Cambridge: Lutterworth Press, 1991.

Pennington, Richard. *A Descriptive Catalogue of the Etched Works of Wenceslaus Hollar 1607–77*. Cambridge: Cambridge University Press, 2002.

Poole, William. 'A Fragment of the Library of Theodore Haak (1605–1690)'. *Electronic British Library Journal*, 2007, pp. 1–38, www.bl.uk/eblj/2007articles/pdf/eblj-article62007.pdf (accessed 12 October 2013).

Prosperetti, Leopoldine van Hogendorp. '"Conchas Legere": Shells as Trophies of Repose in Northern European Humanism'. *Art History*, vol. 29, no. 3 (2006), pp. 387–413.

Raven, Charles. *John Ray: Naturalist*. Cambridge: Cambridge University Press, 1986.

Ray, Clayton E. *Geology and Paleontology of the Lee Creek Mine, North Carolina*, vol. II. Washington DC: Smithsonian Institution Press, 1987.

Ray, John. *Observations Topographical, Moral and Physiological; Made in a Journey Through part of the Low Countries, Germany, Italy, and France.* John Martyn, London, 1673.

Ray, John. *The Correspondence of John Ray*, ed. Edwin Lankester. London: The Ray Society, 1848.

Ray, John, and Francis Willughby. *The Ornithology of Francis Willoughby...* London: John Martyn, 1678.

Reinarz, Jonathan. *Past Scents: Historical Perspectives on Smell.* Urbana-Champaign: University of Illinois Press, 2014.

Renaux, Alain. *Louis XIV's Botanical Engravings.* Aldershot: Lund Humphries, 2008.

Ridder-Symoens, Hilde de. 'The Mobility of Medical Students from the Fifteenth to the Eighteenth Centuries: The Institutional Context'. In Ole Peter Grell, Andrew Cunningham and Jon Arrizabalaga (eds), *Centres of Medical Excellence? Medical Travel and Education in Europe, 1500–1789*, pp. 47–92. Farnham: Ashgate, 2010.

Rioux, Jean-Antoine. *Le Jardin des plantes de Montpellier: les leçons de l'histoire.* Sauramps Médical, Montpellier, 2004.

Roberts, Bryn. 'Memoirs of Edward Lhwyd, Antiquary and Nicholas Owen's British Remains'. *National Library of Wales Journal*, vol. 19, no. 1 (1975), pp. 67–87.

Roos, Anna Marie. 'The Sixteenth-Century Portrait Miniatures of Nicholas Hilliard: The Interconnections of Media'. Master of Humanities thesis, University of Colorado, 1991.

Roos, Anna Marie. 'A Speculum of Chymical Practice: Isaac Newton, Martin Lister (1639–1712), and the Making of Telescopic Mirrors'. *Notes and Records of the Royal Society* 20 (2010), pp. 105–20.

Roos, Anna Marie. *Web of Nature: Martin Lister (1639–1712), the First Arachnologist.* Leiden: Brill, 2011.

Roos, Anna Marie. 'A Discovery of Martin Lister Ephemera: The Construction of Early Modern Scientific Texts'. *Bodleian Library Record*, vol. 26, no. 1 (2012), pp. 125–36.

Roos, Anna Marie. 'Franz Michael Regenfuss, *Auserlesene Schnecken, Muschelen und andre Schaalthiere*'. In Christopher Pressler and Karen Attar (eds), *Senate House Library, University of London*, essay 26. London: Scala, 2012.

Roos, Anna Marie. 'The Art of Science: A "Rediscovery" of the Lister Copperplates'. *Notes and Records of the Royal Society*, vol. 66, no. 1 (2012), pp. 19–40.

Roos, Anna Marie. *The Correspondence of Dr. Martin Lister (1639–1712)*, Volume 1: *1662–1667.* Leiden: Brill, 2015.

Roos, Anna Marie. 'Only meer Love to Learning': A Rediscovered Travel Diary of Naturalist and Collector James Petiver (c.1665–1718)'. *Journal of the History of Collections*, December 2016. doi: 10/1093/jhc/fhw041.

Roper, Lyndal. 'Witchcraft and Fantasy in Early Modern Germany'. In Jonathan Barry, Marianne Hester and Gareth Roberts (eds), *Witchcraft in Early Modern Europe: Studies in Culture and Belief*, pp. 207–36. Cambridge: Cambridge University Press, 1998.

Rudwick, Martin J.S. *Earth's Deep History: How It Was Discovered and Why It Matters.* Chicago: University of Chicago Press, 2014.

Ruestow, Edward G. *The Microscope in the Dutch Republic: The Shaping of Discovery.* Cambridge: Cambridge University Press, 1996.

Salmon, William. *Polygraphice.* London: Thomas Passenger & Thomas Sawbridge, 1677.

Schaffer, Simon, and Larry Stewart, 'Vigani and After: Chemical Enterprise in Cambridge 1680–1780'. In Mary D. Archer and Christopher D. Haley (eds), *The 1702 Chair of Chemistry at Cambridge: Tranformation and Change*, pp. 31–56. Cambridge: Cambridge University Press, 2005.

Schiebinger, Londa. *Plants and Empire: Colonial Bioprospecting in the Atlantic World.* Cambridge MA: Harvard University Press, 2004.

Sebastian, Anton (ed.). *A Dictionary of the History of Medicine.* New York: Informa Health Care, 1999.

Shadwell, Thomas. *The Virtuoso* [1676]. In *Regents Restoration Drama*, ed. Marjorie Hope Nicolson and David Stuart Rodes. Lincoln: University of Nebraska Press, 1966.

Shapin, Steven, and Simon Schaffer. *Leviathan and the Air Pump: Hobbes, Boyle and the Experimental Life.* Princeton University Press, Princeton NJ, 1985.

Shinn, Abigail. 'Cultures of Mending'. In Andrew Hadfield, Matthew Dimmock and Abigail Shinn (eds), *The Ashgate Research Companion to Popular Culture in Early Modern England*, pp. 235–6. Farnham: Ashgate, 2014.

Skippon, Philip. 'An Account of a Journey Made Thro' Part of the Low-Countries, Germany, Italy, and France'. In *A Collection of Voyages and Travel*, vol. 6. London: Churchill, 1732.

Sloan, Kim. *'A Noble Art': Amateur Artists and Drawing Masters, c.1600–1800.* London: British Museum Press, 2000.

Smith, Mark Michael. *Sensing the Past: Seeing, Hearing, Smelling, Tasting, and Touching in History.* Berkeley: University of California Press, 2008.

Spary, E.C. 'Rococo Readings of the Book of Nature'. In Marina Frasca-Spada and Nick Jardine (eds), *Books and the Sciences in History*, pp. 255–75. Cambridge: Cambridge University Press, 2000.

Spary, E.C. 'Scientific Symmetries'. *History of Science* 42 (2004), pp. 1–46.

Sprackling, Robert. *Medela ignorantiae.* London: R. Crofts, 1665.

Stafford, Barbara. *Artful Science: Enlightenment Entertainment and the Eclipse of Visual Education.* Cambridge MA: MIT Press, 1996.

Stainton, Lindsay, and Christopher White. *Drawing in England from Hilliard to Hogarth.* London: British Museum Publications, 1987.

Stallybrass, Peter. 'Printed Collections and Erasable Writing'. *Proceedings of the American Philosophical Society*, vol. 150, no. 4 (2006), pp. 553–67.

Stearns, Raymond. 'James Petiver: Promoter of Natural Science, c.1663–1718'. *Proceedings of the American Antiquarian Society* 62 (1952), pp. 243–65.

Stoye, John. *English Travellers Abroad, 1604–1667.* New Haven CT and London: Yale University Press, 1989.

Sturtevant, A. 'Inheritance of Direction of Coiling in *Limnaea*'. *Science* 58 (1923), pp. 269–70.

Sung, Mei-Ying. *William Blake and the Art of Engraving.* London: Pickering & Chatto, 2009.

Tallian, Timea. 'John White's Materials and Techniques'. In Kim Sloan (ed.),

European Visions: American Voices. London: British Museum, 2009; www.britishmu-seum.org/pdf/3–Tallian-Materials%20and% 20Techniques.pdf.

Terrall, Mary. *Catching Nature in the Act: Réaumur and the Practice of Natural History in the Eighteenth Century.* Chicago: University of Chicago Press, 2014.

Thornton, R.K.R., and T.G.S. Cain (eds). *A Treatise Concerning the Arte of Limning by Nicholas Hilliard together with a 'A more compendious Discourse Concerning ye Art of Limning'.* Manchester University Press, Manchester, 1992.

Tilley, Christopher. *Metaphor and Material Culture.* Oxford: Wiley, 1999.

Tillott, P.M. *A History of the County of York: The City of York.* London: Victoria County History, 1961.

Twigg, J.D. 'The Parliamentary Visitation of the University of Cambridge, 1644–1645'. *English Historical Review*, vol. 98, no. 287 (1983), pp. 513–28.

Tyler, R.T. *Francis Place: 1647–1728,* exhibition catalogue. York: York City Art Gallery, 1971.

Unwin, Robert. 'A Provincial Man of Science at Work: Martin Lister, FRS, and His Illustrators, 1670–1683'. *Notes and Records of the Royal Society* 49 (1995), pp. 209–30.

Vertue, George. *A Description of the Works of the Ingenious Delineator and Engraver Wenceslaus Hollar.* London: William Bathoe, 1759.

Vertue, George. *Notebooks,* 6 vols. Oxford: Walpole Society, 1934–55.

Warneke, Sara. *Images of the Educational Traveller in Early Modern England.* Leiden: Brill, 1995.

Watson, Hugh. 'The Names of the Two Common Species of Viviparus'. *Proceedings of the Malacological Society* 31 (June 1955), pp. 163–74.

Wear, Andrew. 'The Popularization of Medicine in Early Modern England'. in Roy Porter (ed.), *The Popularization of Medicine 1650–1850.* Routledge, London, 1992, pp. 17–41.

Whittet, T.D. 'Apothecaries and Their Lodgers: Their Part in the Development of the Sciences and Medicine'. *Journal of the Royal Society of Medicine Supplement No. 2,* 76 (1983), pp. 1–32.

Wilbur, Marguerite Eyer. *The East India Company and the British Empire in the Far East.* Stanford CA: Stanford University Press, 1945.

Wilkins, Guy. *A Catalogue and Historical Account of the Sloane Shell Collection.* London: British Museum, 1953.

Williams, Elizabeth. 'Medical Education in Eighteenth-century Montpellier'. In Ole Peter Grell and Andrew Cunningham (eds), *Centres of Medical Excellence? Medical Travel and Education in Europe, 1500–1789,* pp. 247–68. Farnham: Ashgate, 2010.

Willughby, Francis, and John Ray. *De historia piscium libri quatuor.* Oxford: [University Press at the] Sheldonian Theatre for the Royal Society, 1686.

Wilson, Catherine. *The Invisible World: Early Modern Philosophy and the Invention of the Microscope.* Princeton NJ: Princeton University Press, 1995.

Withington, Phil. 'Views from the Bridge: Revolution and Restoration in Seventeenth-Century York'. *Past and Present* 170 (2001), pp. 121–51.

Wood, Anthony à. *Athenae oxonienses … to which are added the Fasti oxonienses,* ed. Philip Bliss, 4 vols. London: F.C. & J. Rivington, 1815.

Woodley, J.D. 'Anne Lister, Illustrator of Martin Lister's *Historiæ Conchyliorum* (1685–1692)'. *Archives of Natural History* 21 (1994), pp. 225–9.

Woolf, Daniel. *The Social Circulation of the Past: English Historical Culture, 1500–1730.* Oxford: Oxford University Press, 2003.

Yeo, Richard. 'Between Memory and Paperbooks: Baconianism and Natural History in Seventeenth-century England'. *History of Science 45*, March 2007, pp. 1–46.

Yeo, Richard. *Notebooks, English Virtuosi, and Early Modern Science.* Chicago and London: University of Chicago Press, 2014.

INTERNET SOURCES

'Amazing Rare Things: Natural History in the Age of Discovery'. The Queen's Gallery, Buckingham Palace, London, 14 March–28 September 2008. www.royalcollection.org.uk/microsites/amazingrarethings

Anstey, Peter. 'Two Forms of Natural History'. *Early Modern Experimental Philosophy*, 17 January 2011. University of Otago. https://blogs.otago.ac.nz/emxphi/2011/01/two-forms-of-natural-history.

Delbourgo, James. 'Slavery in the Cabinet of Curiosities: Hans Sloane's Atlantic World'. www.britishmuseum.org/pdf/delbourgo%20essay.pdf.

Kissack, Chris. *Bordeaux Wine Guide*, Introduction. www.thewinedoctor.com/regionalguides/bordeaux.shtml.

Kusukawa, Sachiko. 'Origins of Science as a Visual Pursuit'. https://picturingscience.wordpress.com.

Mabey, Richard. 'Exploring the Theatrical Space of a Garden'. *New Statesman*, 7 August 2015. www.newstatesman.com/2015/07/putting-down-roots.

Monticello Archaeology Department, *Monticello Research Report*, August 2003. www.monticello.org/site/research-and-collections/cowrie-shell.

Oxford Dictionary of National Biography, Oxford University Press, Oxford, 2004. www.oxforddnb.com.

Roos, Anna Marie (ed.). 'The Correspondence of Martin Lister'. In *Early Modern Letters Online*, Cultures of Knowledge. http://emlo.bodleian.ox.ac.uk/blog/?catalogue=martin-lister.

Roos, Anna Marie (ed.). *The Travel Journal of Dr Martin Lister (1639–1712)*. http://lister.history.ox.ac.uk.

'Women's Work: Portraits of 12 Scientific Illustrators from the 17th to the 21st Century'. http://womenswork.lindahall.org.

Picture credits

COLOUR PLATES

1 © Wellcome Images
2 © Anna Marie Roos/Bodleian Library, University of Oxford, Lister Copperplate 17
3 © Bodleian Library, University of Oxford, Lister Copperplates 162 and 858
4 © Tate, London, 2017
5 © Bodleian Library, University of Oxford, MS. Lister 4, fol. 48
6 © Anna Marie Roos/Bodleian Library, University of Oxford, MS. Lister 19, frontispiece
7 © Senate House Library, University of London
8 © Anna Marie Roos
9 © York Museums Trust
10 © Wellcome Images/Science Museum, London
11 © Oxford University Museum of Natural History
12 © British Library Board, London, All Rights Reserved, Sloane MS 4002 f.31r/Bridgeman Images
13 © Ashmolean Museum, University of Oxford
14 © Bodleian Library, University of Oxford, RR.y.56
15 Royal Collection Trust/© Her Majesty Queen Elizabeth II 2017
16 © Anna Marie Roos
17 © Bodleian Library, University of Oxford, Lister L 95
18 © Bodleian Library, University of Oxford, Lister L 95
19 © Biodiversity Library
20 © British Library Board. All Rights Reserved, MS. Add. 5262, no 152/Bridgeman Images
21 © Wellcome Images
22 © Science Museum Archives, Wroughton, MS 685, fol. 61
23 © Science Museum Archives, Wroughton, MS 685, fol. 61
24 © Bodleian Library, University of Oxford, RR.y.56
25 © Anna Marie Roos, by permission of The Trustees of the Natural History Museum, London
26 © Anna Marie Roos, by permission of The Trustees of the Natural History Museum, London
27 © Anna Marie Roos, by permission of The Trustees of the Natural History Museum, London
28 © Anna Marie Roos, by permission of The Trustees of the Natural History Museum, London
29 © Anna Marie Roos, by permission of The Trustees of the Natural History Museum, London
30 © Bodleian Library, University of Oxford, Lister L 95, fol. 66
31 © Bodleian Library, University of Oxford, Lister L 95, fol. 84a
32 © Bodleian Library, University of Oxford, Lister Copperplate 46
33 © Bodleian Library, University of Oxford, Lister Copperplate 46 (verso)
34 © Bodleian Library, University of Oxford, Lister D 49, Tab. 17
35 © The Royal Society, London
36 © Bodleian Library, University of Oxford, MS. Lister 9, fol. 115r
37 © Bodleian Library, University of Oxford, MS. Lister 9, fol. 122v
38 © Bodleian Library, University of Oxford, Lister D 49, Tab. 4
39 Rijksmuseum, Amsterdam
40 © The Royal Society, London
41 Wikimedia/Creative Commons
42 © Bodleian Library, University of Oxford, MS. Lister 9, fols. 18v-19r
42 © Bodleian Library, University of Oxford, MS. Lister 9, fols 5v-6r
43 © Bodleian Library, University of Oxford, Lister Ephemera Box 3
44 © Bodleian Library, University of Oxford, Lister Ephemera Box 4
45 © Anna Marie Roos/Bodleian Library, University of Oxford, Lister Ephemera Box 4

Index

Entries in italics refer to images